Photographer's Guide to the Canon PowerShot S95

Photographer's Guide to the Canon PowerShot S95

Getting the Most from Canon's Pocketable Digital Camera

Alexander S. White

White Knight Press Henrico, Virginia Copyright © 2011 by Alexander S. White. All rights reserved. No part of this publication may be reproduced, stored in a retrieval system or transmitted in any form or by any means, electronic, mechanical, photocopying, recording or otherwise without the prior written permission of the copyright holder, except for brief quotations used in a review.

Published by White Knight Press 9704 Old Club Trace Henrico, Virginia 23238

ISBN: 978-0-9649875-6-2

Printed in the United States of America

This book is dedicated to my wife, Clenise.

Contents

Acknowledgments	13
Introduction	14
Chapter 1: Preliminary Setup	17
Setting Up the Camera	17
Charging and Inserting the Battery	17
Inserting the Memory Card	19
Setting the Language, Date, and Time	24
Chapter 2: Basic Operations	26
Taking Pictures	26
Fully Automatic: Auto Mode	26
Basic Variations from Fully Automatic	29
Focus	30
Autofocus	30
Manual Focus	32
Exposure	33
Exposure Compensation	33
Flash	36
Movie Recording	38
Viewing Pictures	40
Review While in Recording Mode	41
Reviewing Images in Playback Mode	41
Playing Movies	41
Chapter 3: The Shooting Modes	43
Auto Mode	44
Program Mode	45
Aperture Priority Mode	46
Shutter Priority Mode	50
Manual Exposure Mode	53
Scene Mode	56
Portrait	57
Landscape	58
Kids & Pets	58
Smart Shutter	59
Super Vivid	60
Poster Effect	60
Color Accent	61
Color Swap	62
HDR	63
Nostalgic	65

Fish-eye Effect	66
Miniature Effect	67
Beach	68
Underwater	68
Foliage	68
Snow	69
Fireworks	69
Stitch Assist	69
Low Light Mode	70
Custom Mode	72
Chapter 4: Recording Menu, Function Menu, and My	Menu
	75
The Recording Menu	75
AF Frame	78
Face AiAF	78
Center	78
Tracking AF	79
Digital Zoom	80
AF-Point Zoom	82
Servo AF	83
AF-assist Beam	83
MF-Point Zoom	84
Safety MF	84
Flash Settings	85
Flash Mode	85
Flash Exposure Compensation and Flash O	
Chryston Cryp a	87
Shutter Sync.	87
Red-Eye Correction	88
Red-Eye Lamp	88
ISO Auto Settings	88
Safety Shift Review	89
Review Info	90
Blink Detection	90 92
	92
Custom Display IS Mode	93
Date Stamp	93
Set Shortcut button	94
Unassigned	95
Face Select	95
i-Contrast	95
ISO Speed	96
100 opecu	70

White Balance	96
Custom White Balance	96
My Colors	97
Bracketing	97
Drive Mode	97
Light Metering	97
Aspect Ratio	97
RAW or JPEG	98
REC Pixels/Compression	98
Movie Quality	98
Servo AF	99
Red-Eye Correction	99
AF Lock	99
AEL	100
Digital Tele-converter	100
Display Off	100
Save Settings	101
The Function Menu	102
i-Contrast	103
ISO	104
White Balance	106
My Colors	109
My Colors Off	110
Vivid	110
Neutral	111
Sepia	111
B/W	112
Positive Film	112
Lighter Skin Tone	113
Darker Skin Tone	113
Vivid Blue	113
Vivid Green	114
Vivid Red	114
Custom Color	115
Bracketing	115
Exposure bracketing	116
Focus bracketing	117
Continuous Shooting	118
Metering Method	120
Aspect Ratio	121
Image Type	124
Image Size and Quality	126
My Menu	128

Chapter 5: Other Controls	131
Mode Dial	131
Shutter Release Button	132
Zoom Lever	132
Power Button	133
Control Ring and Ring Function Button	133
Lamp	136
Shortcut Button	137
Playback Button	137
Display Button	138
Menu Button	139
Control Dial and its Buttons	139
Control Dial	140
Func./Set Button	141
Direction Buttons	142
Top Button	143
Right Button: Flash Settings	145
Bottom Button: Self-timer/Trash	146
Indicator	147
Chapter 6: Playback and Printing	149
Normal Playback	149
Index View and Enlarging Images	150
Scroll Display	152
Different Playback Screens	152
Filtered Playback and Jumping	156
The Playback Menu	159
Smart Shuffle	160
Slideshow	160
Erase	162
Protect	163
Rotate	164
Favorites	164
My Category	165
People	165
Scenery	165
Events	166
i-Contrast	167
Red-Eye Correction	168
Trimming	169
Resize	170
My Colors	171
Scroll Display	172
Resume	172

Transition	172
Printing Images from the Camera	173
Printing Directly from the Camera	173
The Print Menu	175
Chapter 7: Setup Menu	176
Mute	177
Volume	177
Sound Options	178
Hints & Tips	178
LCD Brightness	178
Start-up Image	179
Format	179
File Numbering	180
Create Folder	180
Lens Retract	181
Power Saving	181
Time Zone	182
Date/Time	183
Distance Units	183
Video System	184
CTRL via HDMI	184
Eye-Fi Settings	184
Language	185
Reset All	186
Chapter 8: Motion Pictures	187
Movie-making Overview	187
Quick Guide to Recording a Movie Clip	188
Other Settings for Movies	191
Recording Menu	192
Digital Zoom	192
AF-assist beam	193
Safety MF	194
Wind Filter	194
Custom Display	194
IS Mode	194
Set Shortcut Button	194
Function Menu	195
Movie Mode	195
Miniature Effect	195
Color Accent and Color Swap	196
White Balance	197
My Colors	197
Image Quality	197

Other Settings and Controls	198
Exposure Compensation and Exposure Lock	198
Self-timer	200
Control ring	200
Movie Playback	200
Chapter 9: Other Topics	203
Macro (Closeup) Shooting	203
Using RAW Quality	205
Using Flash	207
Other Flash Settings	211
Infrared Photography	212
Street Photography	215
Making 3D Images	217
Connecting to a Television Set	219
APPENDIX A: Accessories	222
Cases	222
Batteries	223
AC Adapter	224
Hand Grip	226
Add-on Filters and Lenses	226
Flash	228
APPENDIX B: Quick Tips	232
APPENDIX C: Resources for Further Information	238
Books	238
Web Sites	238
Digital Photography Review	239
Reviews of the PowerShot S95	239
The Official Canon Site	240
Flickr Discussion Group	240
Ken Rockwell	241
Infrared Photography	241
Kleptography	241
Lensmate	241
CHDK: Experimental Tinkering	242
Index	243

Acknowledgments

his is the fifth of my "Photographer's Guide" books about the operation of advanced compact digital cameras. All of the earlier books were about Panasonic or Leica models. With this book about a Canon camera, I needed to focus on a different menu system, terminology, and controls. To help make sure I understood the functioning of the camera and accurately explained its features, I reached out to the many talented and dedicated contributors to the "Canon Talk" forum at dpreview.com, a premier web site for discussions about digital photography. The response was amazing and extraordinarily helpful. I am particularly indebted to Jerry Fagin, Vjim Filomena, Santi Gonzalez, Steven Heller, Paul Jordan, John Laninga, Eric Nicholson, Gary Ruben, and Joel Rubenstein for their superlative assistance in scouring a draft of the book for errors or points that needed better discussion. Their help greatly improved the text and images in the book. I'm also grateful to Guy Parsons, a Panasonic user who graciously agreed to proofread the text. Any remaining errors or problems are solely my responsibility.

All photographs in this book that illustrate the capabilities or features of the Canon PowerShot S95 camera are ones that I took with that camera. The photographs that show that camera's controls were taken with a Sony DSLR-A850, mostly with a Sony 50mm macro lens.

Finally, as with my earlier books, the greatest support in every possible way, from joining me on trips to take photographs for this book to editing and proofreading the final text, has come from my wife, Clenise.

Introduction

his book is a guide for users of the Canon PowerShot S95 compact digital camera, which has earned a reputation as one of the most capable "point-and-shoot" digital cameras on the market today. If you have purchased this book, chances are you are already convinced that the PowerShot S95 is one of the best options available today in the realm of small digital cameras. But I'll still mention some of the features that make it an outstanding choice in my opinion.

For me, the one feature of the S95 that stands out above others is its truly small size. This camera, unlike virtually any other current model with such advanced features, is not just portable but "pocketable." It will fit readily into a jacket or trousers pocket and can be held unobtrusively in one hand when you don't want to call attention to your camera. And, in order to gain this degree of portability, the camera doesn't give up much in the way of capability. You can set the S95 to its Auto shooting mode and get great results most of the time with no further settings. However, the camera also offers full manual control of focus and exposure, continuous shooting, focus and exposure bracketing, excellent low-light performance, and numerous special features, including a variety of ways to manipulate colors, and a built-in HDR (High Dynamic Range) shooting mode. Also, like other cameras in this class, the S95 provides HD (high-definition) video shooting.

The S95 is not the perfect camera, of course; no camera can serve as the ideal tool for all situations. In this case, the major drawbacks often cited are that the camera lacks an optical viewfinder, and has no system for attaching one. A related issue is that the S95 has no accessory shoe, which could be used to attach items such as a viewfinder or an external flash unit. (There is a Canon flash unit that can be used with the S95—the HF-DC1 High-Power Flash, which is discussed in Appendix A.) In addition, the camera does not have a very rapid continuous shooting capability, and its video features are not as strong as those of some other cameras in its class. All in all, though, the S95's virtues far outweigh its negatives.

This introduction to the camera's features is, of course, not complete, but it serves to illustrate that this camera has an impressive set of capabilities that should be attractive to serious amateur photographers—those who want a camera that gives them numerous options for creative control of their images and that can be carried around at all times, so they will have a substantial photographic apparatus with them when a good picture-taking opportunity pops up.

My goal with this book is to provide a thorough and useful guide to the camera's features, explaining how they work and when you might want to use them. The book is aimed largely at beginning and intermediate photographers who are not satisfied with the technical documentation that comes with the camera and who need a more user-friendly explanation of the camera's many controls and menus. For those who are seeking more advanced information, I provide some discussion of topics that go beyond the basics, and I include in the appendices information that should help you uncover additional resources.

One note on the scope of this guide: I live in the United States, and I bought my camera in the U.S. market. I am not familiar

with the variations for cameras sold in Europe or elsewhere, such as different batteries or chargers. The photographic functions are not different, though, so this guide should be useful to photographers in all locations, apart from that narrow range of issues. I have stated measurements of distance and weight in both the English and metric systems, for the benefit of readers in various countries around the world.

Chapter 1: Preliminary Setup Setting Up the Camera

will assume your Canon PowerShot S95 has just arrived at your home or office, perhaps purchased from an internet site or a retail store. The box should contain the camera itself, battery, battery terminal cover, battery charger, wrist strap, USB cable, A/V cable, software and user's manual on a CD, and the brief "Getting Started" instruction pamphlet. There should also be a warranty card and one or two other items, such as the introductory pamphlet in another language.

It may be a good idea to attach the wrist strap as soon as possible, because it can help you keep a tight grip on the camera. Some users prefer a smaller strap, because they find the included one too large to be useful. I will admit that I have never attached the strap myself, though, because it can make it harder to fit the camera into some cases. This camera is so small that I find I can hold it firmly in my hand without much risk of dropping it, even without a strap. I did attach a custommade hand grip, which is discussed in Appendix A.

Charging and Inserting the Battery

The Canon battery for the PowerShot S95 is the NB-6L. This battery has to be charged in an external charger; you can't

charge it while it's in the camera, even if you connect the camera to the optional AC adapter. So it's a very good idea to get an extra battery if you're going to be doing a large amount of shooting with the camera. I'll talk about batteries and other accessories in Appendix A.

For now, let's get the battery charged.

You can only insert it in the charger one way; look for the set of three goldish-colored metal contact strips on the battery, then look for the corresponding set of three contacts inside the battery compartment, and insert the battery so the two sets of contacts will meet up. With the battery inserted, plug the charger into any standard AC outlet or surge protector. The orange light comes on to indicate that the battery is charging. When the green light comes on, after about two hours, the battery is fully charged and ready to use.

Now that you have a charged battery, hold the camera upside down so the writing on the bottom is right side up. Press down on the raised area with six dots at the far right of the camera's bottom, and slide the battery compartment door to the right until it pops open. To insert the battery, look for the sets of metal contacts on the battery and inside the battery compartment, and guide the battery accordingly. You may need to use the right side of the battery to nudge the brown latching mechanism inside the battery compartment to the right, to allow the battery to slide in. Slide it all the way in until the

brown latch catches above the battery and locks it in place. Then close the battery compartment door, slide the door back to the left until it catches, and you're done. (Or you can leave the door open if you're going to insert a memory card, as discussed below.)

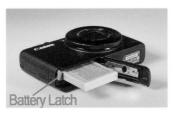

Inserting the Memory Card

The PowerShot S95 does not ship with any memory card. If you turn the camera on with no memory card inserted, you will see the error message "No memory card," and if you then press the shutter button to take a picture, you will see the even more urgent warning "Cannot record!" So, the chances are pretty good that you will notice that your pictures are not being saved. Some other camera models have a small amount of built-in memory so you can take a few pictures even without a card, but the PowerShot S95 does not have any such safety net. To avoid the frustration of having a great camera that can't save any images, you need to insert a memory card.

The PowerShot S95 uses two types of cards. The type most commonly used is the SD card, which is quite small—about the size of a large postage stamp. SD cards come in several varieties. The standard card, called simply SD, comes in capacities from 8 MB to 2 GB. A higher-capacity card, SDHC, comes in sizes from 4 GB to 32 GB. The newest, and highest-capacity card, SDXC (for extended capacity) comes in sizes of 48 GB, 64 GB, and up; this version of the card can have a capacity up to 2 terabytes (TB), theoretically, and SDXC cards have faster transfer speeds than the smaller-capacity cards. The S95 can also accept another type of similar-sized memory card called a

MultiMediaCard (MMC), which now comes in several different variations, including MMCplus and HC MMCplus, with higher storage capacities and speeds than the original MMC variety. The Transcend 4 GB MMCplus card worked very well in the S95; it seemed to operate just like an SDHC card.

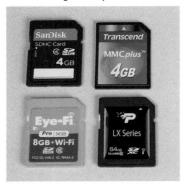

What card and size should you use? It depends on your needs and intentions. If you're planning to record a good deal of high-definition (HD) video or large numbers of RAW photos, you should get the biggest card you can afford. There are several variables to take into account in computing how many images or videos you can store on a particular size of card, such as which aspect ratio you're using (16:9, 3:2, 4:3, 1:1, or 4:5), picture size, and quality. To cut through the complications, here are a few examples of what can be stored on a given card. If you're taking RAW images (the highest quality) in 4:3 aspect ratio (that is, the image is 4 units wide for every 3 units high), with a 2 GB SD card, you can store 135 of the highest-quality (RAW) images, 746 high-quality JPEG images (Large size and Fine quality), or more than 10,000 of the smallest size and lowest-quality images.

If you're interested in video, here are some guidelines. You can fit about 12 minutes of the highest-quality high-definition (HD) video on a 2 GB card, or about 1 hour and 43 minutes on a 16 GB card. A 2 GB card will hold about 22 minutes of lesser-quality VGA video or about 60 minutes of video at the low-

est quality, 320 X 240 pixels. Note, though, that the camera is limited to recording just under 30 minutes of HD video in one sequence, or about one hour of the lower-quality video modes.

One other consideration is the speed of the card. I often use a 4 GB Lexar Professional SDHC card, rated at a speed of 133x. That level of speed is important to get good results for recording images and video with this camera. You should try to find a card that writes data at a rate of 10 MB/second or faster to record HD video. If you go by the Class designation, a Class 4 card should be sufficient for shooting stills, and a Class 6 card should suffice for recording video.

Finally, you need to realize if you have an older computer with a built-in card reader, or just an older external card reader, chances are it will not read the newer SDHC cards. In that case, you would have to either get a new reader that will accept SDHC cards, or download images from the camera to your computer using the USB cable. Using the newest variety of card, SDXC, can be even more problematic; at this writing there are compatibility issues with some computers. In mid-2010 I tried a 64GB SDXC card, and my MacBook Pro could not read it at all at first, even when I left it in the camera and connected the camera to the computer by USB cable. I eventually found an SD card reader, the Sonnet 21-in-1 Express-Card/34 Memory Card Reader & Writer, that could read all the images and movies from the SDXC card on my MacBook Pro, with a software driver provided on the company's web site at www.sonnettech.com. I was fortunate that my computer had an ExpressCard/34 slot, which not that many Mac computers have nowadays. As an added benefit, after I downloaded the driver from the sonnettech.com site, my computer was able to read the files from the SDXC card when the camera was connected to the computer by its USB cable, without even using the ExpressCard reader.

Since my earlier experience with SDXC cards, the situation

has improved. If you are using a computer with a relatively new version of the operating system, it will be able to read SDXC cards, provided you are using a compatible card reader. Specifically, the cards can be read by Windows 7; by Windows Vista with Service Pack 1 or 2; and by Windows XP with a software patch for reading the exFAT file system. That patch is available at http://www.microsoft.com/downloads. For Macintosh computers, you need to have Max OS X version 10.6.6 or later; otherwise, you need a patch such as the one I found at sonnettech.com.

As I write this, SDXC cards cost at least \$150.00, though prices are dropping. You may want to wait until the prices come down some more, unless you absolutely need the 48 GB, 64 GB, or 128 GB storage capacity, and can deal with the compatibility issues.

Finally, if you will have access to a wireless (Wi-Fi) network where you use your camera, you may want to consider getting an Eye-Fi card. This special type of storage device looks very much like an ordinary SDHC card, but it includes a tiny transmitter that lets it connect to a wireless network and send your images to your computer on that network as soon as the images have been recorded by the camera.

I have tested an 8 GB Eye-Fi card, the Pro X2 model, with the S95, and it works well. Within a few seconds after I snap a picture with this card installed in the camera, a little thumbnail image appears in the upper right corner of my computer's screen showing the progress of the upload. When all images are uploaded, they are available in the Pictures/Eye-Fi folder on my computer. The Pro X2 model can handle RAW files and video files as well as the smaller JPEG files. (At the time of this writing, the Pro X2 is the only variety of Eye-Fi card that can handle RAW files.) An Eye-Fi card is not a necessity, but I enjoy the convenience of having my images sent straight to my computer without having to put the card into a card reader

or to connect the camera to the computer with a USB cable.

In summary, you have quite a few options for choosing a memory card. Personally, I like to use a high-speed 16 GB or 32 GB SDHC card, just to have extra capacity and speed in case they are needed. I like the convenience of the Eye-Fi card also, but, unless you do a lot of photography within range of a wireless network so the images can be uploaded quickly, it may not be worth your while to get that type of card.

Once you have selected your card, open the same little door on the bottom of the camera that covers the battery compartment, and slide the card in until it catches, with its label facing the battery. To remove the card, you push down on its edge until it releases and springs up so you can grab it. Once the card has been pushed down until it catches, close the compartment door by pushing it to the left.

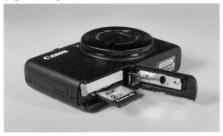

Although the card may work fine when first inserted in the camera, it's always a good idea to format a card when first using it in a camera, so it will definitely be set up with the correct file structure and will have any bad areas blocked off from use. To do this, turn on the camera by pressing the power button, press the Menu button at the bottom right of the camera's back, then press the right direction button (right edge of the control dial on the camera's back) to highlight the tab at the top of the screen with the wrench and mallet icon. That icon indicates the Setup menu. Then use the down direction button or the control dial to scroll down through the Setup menu until you reach the Format command. Press the Func./Set button (in the

center of the control dial) when that command is highlighted, then, on the next screen, highlight OK, and press the Func./Set button again to carry out the command.

One note for when you're shooting pictures with the camera: When it's recording to an SD card or MMC, the little green light on the back of the camera, just above the S button, blinks. When that indicator is blinking, it's important not to turn off the camera or otherwise interrupt its functioning, such as by taking out the battery or disconnecting an AC power adapter. You need to let the card complete its recording process in peace.

Setting the Language, Date, and Time

You need to make sure the date and time are set correctly before you start taking pictures, because the camera records that information (sometimes known as "metadata," meaning data beyond the information in the picture itself) invisibly with each image, and displays it later if you want. Someday you may be very glad to have the date (and even the time of day) correctly recorded with your archives of digital images.

To get these basic items set correctly, press down on the camera's power switch, marked On/Off, on top of the camera, to turn the camera on. Then press the Menu button at the lower right of the camera's back. Press the right side of the control dial, marked with a lightning bolt, to move the orange menu selection block to highlight the wrench and mallet icon that represents the Setup menu. Press the lower side of the control dial, marked with a trash can and self-timer icon, to move the highlight down to the Date/Time line on the menu, and press the center button in the control dial, marked Func./Set, to activate the date and time settings. Move left and right through the date, year, and time settings, and change the settings with up and down movements of the cursor. When everything is set correctly, press the center Func./Set button to confirm.

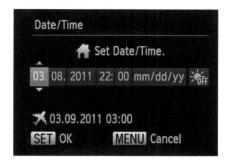

If you need to change the language that the camera uses for the menus and other messages, navigate on the Setup menu to the next-to-bottom line, and press the Func./Set button to select the Language menu item. Then navigate with the cursor buttons (the four sides of the control dial) to the language of your choice, and press the Func./Set button to select it.

Chapter 2: Basic Operations

Taking Pictures

ow that the PowerShot S95 has the correct time and date set and has a fully charged battery inserted, along with a memory card, let's explore some scenarios for basic picture-taking. For now, I won't get into discussions of what the various options are and why you might choose one over another. I'll just lay out a reasonable set of steps that will get you and your camera into action and will deposit a decent image on your memory card.

Fully Automatic: Auto Mode

Here's the drill if you want to set the camera to its most automatic mode and let it make (almost) all of the decisions for you. This is a good way to go if you're in a hurry and need to grab a quick shot without fiddling with settings, or if you're new at this and would rather let the camera do its magic without having to provide much input.

1. Find the mode dial on top of the camera at the right, and

turn it until the word "Auto" is next to the small white indicator line.

- ATANO
- 2. Turn on the power by pressing the On/Off button. The LCD screen will illuminate to show that the camera has turned on.
- 3. Press the Func./Set button in the center of the control dial on the back of the camera. This action brings up a line of numbers at the bottom of the screen, and a couple of entries along the lower left side of the screen. Press the lower edge of the control dial (the part marked by the trash can and self-timer icon) to move the orange highlight to the bottom entry on the left side of the screen. This entry will be either L, M1, M2, or S. Highlight the L, to select Large for your image size.

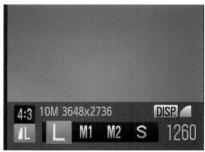

- 4. Press the DISP button, as prompted on the screen. This button is at the left bottom of the control area on the camera's back. Then use the direction buttons (edges of the control dial) to highlight the pie-piece-shaped smooth figure, rather than the jagged figure. This action selects Fine for the quality of your images.
- 5. If the menu has not disappeared, press the up direction button (marked by a symbol with plus and minus signs) to highlight the numbers above the L and the smooth shape. These

numbers will be either 16:9, 3:2, 4:3, 1:1, or 4:5. They represent the aspect ratio of the image—that is, the ratio of the width of the image to its height. For example, with 4:3, the image is 4 units wide for 3 units high. I recommend that you select either 4:3 or 3:2 at this point.

- 6. Press the Func./Set button again to make the menu disappear, if it hasn't disappeared already.
- 7. Aim the camera toward the subject and look at the LCD screen to compose the picture as you want it. Locate the zoom lever on the ring that surrounds the shutter button on the top right of the camera. Push that lever to the left, toward the icon showing a group of three trees, to get a wider-angle shot (including more of the scene in the picture), or to the right, toward the icon showing a single tree, to get a telephoto, zoomed-in shot.

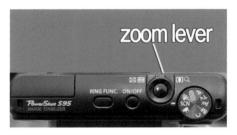

- 8. If you're indoors or in an area with low light, be careful not to hold your finger on top of the flash at the top left of the camera, in front of the PowerShot S95 label. The camera may try to pop the flash up, but it can't if your finger is blocking it.
- 9. Once the picture looks good on the LCD screen, push the shutter button halfway down and pause in that position. You should hear a little beep and see a steady (not blinking) green light to the right of the LCD screen, indicating that the picture will be in focus. If you see an orange light instead, that means the flash is ready to fire.

10. After you have made sure the focus and exposure were properly measured in the previous step, push the shutter button all the way down to take the picture.

Basic Variations from Fully Automatic

At this point I won't go into a discussion of all of the various still-picture shooting modes, except to name them. Besides Auto, which I just discussed, there are Program (P), Shutter Priority (Tv), Aperture Priority (Av), Manual (M), Scene (SCN), and Low Light (Candle). There is also one Custom mode (C), which you can set up yourself. I'll talk about all of the still-shooting modes in Chapter 3, and the Movie mode in Chapter 8. For now, I'm going to discuss the various functions and features of the PowerShot S95 that you can adjust to suit whatever picture-taking situation you may be faced with. Not all of the settings can be adjusted in Auto mode, so we'll set the camera down to a lower level of automation, to the Program mode. In that mode, you'll be able to control most of the camera's functions for taking still pictures.

I'm not going to repeat the basic steps for taking a picture, because those are quite simple. If you need a refresher on those steps, see the list in the above discussion of Auto mode.

To start, set the mode dial to P, for Program.

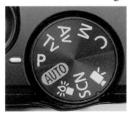

You will immediately see some different indications on the LCD screen, to show that some of the Auto mode settings have changed, or that some settings have newly become available,

because you now have more control over matters such as picture size and quality, ISO, exposure compensation, and others. Using the Program setting, the camera will determine the proper exposure, both the aperture (size of opening to let in light) and the shutter speed (how long the shutter is open to let in light). So in this mode you won't be making any decisions about those settings; those decisions can be made in other modes, which I'll discuss later, in Chapter 3. That still leaves lots of decisions you can make, though, so let's talk about the various settings you can adjust in Program mode.

Focus

Now that you're not in Auto mode, you have control over focus. Your first choice is between manual focus and autofocus. In other words, you have the option of setting the camera to the MF setting, for manual focus. You also have the ability to select which of several types of autofocus operation you want the camera to use, if you opt for autofocus instead.

Autofocus

I'll discuss the various autofocus modes in more detail in Chapter 4. Here we'll just make sure a standard autofocus mode is selected. First, press the left direction button on the control dial (marked by a flower icon and the letters MF). This action puts three options on the LCD screen: from left to right, they are the flower icon, for macro (close-up) autofocus; an icon showing mountains and a person, for normal autofocus; and the letters MF, for manual focus.

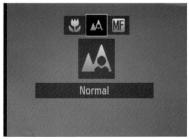

For now, use the direction buttons to select the center icon, for normal autofocus. (You have to be quick; the three choices disappear quickly.) You can press the Func./Set button to confirm your choice, or just let it go, and the choice will confirm itself.

There are several other focus-related options you can set, but for now, let's just use one of them. Press the Menu button at the lower right of the camera's back, then make sure the camera icon is highlighted at the top of the three columns of menus. That icon represents the Recording menu. Move down into the list of menu items using the down direction button, and highlight the first option, AF Frame.

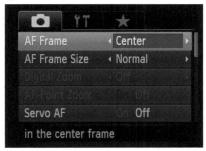

Use the left and right buttons to change the value for this item to Center, which means the autofocus system will place a focus frame in the center of the screen and will focus on that area. Press the Menu button again to exit the menu system.

When you aim the camera at a subject, center the most important subject in the white focus rectangle. Press the shutter button halfway down so the camera will evaluate the exposure and the focus. You should hear a beep and see a steady green or orange light if everything is ready for you to take the picture. (If the orange light is blinking, that means the camera is warning you that the shutter speed is so slow that the picture may be blurred from camera shake. If that happens, press the right direction button, marked by a lightning bolt, and then use the direction buttons to select the icon of an A next to a lightning bolt, which turns on automatic flash mode.) If every-

thing looks okay to you, go ahead and press the shutter button all the way down to take the picture.

Suppose you want to take a picture in which your main subject is not in the center. Maybe your shot is set up so that a person is standing off to the right of center, and there is some attractive scenery to the left of the scene. Place the focus frame over the part of the picture that needs to be in focus—in our example, the person to the right. Then press the shutter button halfway down until the camera focuses and beeps. Keep the button pressed halfway to lock in the focus (and exposure) while you move the camera back to create your desired composition, with the person off to the right. Then take the picture, and the area you originally focused on will be in focus.

Manual Focus

There are other autofocus modes, but I won't discuss those at this point. Let's talk instead about manual focus, the other major option for focusing. Why would you want to use manual focus when the camera will focus for you automatically? Many experienced photographers like the amount of control that comes from being able to set the focus exactly how they want it. And, in some situations, such as focusing in dark areas or areas behind glass, taking extreme close-ups, or cases where there are objects at various distances from the camera, it may be useful for you to be able to control exactly where the point of sharpest focus lies.

To take advantage of this capability, go back to the left direction button, with the letters MF, and press it; then quickly navigate over to the right-most option and select the MF icon on the screen. This action places the camera in manual focus mode. At this point, all you need to do is adjust the focus by turning the control dial, the ridged wheel on the back of the camera. As you turn it, you will see a white bar go up and down inside a scale on the right side of the LCD screen, in-

dicating the approximate focusing distance. You also may see an enlarged area in the center of the screen, depending on the menu options that are in effect.

Once the camera is set to manual focus mode, all you have to do is turn the control dial until you achieve the sharpest possible focus for whatever part of the picture you want to focus on.

If you would like to take advantage of the camera's autofocus capability but then fine-tune the focus manually, here is a different approach: Start out in normal autofocus mode, and press the shutter button down halfway to let the camera focus automatically. Then, while the shutter button is still halfway down, press the MF (left) button. This action places the camera into manual focus mode, with a starting focus point already set by the autofocus mechanism. You can then adjust the focus using the control dial, as needed.

Exposure

Next, I'll discuss some ways to control exposure, rather than letting the camera make all the decisions. The PowerShot S95's Auto mode is very good at choosing the right exposure, and so is the Program mode. But there are going to be some situations in which you want to override the camera's automation.

Exposure Compensation

First, let's take a look at the control for adjusting exposure to

account for an unusual, or non-optimal, lighting situation. Suppose your subject is a person standing in front of a window that is letting in sunlight. We'll say the camera is set for Program mode and is set to the normal autofocus mode (not manual focus or macro focus). The camera will do a good job of averaging the amount of light coming into the lens, and will expose the picture accordingly. The problem is, the window and its frame will likely "fool" the camera into closing down the aperture, because the overall picture will seem quite bright. But your subject, who is being lit from behind (by backlight), will seem too dark in the picture.

One solution here, which the PowerShot S95 makes very easy to carry out, is the exposure compensation control. Look closely at the top direction button on the control dial. That button is labeled with a little plus and minus sign, with the plus on a black background and the minus on white. This control activates the exposure compensation system, which will override the automatic exposure as much as you tell it to, within limits. (You don't always need to use this button when you want to activate exposure compensation, but it's good to know about it for the times when you do need it, as I'll explain in a minute.)

Go ahead and set up your camera in Program mode, and aim at your subject. Now press that top button, and you will see a scale show up on the screen, reading from -2 to +2 EV in increments of one-third EV.

The EV stands for Exposure Value, which is a standard mea-

sure of brightness. Once this scale has appeared, you turn the control dial clockwise or counter-clockwise to move the values higher or lower, as indicated by a little green dot that moves beneath the value that is being set. If you use the dial to move the green dot to -2, the picture will be considerably darker than the automatic exposure would produce. If you move it to +2, the picture will be noticeably brighter. The camera's screen brightens and darkens to show you how the exposure is changing, before you take the picture.

When you're using exposure compensation, don't just settle for one adjustment. If you have the time, and want to really fine-tune your exposure, try this technique: shoot, then check the result on the LCD; if it's too bright or too dark, adjust the exposure compensation again; repeat shooting and adjusting until the exposure looks just right.

Once you've taken the picture, you should reset the EV compensation back to zero, in the middle of the scale, so you don't unintentionally affect the pictures you take later. You need to be careful about this, because the camera will maintain any EV value you set, even when it's turned off and then on again.

Now I should explain what I meant earlier when I said that you don't always need to press the exposure compensation button to activate exposure compensation. When the camera is set to autofocus, you can just start turning the control dial, and the exposure compensation scale will appear and the value will be adjusted as you continue to turn the dial. However, if you set the camera to manual focus as discussed earlier, then turning the control dial will adjust the manual focusing. So, in that situation, you do have to press the exposure compensation button, which will change the function of the control dial to controlling exposure compensation rather than manual focus.

In this situation, the camera provides you with information as to which function is being adjusted by the control dial. Look

on the LCD screen for a green disc with perforations around its perimeter; that symbol represents the control dial.

When it is next to the MF icon, the control dial adjusts manual focus; when the green disc is next to the exposure compensation numbers at the bottom of the screen (for example, ± 0), the dial is controlling exposure compensation. (You will also at times see a different green icon, looking like an open hoop, representing the control ring, which surrounds the lens on the front of the camera. I'll discuss the control ring in Chapter 5.)

So, to make this point clear: When the camera is set to manual focus mode, press the exposure compensation button to switch the function of the control dial between manual focus and exposure compensation. At other times, just start turning the control dial to adjust exposure compensation.

Finally, when you are adjusting exposure compensation, if you press the DISP. button, the camera switches into Auto Exposure Bracketing mode, and presents you with the screen for setting the bracketing interval. (Bracketing is discussed in Chapter 4.)

Flash

Later on, in Chapters 3 and 4, I'll discuss several other topics dealing with exposure, such as Manual mode, Aperture Priority and Shutter Priority modes, i-Contrast, and others. For

now I'm going to discuss the basics of using the PowerShot S95's built-in flash unit, because that is something you may need to do on a regular basis. In Appendix A, I'll discuss using other flash units, and in Chapter 9 I'll discuss other options for using the flash, such as controlling its output and preventing "red-eye."

The built-in flash on the S95 is not especially powerful, but it can provide enough illumination to let you take pictures in dark areas and to brighten up areas that would otherwise be lost in shadows, even outdoors on a sunny day. The flash unit will pop up on its own in certain situations, or you can force it

to pop up yourself. The key to controlling the behavior of the flash is the right direction button at the right edge of the control dial on back of the camera; it has a lightning bolt icon on it to announce its identity as the flash-control button. In any shooting mode for still pictures, press down on this button once to summon the flash icons, and then press it again one or more times to select the icon you want

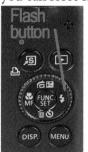

Depending on the shooting mode the camera is in, the options may be auto flash, flash off, flash forced on, and slow synchro. When the camera is set for certain types of shooting, such as HDR, the flash is forced off and cannot be turned on.

Let's explore a common scenario to see how the flash works. Make sure the camera is turned on and the mode dial on top of the camera is set to the Auto shooting mode.

Go ahead and press the right (flash) button, with the lightning bolt icon on it. You will see two options—a lightning bolt with an A, for Auto flash, and a lightning bolt with the universal "no" sign crossing it out, for flash forced off. You can press the flash button again to select either of these choices.

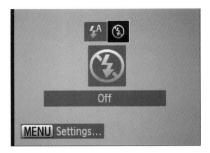

Next, try setting the mode dial to P, for Program mode, and then press the flash button. You will find more options available: auto, flash forced on, slow synchro, and flash forced off.

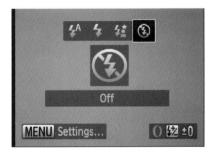

You can move through this list in various ways—keep pressing the flash button, use both the left and right buttons, or turn the control dial to move from option to option. Later on, in Chapter 9, I'll talk more about the various flash options, such as slow synchro, and how they work. For now, you know how to choose them.

Movie Recording

Let's take a look at recording a short video sequence with the PowerShot S95. In Chapter 8, I'll discuss some of the other options for video recording, but for now, let's stick to the basics. Once the camera is turned on, turn the mode dial on top of the camera to the movie camera icon, for Movie mode.

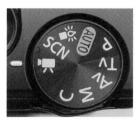

Then press the Func./Set button in the center of the control dial to pop up the function menu at the left side and bottom of the screen. Use the up and down direction buttons to navigate to the bottom entry on the left side of the screen, which is a number inside a half-rectangle—either 320, 640, or 1280, the number of pixels in the larger dimension of the movie frame.

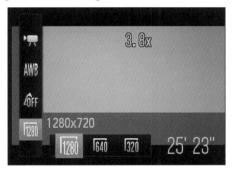

Choose 1280, which sets the camera to record high-definition (HD) video, at a size of 1280 x 720 pixels. Then scroll back up to the top of the left side of the screen, and make sure that the plain movie camera icon is selected, accompanied by the word Standard. I'll talk about the non-standard movie modes later, in Chapter 8. Finally, press the Func./Set button again to dismiss the function menu.

Be sure the camera is set to focus automatically, unless for some reason you want to use manual focus for your motion picture. (If you see the MF icon at the top of the screen, press the MF button and select Normal autofocus instead.) Now compose the shot the way you want it, press the shutter button halfway down to focus, and, when you're ready, press the shut-

ter button all the way down. You don't need to hold the button down; just press and release. The LCD screen will show a REC indicator, and the camera will keep recording until it reaches a recording limit, or until you press the shutter button again to stop the recording. Don't be concerned about the level of the sound that is being recorded, because you have no control over the audio volume while recording.

Here's one point that's important to note: When you record a movie, the camera locks in the focus as it was when you first pressed the shutter button, and the focus will not change during the recording, even if you use manual focus. However, you can zoom using the zoom lever during the recording, but not with the control ring on the front of the camera. (Only digital zoom, not optical zoom, is available while recording; I'll discuss this further in Chapter 8.) The camera will automatically adjust the exposure as lighting conditions change. Obviously this is not the best of situations for video recording; the PowerShot S95 can record excellent-quality video footage, but it is no substitute for a dedicated camcorder that can alter all of its settings during the shoot.

One other point that's not specific to the PowerShot S95: Unless you have a good reason to do otherwise, try to hold the camera as steady as possible, and don't zoom unnecessarily or move the camera except in very smooth, slow motions, such as a pan (side-to-side motion) to take in a wide scene gradually. Video from a jerkily moving camera can be very disconcerting to the viewer.

Viewing Pictures

Before I delve into more advanced settings for taking still pictures and movies, as well as other matters of interest, I need to talk about the basics of viewing your images in the camera.

Review While in Recording Mode

First, every time you take a still picture, the recorded image will show up on the screen for a brief (or not so brief) amount of time, if you have the Recording menu's Review option set for that function. I'll discuss the details of that setting in Chapter 4. By default, your image will stay on the screen for 2 seconds after you take a new picture.

Reviewing Images in Playback Mode

If you are reviewing images that were taken previously, you enter Playback mode by pressing the small blue triangle on the right side of the camera's back.

You can then scroll through the recorded images using the left and right direction buttons or the control dial. If you turn the control dial quickly, the images will rush by in a continuous stream, as they can on an iPod. (This Scroll Display function can be turned off on the Playback menu.) You can enlarge any image using the zoom lever on top of the camera, and you can scroll through the enlarged image using the direction buttons. If you press the zoom lever in the other direction, towards

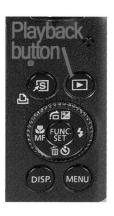

the wide-angle setting, you will see index screens with increasing numbers of thumbnail images; you can select any image from those screens by pressing the Func./Set button. I'll discuss more of your playback options in Chapter 6.

Playing Movies

To play back motion pictures, move through the recorded images by the methods described above until you find an im-

age for which the screen shows the movie camera icon at the upper left, next to the word SET. With the still frame from the motion picture displayed on the camera's LCD, press the Func./Set button (the button in the center of the control dial) to bring up a menu of VCR-like controls.

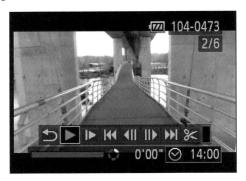

Scroll through the line of controls using the direction buttons or the control dial, and press the Func./Set button to activate the control you want to use. To pause the movie, press the Func./Set button to bring up the control menu again. Also, you can raise or lower the volume of the audio by pressing the up and down direction buttons. You will see a little yellow volume bar raise and lower at the end of the line of on-screen controls when you adjust the volume in this way.

If you want to play the movies on a computer or edit them with video-editing software, they will import nicely into software such as iMovie for the Macintosh, or any other program for Mac or Windows that can deal with video files with the extension .mov. This is the extension for Apple Computer's QuickTime video playback software; QuickTime itself can be downloaded from Apple's web site. For some Windows-based video editing software, you may need to convert the Power-Shot's movie files to the .avi format before importing them into the software. You can do so with a program such as mp-4cam2avi, which is easily found through an internet search.

Chapter 3: The Shooting Modes

up the camera for quick shots, relying heavily on features such as Auto mode, for taking pictures whose settings are controlled mostly by the camera's automation. As with others of the more sophisticated digital cameras, though, with the PowerShot S95 there is a large and potentially bewildering range of options available for setting the camera, particularly for recording still images. One of the main goals of this book is to remove the "bewildering" factor from the camera's aura while extracting the essential usefulness from the broad range of features available. To do this, we need to turn our attention to two subjects—shooting modes and the recording menu options. First, I'll discuss the shooting modes.

Whenever you set out to record still images, you need to select one of the available shooting modes: Auto, Program, Shutter Priority, Aperture Priority, Manual, Custom, Scene, or Low Light. (The only other mode available is for movies.) So far, we have worked with the Auto and Program modes. Now we will look at the others, after some review of the first two.

Auto Mode

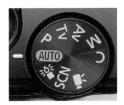

I've already talked about this shooting mode. This is the one you probably want to select if you just need to have the camera ready for a quick shot, maybe in an environment with fast-paced events when you won't have much time to fuss

with settings of things such as ISO, white balance, aperture, or shutter speed.

To set this mode, turn the mode dial, on top of the camera to the right of the shutter button, to the green label with the word "Auto" in it. When you select this mode, the camera makes quite a few decisions for you and limits your options in several ways. For example, you can't set ISO or white balance to any value other than Auto, and you can't choose the metering method or use bracketing. Perhaps most important, in Auto mode you cannot select RAW for the quality setting, which is set automatically to JPEG. I'll discuss RAW later, in Chapter 4, but if you want to have the highest possible quality of images or intend to process them using one of the more sophisticated photo editing programs, like Adobe Photoshop, you won't like having to do without the RAW quality setting.

One interesting aspect of Auto mode is that, in this mode, the camera uses its built-in programming to attempt to figure out what sort of scene you are shooting. (See the chart of icons displayed and what they mean at page 179 of the Canon user's manual.) So, if you see different icons, or the AUTO icon with different-colored backgrounds, that means that the camera is evaluating the scene for factors such as brightness, backlighting, the presence of human subjects, and the like, so it can use the best possible settings for the situation.

For example, for the image on the left below, the camera used

its generic Auto setting, while, for the one on the right, in which the figurine was closer to the lens, the camera interpreted the scene as a macro, or closeup shot, and switched automatically into Macro mode, indicated by the flower icon.

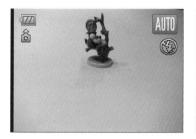

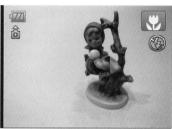

Program Mode

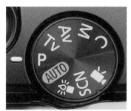

Choose this mode by turning the mode dial to the P setting. Program mode lets you control many of the settings available with the camera, apart from shutter speed and aperture. (You still can override the camera's automatic expo-

sure to a fair extent, though, by using exposure compensation, Program Shift, and exposure bracketing, or Auto Bracket, both of which are discussed in Chapter 4.) You don't have to make a lot of decisions if you don't want to, however, because the camera will make reasonable choices for you as defaults.

One way to look at Program mode is that it greatly expands the choices available through the Recording menu. You will be able to make choices involving picture quality, image stabilization, ISO sensitivity, metering method, and others. I won't discuss all of those choices here; if you want to explore that topic, go to the discussion of the Recording menu in Chapter 4 and check out all of the different selections that are available. It is worth mentioning here that Program mode has the great

advantage of letting you choose RAW quality for your still images. To do that, activate the Function menu by pressing the Func./Set button in the center of the control dial. Using the up and down direction buttons, navigate down to the next-to-bottom item on the list of icons on the left side of the screen. Then use the right button or the control dial to select RAW from the list on the bottom of the screen, as opposed to JPEG.

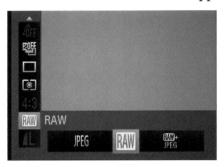

(JPEG stands for Joint Photographic Experts Group, an industry group that sets standards for photographic file formats.) Or, if you prefer, select RAW+JPEG. With that setting, the camera actually records two images as noted, so you will have both the RAW and the non-RAW image available. This choice can be useful if you won't have immediate access to software for editing the RAW images, and want to be able to use the lesser-quality images quickly.

Aperture Priority Mode

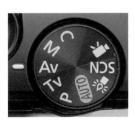

Aperture Priority mode is the inverse of Shutter Priority. You set this shooting mode by turning the mode dial to the Av setting, for Aperture value. Before discussing the nuts and bolts of the settings for this mode, let's talk about what aperture is and why you would want to control it. The camera's aper-

ture is a measure of how wide its opening is to let in light. The

aperture's width is measured numerically in f-stops. For the PowerShot S95, the range of f-stops is from f/2.0 (wide open) to f/8.0 (most narrow). The amount of light that is let into the camera to create an image on the camera's sensor is controlled by the combination of aperture (how wide open the lens is) and shutter speed (how long the shutter remains open to let in the light).

For some purposes, you may want to have control over how wide open the aperture is, but still let the camera choose the corresponding shutter speed. Here are a couple of examples involving depth of field. Depth of field is a measure of how well a camera is able to keep multiple objects or subjects in focus at different distances (focal lengths). For example, say you have three of your friends lined up so you can see all of them, but they are standing at different distances - five, seven, and nine feet (1.5, 2.1, and 2.7 meters) from the camera. If the camera's depth of field is quite narrow at a particular focal length, such as five feet (1.5 meters), then, in this case, if you focus on the friend at that distance, the other two will be out of focus and blurry. But if the camera's depth of field when focused at five feet is broad, then it may be possible for all three friends to be in sharp focus in your photograph, even if the focus is set for the friend at five feet.

What does all of that have to do with aperture? One of the rules of photographic optics is that the wider the camera's aperture is, the narrower its depth of field is at a given focal length. So in our example above, if you have the camera's aperture set to its widest opening, f/2.0, the depth of field will be narrow, and it will be possible to keep fewer items in focus at varying distances from the camera. If the aperture is set to the narrowest, f/8.0, the depth of field will be greater, and it will be possible to have more items in focus at varying distances.

This effect is not as pronounced with the S95 as with larger cameras, because its small sensor and wide-angle lens give it a

relatively wide depth of field. However, you can get the general idea from the two images below, each one showing a line of jacks at increasing distances from the camera. The image on the left was taken with the PowerShot S95 at f/3.2, resulting in slight blurring of the farther jacks. The example on the right was taken at f/8.0, resulting in sharper images of all of the jacks.

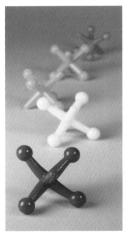

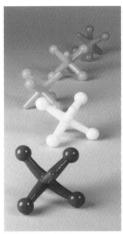

In practical terms, if you want the sharpest picture possible, especially with subjects at varying distances from the lens, and you want them to be in focus to the greatest extent possible, then you may want to control the aperture, and make sure it is set to the highest number (narrowest opening) possible.

On the other hand, there are occasions when photographers prize a narrow depth of field. This situation arises often in the case of outdoor portraits. For example, you may want to take a photo of a subject outdoors with a background of trees and bushes, and possibly some other, more distracting objects, such as a swing set or a tool shed. If you can achieve a narrow depth of field, you can keep your subject in sharp focus, but leave the background quite blurry and indistinct. This effect is sometimes called "bokeh," a Japanese term describing an aesthetically pleasing blurriness of the background. You have undoubtedly seen images using this effect. In this situation,

the blurriness of the background can be a great asset, reducing the distraction factor of unwanted objects and highlighting the sharply focused portrait of your subject. In the example below the actual subject is the small tree, and the people in the background are purposely blurred.

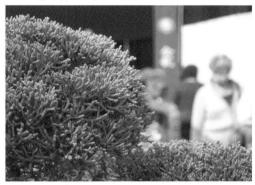

So with our awareness of the virtues of selecting an aperture, on to the technical steps involved. Once you have moved the mode dial to the Av setting, the next step is quite simple. Aim the camera at your subject, and use the control ring (the large, ridged ring around the lens) to change the aperture.

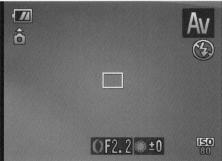

The number of the f-stop (in this case, f/2.2) will display in the bottom center of the screen next to the green icon showing that you can use the control ring to change the aperture. The shutter speed will show up also, on the left of the bottom of the screen, but not until you have pressed the shutter button halfway down, to let the camera evaluate the lighting conditions.

One more note on Aperture Priority mode that might not be immediately obvious and could easily lead to confusion: Not all apertures are available at all times. In particular, the widest-open aperture, f/2.0, is available only when the lens is zoomed out to its wide-angle setting (moved toward the icon of a group of trees). At higher zoom levels, the widest aperture available is f/4.9. To see an illustration of this point, here is a quick test. Zoom the lens out by moving the zoom lever all the way to the left, toward the group-of-trees icon. Then select Aperture Priority mode and select an aperture of 2.0 by turning the control ring all the way in the direction for lower numbers. Now zoom the lens in by moving the zoom lever to the right, toward the single-tree icon. After the zoom action is finished, you will see that the aperture has been changed to f/4.9, because that is the limit for the aperture at the telephoto zoom level. (The aperture will change back to f/2.0 if you move the zoom back to the wide-angle setting.)

Shutter Priority Mode

In Shutter Priority mode, you choose whatever shutter speed you want, and the camera will set the corresponding aperture

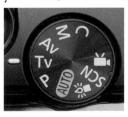

in order to achieve a proper exposure of the image. In this mode, you can set the shutter to be open for a variety of intervals ranging from 15 full seconds to 1/1600 of a second. If you are photographing fast action, such as a baseball swing or a hurdles event at a track

meet and you want to stop the action with a minimum of blur, you will want to select a fast shutter speed, such as 1/1000 of a second. In other cases, for creative purposes, you may want to select a slow shutter speed to achieve a certain effect, such as leaving the shutter open to capture a trail of automobiles' taillights at night. Or, possibly, you might want to photograph a model train whizzing by on its track, and use a slow shutter

speed to convey a sense of rapid motion.

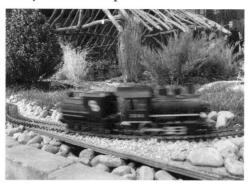

In other situations, your aim may not be so much to convey a sense of motion as to smooth out a flow of water by using a slow shutter speed. In the first image below, the PowerShot S95 was set to a shutter speed of 1/125 second to freeze the waterfall's motion; in the second one, the shutter speed was set to 1/4 second, resulting in an image of smooth-flowing water.

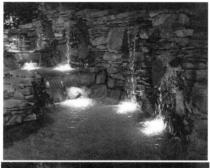

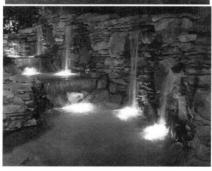

You select this mode by turning the mode dial on top of the camera to the Tv indicator. (The Tv stands for "Time value," but this mode is more commonly called "Shutter Priority.") Then you select the shutter speed by turning the control ring —the large, ridged ring that surrounds the lens. The LCD will display a scale showing the changing shutter speeds, and the selected speed will then appear on the left side of the screen, next to a green circular icon that indicates that the control ring is used to change the shutter speed.

When you press the shutter button halfway down to evaluate the exposure, the camera will select the appropriate aperture to achieve a proper exposure.

Once you've pushed the shutter button halfway down, you need to watch the color of the aperture (f-stop number) on the screen. If that number turns orange, that means that proper exposure at that shutter speed is not possible at any available aperture, according to the camera's calculations. For example, if you set the shutter speed to 1/320 of a second in a fairly dark indoor setting, the aperture number (which will be f/2.0, the widest setting, if the zoom is set to wide angle) may turn orange, indicating that proper exposure is not possible. One good thing in this situation is that the camera will still let you take the picture, despite having turned the number orange to warn you. The camera is saying, in effect, "Look, you may not want to do this, but that's your business. If you want a dark picture for some reason, help yourself." (Note: This situation is less likely to take place when you're in Aperture Priority mode,

because, unlike the situation with f-stops, there is a wide range of shutter speeds for the camera to choose from: a range from 15 seconds to 1/1600 second.) If you want to reduce the risk of a badly exposed image in either Aperture Priority or Shutter Priority mode, you can use the Safety Shift feature, discussed in Chapter 4, which will override your setting of aperture or shutter speed if necessary to expose the image properly.

When setting the shutter speed, note that the fractions of a second are easy to read, because they are displayed as standard fractions, such as 1/5 or 1/200. Some of the longer times are a bit harder to read; the camera displays them using quotation marks. So, for example, three-tenths of a second is displayed as 0"3, and two and one-half seconds is displayed as 2"5.

Manual Exposure Mode

The PowerShot S95 has a fully manual mode for control of exposure, which is one of the great features of this camera. Not all compact cameras have a manual exposure mode, which is a tremendous boon for serious photographers who

want to exert full creative control over exposure decisions.

The technique for using this mode is not too far removed from what we discussed in connection with the Aperture Priority and Shutter Priority modes. To control exposure manually, set the mode dial to the M indicator. You now have to control both shutter speed and aperture by setting them yourself. With some other cameras, this process is confusing, because you have to use the same control for both settings and switch its function back and forth between them. With the S95, there is no such problem because of the existence of the control ring. To set the aperture, turn the control ring around the lens; to set the shutter speed, turn the control dial on the back of the camera. You will see green icons to the left of the two values,

indicating the use of the control dial for shutter speed and the control ring for aperture.

As you adjust those values, watch the vertical scale at the right of the screen. You will see a small white indicator that moves up and down along the scale as the values change. When the exposure is set so the camera's meter judges it to be accurate, the white indicator is centered halfway up the scale. If the indicator is below the center, the exposure is too dark; if it is above the center, it is too bright. If the setting becomes more extreme than the scale can indicate, the indicator turns orange.

Of course, you don't have to center the indicator; it is there only to give you an idea of how the camera would meter the scene. You very well may want parts of the scene to be darker or lighter than the metering would indicate to be "correct."

If you would like to start out by setting the exposure manually, but then let the camera take over, once you have set the aperture and shutter speed, press the shutter button down halfway, and while holding it there, press the up direction button (exposure compensation button). At that point, the camera will display a scale of aperture and shutter speed settings, and will adjust the exposure to the "correct" metered exposure, if it is possible to do so under the existing lighting conditions. You can then press the shutter button down the rest of the way to take the picture at the adjusted exposure.

Note that, as with Aperture Priority mode, you cannot set the aperture to f/2.0 when the lens is fully zoomed in.

With Manual exposure mode, the settings for aperture and shutter speed are independent of each other. When you change one, the other one stays unchanged until you change it manually. The camera is leaving the creative decision about exposure entirely up to you, even if the resulting photograph would be washed out by excessive exposure or under-exposed to the point of near-blackness.

Finally, you should be aware of how to set the camera's ISO in Manual mode. In Chapter 4, which discusses the Function menu, I'll talk more about the ISO setting, which controls how sensitive the camera's sensor is to light. With a higher ISO, the image is exposed more quickly, so the shutter speed can be faster and the aperture more narrow. In other shooting modes, the camera can set ISO automatically, but in Manual mode you have to set it yourself. To do this, press the Func./Set button in the center of the control dial, highlight the ISO setting near the top of the menu on the left, and then scroll across the menu at the bottom of the screen; select a low number like 80 or 100 to emphasize image quality when there is plenty of light; select a higher number in dimmer light.

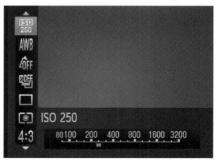

Scene Mode

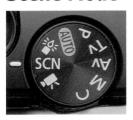

Scene mode is a rather different animal from the other shooting modes we have discussed. This mode does not have a single defining feature, such as permitting control over one or more aspects of exposure. Instead, when you

select Scene mode and then choose a particular Scene type within that mode, you are in effect telling the camera what type of environment the picture is being taken in, and what type of image you are looking for, and letting the camera make a group of decisions as to what settings to use to produce that result. One aspect of using this shooting mode is that you are not able to select many of the options that are available in Program, Aperture Priority, and Manual exposure mode, such as RAW images, My Colors, white balance, and ISO.

Although some photographers may not like Scene mode because it seems to take the creative decisions away from you, I have found that it can be quite useful in certain situations. Remember that you don't have to use the various settings only for their labeled purposes; you may find that some of them offer a group of settings that is well-suited for some shooting scenarios that you are regularly faced with. Let's take a look at how Scene mode works and you can decide for yourself whether you might take advantage of it on some occasions.

You enter Scene mode by turning the mode dial to the SCN indicator. Now you are in Scene mode, but unless you want to settle for whatever type of scene setting is already in place, you now need to make another choice, and pick one from the fairly impressive list of 19 scene settings.

To make this further choice, you need to use the Function menu by pressing the Func./Set button in the center of the control dial. The icon for the current scene setting is at the top of the string of icons at the left of the screen. Once you have the orange highlight on that icon, use the left and right direction buttons or the control dial to move through the 19 possible choices.

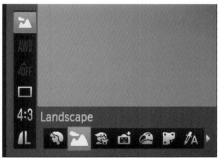

One very good thing about the Scene menu system is that each scene is labeled as you move the selector over it, so you are not left trying to puzzle out what each icon represents. As you keep pushing the right button or moving the control dial to move the selector over the other scene types, when you reach the right edge of the screen, the selector wraps around to the first setting on the left and continues going.

That's all there is to do to select a scene type. But there are numerous choices, and you need to know something about each choice to know whether it's one you would want to select. In general, each different scene setting carries with it a variety of values, including things like focus mode, flash status, range of shutter speeds, sensitivity to various colors, and others. Let's look at the complete list of 19 scene settings, moving from left to right along the bottom line of the screen, so you can make an informed choice.

Portrait

For rich flesh tones with a softening effect. You should stand fairly close to the subject and set the zoom to full telephoto, so as to blur the background if possible. The flash mode is ini-

tially set to auto, but you can switch the flash off if you want.

Landscape

Designed for outdoor scenery and vistas in the distance. The flash is initially set to forced off, but you can turn it on for fill flash or auto flash if you so desire.

Kids & Pets

Intended for subjects that move around unpredictably. The camera sets Servo AF for its focusing mode, though you cannot make that setting yourself in this situation. With Servo AF, the camera displays a blue frame and will maintain the exposure and focus for the subject within the blue frame once you press the shutter button down halfway and hold it there.

Smart Shutter

This setting is not designed for a particular type of subject. Instead, it gives you several tools for triggering the camera automatically by smiles, winks, and faces. When you select Smart Shutter from the scene icons at the bottom of the screen, you will see the DISP. label on the screen. Press the DISP. button, and you will see a sub-menu with three options: Smile, Wink self-timer, and Face self-timer. They work as follows:

With the Smile setting highlighted, press the up and down buttons to change the number of shots the camera will take, from 1 to 10. Once you have set the number of shots, press the DISP. button again. Now the camera will be in smile-detection mode, waiting until it sees a smile. Once it does, the self-timer lamp on the front of the camera will light up once, and the camera will take the number of shots you set. This function is not perfect, but it works quite well. You may have to tell your subject to open his or her mouth wide and show a lot of teeth to trigger the camera, but this can be a way to make sure the subject smiles. It also can be a good conversation starter.

The next Smart Shutter sub-option is the Wink self-timer, which works in similar fashion to the smile detector, except that, for winks, you have to press the shutter button fully. Then the camera will wait until it sees a person wink (closing one or both eyes momentarily); once it does, it will trigger the shutter for the number of shots you have set.

The third and final sub-option is the Face self-timer. This option is similar to the Wink Self-Timer, in that you have to press the shutter button fully down, and the camera will take the picture once it detects a new face in the scene before it. If it doesn't see a new face, it will trigger the shutter after 15 seconds anyway. As with the other options, you can set the camera to take from 1 to 10 shots when triggered.

Super Vivid

This setting intensifies all the colors in your image, giving a dramatic, super-saturated effect. This is the sort of result you could achieve with post-processing software such as Photoshop Elements, but, if you like to experiment with the appearance of your images as they come from the camera, this setting can yield striking results. The image on the left below shows a scene taken using the Super Vivid setting, with another version of the image beside it, taken with the Landscape setting, to illustrate the dramatic difference from using Super Vivid.

Poster Effect

This option, like Super Vivid, alters the appearance of your image in a striking way. The "posterized" shot emphasizes the shape and color of your subject and renders it with a stylized look, removing some of the realism and making the scene look more like a painting done with poster colors or pastels. The following image illustrates the difference of Poster Effect from Landscape and Super Vivid, shown earlier.

Color Accent

This option, like the previous two, is not intended for any particular type of scene. Instead, it is more like a procedure. The Color Accent option lets you specify a single color or range of colors to be retained; then, when you take the picture, only that color or range of colors keeps its color, and the rest of the image appears in black and white.

Here is how it works. After selecting Color Accent from the line of icons at the bottom of the screen, press the DISP. button and a small white square appears in the center of the screen. Place that square over the color you want to retain. For example, for the image below, I placed the square over the vase on the left, to retain the reddish hue.

You can also use the up and down buttons to increase the range of colors that are retained. If you press the up button

to increase the number, you increase the range of colors (that is, in this case, more of the reddish colors will be kept); if you press the down button, the number will turn negative, limiting the color to just the particular hue you selected. Then, when you take the picture, every object outside the selected range of colors will be in monochrome.

Color Swap

This procedure is similar to Color Accent except that, instead of retaining one color, it lets you specify one color to transform into another. In the example below, the first image shows the actual scene, and the lower one shows the same scene with the green color of the grass transformed by the camera into the white of snow.

Here is how to accomplish this exchange. After selecting Color Swap, press the DISP. button. You will see a screen that shows

the default settings, by which green is changed to gray. The screen will be blinking, showing alternately the normal image and the color-swapped image using those settings. To change the color settings, position the small square in the center of the screen over the color to be transformed and press the left direction button. Then place the square over the color the first one is to be changed to, and press the right direction button. Then press DISP again to return to the shooting screen, aim at the scene as you wish, and press the shutter button to take the picture. You may need to experiment a bit to find colors that transform well; I found that some color combinations, such as white and black, don't work all that well in some cases.

HDR

The PowerShot S95, like some other modern cameras, has a built-in HDR function, with which the camera automatically takes three shots in rapid succession and then combines them in the camera to produce an enhanced composite image.

This is one of the more important settings on the camera. On some other cameras, this type of setting is not a scene type as it is here, but on the PowerShot S95 you need to remember to look for HDR as one of the numerous Scene mode settings. HDR stands for High Dynamic Range, a photographic technique that involves taking multiple shots at different exposure settings and then combining them, often with software such as Photoshop, so that the best-exposed parts of each shot work together to result in one composite image that exhibits a wide dynamic range—that is, a final image that shows clear details in areas of the scene that were either too bright or too dark in the individual images.

When you select HDR from the list of scene types, the camera forces the flash off. You should also go into the Recording menu yourself and set IS Mode to Off—the image stabilization system can interfere with the processing of the three shots.

Also, because the camera takes some time to take its three shots, and does not align the shots in the camera to eliminate differences among them (as some cameras do), it is not possible to hold the camera steady long enough for the three shots to be taken without some motion blur. So, you need to use a tripod or other very steady support while shooting in the HDR mode. The image on the left below shows an HDR image taken by the PowerShot S95; the image on the right shows the same scene taken in Program mode with no special settings or processing. Although the differences between the two images are not dramatic, you can probably see that the HDR image has less glare and more shadow detail than the other one, and has its brightness levels more evenly distributed.

Here is one other point about HDR that might not be obvious. With the S95 set for HDR, press the DISP button, and the camera puts a short menu on the screen, letting you choose from an abbreviated My Colors menu which, besides the Sepia and B&W effects, also offers Super Vivid and Poster Effect (which are normally considered scene types rather than My Colors settings) as adjustments in addition to the HDR scene type. In other words, although you have selected HDR as your scene type, you have the ability to select an additional My Colors setting or scene type to be combined with HDR, in order to get images that not only have enhanced dynamic range, but also have the enhanced characteristics of one of these other options. Of course, you can also leave this setting at Off, and

be content with plain and simple HDR. It's worthwhile experimenting with this interesting add-on to the HDR setting; you can achieve some dramatic results by combining the heightened impact of an HDR shot with enhanced color effects.

Once you have followed all of these procedures, you may find

that the HDR option gives you an excellent way to pull details out of shadows and out of areas that would otherwise be overly bright. But you don't have to limit yourself to this option; as is shown by the image here, you can always take multiple shots

at different exposure settings on your own, and then combine them later in Photoshop, Photoshop Elements, or one of the specialized software packages that is designed for processing HDR images. The example above shows the same scene as before, but this image was created in Photoshop CS5 by merging three separate photographs.

Nostalgic

This option is designed to give your images an old-time look by fading the intensity of the colors and "roughening" the image. After you select this option, you will see a scale at the bot-

tom of the screen with white bars that represent how strong the effect will be. Turn the control ring around the lens to increase or decrease the strength of the nostalgic effect. If you turn the ring to the full extent, the image will be rendered in black and white with a considerable amount of grainy visual noise, or "roughness."

Fish-eye Effect

This effect attempts to duplicate the results you can get by using a "fish-eye" lens, an extreme wide-angle lens that makes subjects seem to be stretched as if they were spread around a

fish bowl.

you can even turn the effect off with those controls, thereby nullifying your selection of this setting in the first place.

Miniature Effect

This option, which is also available on some other Canon models, has always puzzled me somewhat, because I wonder why it was included. I know that some photographers really like it, though, so I guess I shouldn't question Canon's wisdom. This setting lets you select a certain amount of the center of your image to be in focus, and then the rest of the image (top and bottom or two sides) is rendered with a blurred look. The idea is to take a picture of a normal-sized scene and make it have the look of a shot of a tabletop model, or of a scene taken with a large view camera that uses a tilt-shift lens. Pictures of actual models of that sort may have blurred portions because the camera may be close or tilted, meaning the depth of field is very narrow, so only parts of the image can be in sharp focus.

Once you have selected this effect, press the DISP. button to activate the controls. Then use the zoom lever to make the white box on the screen larger or smaller. Everything inside that box will stay in sharp focus; the areas outside of it will be blurry. Also, you can use the up and down direction buttons to move the white box to cover the part of the image that you want to stay in focus. If you turn the camera sideways, the box will turn also. After you're done setting the white box, press

DISP. again, and then take the picture. You may find that this option is a nice way to isolate a subject in the center of the frame, rather like a vignetting effect.

Beach

This scene type is designed so that images of people in bright sunlight will appear as natural as possible, and not underexposed as the camera compensates for the brightness of the scene. The camera will likely use the flash to counteract the harsh shadows that may be present on a bright beach.

Underwater

This scene type adjusts the color balance of the shot to counteract the blue tinge of the underwater light.

Foliage

With this scene type, the camera emphasizes the greens and other colorful hues of new leaves and other plant life. This is a good place to point out again what I have said earlier—you should not let these scene types be limited to just the type of image mentioned in their names. For example, I took the image below using Foliage mode, but most of the scene is not of foliage. The extra-vivid greens seemed to present a pleasant contrast to the red of the jacket and the colors of the bricks.

Snow

This scene type is similar to the Beach setting, discussed above. Like that option, Snow sets the camera to use the flash and adjusts the colors in an attempt to take photos of people that are not overwhelmed by the brightness of the surroundings.

Fireworks

This scene type sets the camera to capture vivid images of fire-works bursts. It sets the camera to a 2-second shutter speed and low ISO, and intensifies the colors. You should set the camera on a tripod or other sturdy support and turn the image stabilization off in the Recording menu.

Stitch Assist

This setting helps you take a series of images that will be combined later on your computer to form a continuous panorama. There are actually two icons to choose from—panorama from left to right, and panorama from right to left. Choose one of these, and you will see on the screen the live scene, along with a blank gray area. Take the first shot, and the blank area is filled with a portion of the first image, which will stay on the screen as you move the camera into position for the next image in the panorama. The idea is to take the next image with part of the existing image overlapped, so there will be enough material for the software to use in constructing a seamless panorama later. In other words, make sure that a small part of the last image is duplicated by each new image as you take it. You can take a total of up to 26 images in this way.

When you take the series of pictures, you should use a tripod if possible, to keep the images on the same level. Try not to choose a scene with great variations in exposure, because the exposure will be fixed with your first shot. When the images are all taken, use the included PhotoStitch program to weave them together into a panorama. Or, you can use other programs, such as Photoshop or Photoshop Elements. The im-

age below was photographed using Stitch Assist, and the parts were merged together in PhotoStitch.

Low Light Mode

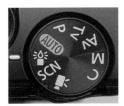

This next shooting mode is specially designed to let you get usable images in conditions with very little available lighting. It has some unusual capabilities coupled with a few restrictions, so be sure you know what you are gaining

and losing before you choose this mode.

You make this selection by turning the mode dial on top of the camera to the icon of the lighted candle. When you do this, you will immediately see one important change on the LCD. No matter what setting you had selected for the size and quality of your images (such as RAW or Large), the camera will set the image size to Medium. If the quality setting was RAW, it will be reset to JPEG, because there is no such thing as a Medium-sized RAW file.

You will also see limitations in your flash options. If you press the right direction (flash) button, you will find that the only two choices available are flash forced off and auto flash; you can't set the flash to forced on. (Chances are, you won't want flash anyway, because that would defeat the purpose of a low-light mode in most cases.) You also can't set the white balance or metering mode, and you can't use the My Colors effects.

Along with the limitations, though, there are several advantages with this mode. The most obvious one is that you can

now set the ISO higher than in any other mode. If you press the Func./Set button to call up the Function menu, you will see that the top item on the left side of the screen is the ISO setting, which will let you set the ISO as high as 12800, far above the normal limit of 3200 in other shooting modes.

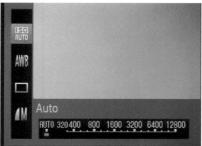

If you set ISO to Auto in this mode, the camera is likely to choose a high ISO setting, such as 1600. (You can't set the ISO below 320 in this mode.) Also, if you turn on continuous shooting through the Function menu, you will find that the fastest speed for rapid-fire shooting is now 3.9 images per second, rather than the limit of 1.9 in other modes.

You will probably want to be careful with Low Light mode to make sure you use it only when there is no other alternative, or where the ISO level will not rise too high, because shooting with extremely high ISO settings is likely to result in graininess that may be unappealing. The first image on the next page was taken in Low Light mode at ISO 640 in a room that was indirectly lighted by daylight; the second image was taken at ISO 12800 at night in a room with minimal, indirect lighting. As you can see, the ISO 640 image does not look too bad; the one taken at ISO 12800 has a badly degraded appearance.

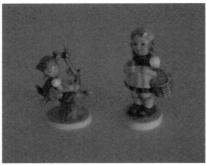

And, of course, your images in Low Light mode are limited to Medium in size, making it difficult to produce large prints that look acceptable. However, you do gain the ability to shoot continuously at twice the rate as in other modes, and, of course, you may capture images that you couldn't readily capture in any other way in such dim light.

Custom Mode

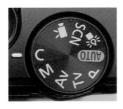

When you turn the mode dial to the C setting, you take advantage of a very powerful and convenient feature of this camera. (I call this setting the Custom shooting mode because of the C, but Canon calls it "Registering Shooting Settings," in case you're looking for the dis-

cussion at page 108 of the user's manual.) You can set up the camera exactly as you want it, with a shooting mode, zoom

amount, white balance, ISO, and other settings, and then recall all of those settings instantly just by turning the mode dial to the letter C. The only shooting modes that you can save settings for are Program, Aperture Priority, Shutter Priority, and Manual; you cannot save them for the Auto, Low Light, Scene, or Movie modes.

Here is how this works. First, take your time and set up the camera with all of the settings you want to be able to recall. For example, suppose you are going to do "street photography." You may want to shoot with a fast shutter speed, say 1/250 second, in black and white, at ISO 1600, using continuous shooting with autofocus, using Large and Fine JPEG images, and shooting in a widescreen 16:9 aspect ratio to take in a wide angle of view.

Your first step is to make all of these settings. Turn the mode dial to Tv for Shutter priority, and turn the control ring around the lens to set a shutter speed of 1/250 second. Then press the Func./Set button to summon the Function menu, and, starting from the top, set ISO to 1600, then go down to My Colors and select the BW option, then go down to continuous shooting and select the icon with the AF on a stack of frames. Finally, select 16:9 for the aspect ratio, JPEG for format, and Large and Fine for the image size and quality. You may also want to push the zoom lever all the way to the left, for wide-angle shooting.

Once all these settings are made, press the Menu button to call up the Recording menu, and scroll down (or scroll up and wrap around to the bottom) to select the Save Settings item, and press OK on the screen that asks, Save Current Settings?

Now, to check how this worked, try making some very different settings, such as Manual exposure with a shutter speed of 1 second, My Colors set to Vivid, continuous shooting turned off, the zoom lever moved all the way to the right for telephoto, and image format set to RAW. Then turn the mode dial back

to the C setting, and you will see that all of the custom settings you made have come back, including the zoom position, shutter speed, and everything else. This is really a wonderful feature, and more powerful than similar features on some other cameras, which can save menu settings but not settings such as shutter speed and zoom position. What is also quite amazing is that, if you now switch back to Manual exposure mode, the camera will restore the settings that you had in that mode before you turned to the C mode.

The only flaw I find with this mode is that there is only one slot for it on the mode dial (some cameras have two), and therefore only one group of settings that can be saved at a time. But it's much better than nothing. I suggest you experiment and find one custom settings group that is the most useful to you, and save it to the C mode for instant recall.

Chapter 4: Recording Menu, Function Menu, and My Menu

the many options included in the Recording menu and the Function menu, which together provide the user with control over the appearance of the images and how they are captured. Depending on your own preferences, you may not have to use these menus too much. You may prefer to use the various Scene mode settings, which choose many of the options for you, or you may prefer, at least on occasion, to use Auto mode, in which the camera makes its own choices. However, it's nice to know that you do have this degree of control over many functions available if you want it, and it is very useful to understand what types of items you can exercise control over. You also can create a customized menu with a few of your most often-used options, using the feature called My Menu, also discussed in this chapter.

The Recording Menu

The Recording menu is easy to use once you have played with it a bit. As I discussed earlier, the menu options can change depending on the setting of the shooting mode dial on top of the camera. For example, if you're in Auto mode, the Recording menu options are very limited, because that mode is for a user who wants the camera to make almost all of the decisions without input. For the following discussion, I'm assuming you have the camera set to Program mode (mode dial turned to the P setting), because in that setting you have access to most of the power of the Recording menu. (Though some menu op-

tions will be unavailable in certain situations.)

Turn the mode dial on top of the camera to P for Program mode. Then enter the menu system by pressing the Menu button—the one at the lower right of the camera's back.

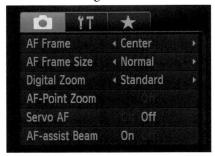

In the menu system, when the camera is in shooting mode, besides the Recording menu, there is the Setup menu, marked at the top by the wrench and mallet icon. The third menu option, marked by a star, is called My Menu; it is a collection of menu items that you can customize as you wish. When the camera is in Playback mode (reached by pressing the Playback button) the three choices are the Playback, Printing, and Setup menus. For now, I will discuss only the Recording menu, marked by the camera icon.

On the Recording menu, you'll see a fairly long list of options. In most cases, each option (such as AF Frame) occupies one line, with its name on the left and its current setting (such as Center or Face AiAF) on the right. In other cases (such as Flash Settings), the option is followed by three dots, meaning you have to press the Func./Set key to see more options on another screen. You have to scroll through several screens to see all of the options. If you find it tedious to scroll with the up and down cursor buttons, you can turn the control dial on the back of the camera, which may help you get through the menus faster. Also, depending on the menu option, you may be able to reach it more quickly by reversing direction with the cursor buttons, and wrapping around to reach the option you

want. In other words, if you're on the top line of the menu, you can scroll up to reach the bottom option. Or, if the highlight is already near the bottom option, you can scroll down to get to the options at the top of the menu. However, in an odd quirk, the wrap-around function works only when you are using the cursor buttons, not the control dial. If you scroll to the bottom of a menu screen with the dial and then try to wrap around to the top, you will find yourself stuck at the bottom. But you can solve this problem by just pressing the down direction button, which will wrap you around to the top line of the menu.

Here's one more tip for navigating the menus: If you have scrolled down into a menu screen, away from the tabs at the top, and you want to switch to a different menu (such as from the Recording menu to the Setup menu), you don't have to scroll all the way to the top of the menu screen and then move over to the next menu with the direction button; instead, you can just push the zoom lever briefly to the right, and you will scroll immediately over to the next menu.

Some of the menu's lines may have a dimmed, "grayed-out" appearance, meaning they cannot be selected under the present settings. For example, if you have set the AF Frame to Face AiAF, you cannot set the AF Frame Size, which is automatically set to Normal, so the AF Frame Size line is grayed out. Also, if you have set the shooting mode to Auto, some options do not even appear on the Recording menu—they just disappear (such as AF Frame and Servo AF, among others).

If you want to follow along with the discussion of the options on the Recording menu, leave the shooting mode set to Program, which gives you access to just about every option on the Recording menu. (Some options are available only in Movie mode, discussed in Chapter 8, and some are available only in other modes; I'll mention those as I come to them.) I'll start at the top, and discuss each option on the way down the list.

AF Frame

This top option in the Recording menu gives you several options for controlling how the autofocus frame is set up, when the camera is in autofocus mode. Once this menu option is highlighted, press the left and right direction buttons to select from the three possible options, as follows:

Face AiAF

With Face AiAF, the camera looks for human faces. If it detects what it believes are faces, it puts a white frame on what appears to be the main subject, and up to two gray frames on other faces. When you press the shutter button halfway, the camera will focus on the main faces and set the exposure and white balance. The LCD will display up to nine green frames to show the faces it has chosen to focus on. This is a good option to choose when you're at a picnic or other group function and you need to take a quick snapshot with as many faces in focus as possible. In other situations, you may want to take more time and select the focus point and other options yourself.

Center

With this option, the camera places an autofocus frame in the center of the screen. You can then place this frame over the area of the scene that you want to be in sharpest focus. You can't move this frame around the screen. However, if the point you want to focus on doesn't happen to be in the center of the image, you can lock focus on it by pressing the shutter button halfway while aiming at it, and then move the camera back to compose the shot as you want; the focus will be locked on the target you chose. With the Center setting, you also have the option of changing the size of the AF frame. To do so, move down to the next menu option, AF Frame Size, which will become active when Center is highlighted. Using the left and right direction buttons, highlight either Normal or Small for the AF frame's size. Using a small frame can be helpful when you need to focus on a very precise area of the image.

Tracking AF

This final option is designed for situations in which you need to track a moving subject, such as an athlete or a playing child. Once you have selected this mode, you will see a small square with four spokes sticking out of its four sides.

Aim this square at the subject you want to track, and press the left direction button. The frame will change to a double set of corner brackets, which the camera will try to keep centered over the subject, even as the subject (or the camera) moves.

When you press the shutter button down halfway to check exposure, the frame will turn blue, and the camera will still keep tracking the subject. To cancel the tracking, press the left button again. Otherwise, press the shutter button all the way down when you are ready to take the picture. If you want, you can also start the process by pressing the shutter button halfway to evaluate exposure; the camera will start tracking with the blue frame at that point.

Note that, when you're using this mode, the left direction

button serves to start and stop tracking a particular subject. Therefore, it cannot perform its other duty of switching into manual focus mode. So, if you want to switch into manual focus while Tracking AF is turned on, you have to hold down the left direction button for more than one second. You will then see the MF icon appear on the screen. If you then want to switch back into a normal autofocus mode, though, you will have to press the left direction button briefly to go back to Tracking AF mode, then press the Menu button and switch out of Tracking AF mode.

It's also worth noting that, although Tracking AF is not available from the Recording menu when the camera is in Auto mode, you can still turn it on in that mode. With the camera set to Auto mode, press the up direction button, and Tracking AF is turned on. It then works just as it does in other shooting modes. You can turn it off by pressing the up direction button again. Note that, even if you don't need to track a moving subject, it can be useful to select Tracking AF in Auto mode, because the camera will then be forced to use the center point of the frame for focusing, rather than just choosing one of the 9 possible focus points itself. In other words, using Tracking AF in auto mode gives you a way to choose the equivalent of the Center option for the AF frame, even though that option is not available from the menu system in Auto mode.

Digital Zoom

This feature lets you zoom in on a scene electronically, beyond the magnifying power of the camera's optical zoom capability. Because it is an electronic zoom, and not an optical one, it does not really increase the information received by the camera; instead, it just magnifies the pixels so they appear larger, which can result in a blocky, pixellated look. That's not to say that digital zoom is completely useless. It can help you compose a scene the way you want to, or to measure the exposure on a small part of the scene before you zoom back out to take

the picture without the digital zoom effect, for example. (And, as discussed in Chapter 8, it's the only zoom available while recording a movie.) But don't be misled by the notion that this feature lets you zoom in to a super magnification with no dropoff in quality of the image.

To use digital zoom for still images, first of all, you have to have the camera set to the 4:3 aspect ratio; otherwise the menu option will be grayed out and unavailable. You can't use digital zoom with RAW files, and it also is unavailable in Low Light mode and with some of the Scene types, including Nostalgic, HDR, Fish-eye, and a few others.

When you select this item from the menu, you will have several options to choose from for its setting: Off, Standard, 1.4x and 2.3x. The Standard setting is for digital zoom, and the numerical settings give you something Canon calls "digital teleconverter," which is supposed to provide better quality, with less likelihood of image deterioration than digital zoom. What the digital tele-converter option does is increase the magnification of the normal lens throughout its range, instead of just providing greater magnification at the upper end of the range, as digital zoom does. Therefore, with digital tele-converter, you can actually use the lens at its lowest optical focal length of 28mm, which allows you to use faster shutter speeds than otherwise, because the aperture can be wider open.

This can be confusing, so I'll use an example. Suppose you turn on digital zoom and set the lens to its widest-angle focal length of 28mm. At that focal length, you can set the aperture to its widest value of f/2.0 and use relatively fast shutter speeds, because a lot of light is coming in through the wide aperture of the lens. Now suppose you move the optical zoom to a range of about 65mm. At that range, the aperture will close down to about f/4.0, because you cannot have a wide-open aperture with the lens zoomed in optically. However, if you now turn on the digital zoom feature to its 2.3x tele-converter setting,

the normal optical focal length (unzoomed) of 28mm is converted to about 64mm. So, without using the optical zoom at all, you have achieved the equivalent of a zoom to about 65mm. Because you have not used the optical zoom, you can still set the aperture to its widest setting of f/2.0, and use faster shutter speeds.

Of course, there is no magic way to achieve a greater zoom range without tradeoffs in image quality. If you are content to use the smaller image sizes, such as Medium (M2) and Small, the camera will be able to compensate by using the excess capacity available to enlarge the image without deterioration. If you have the camera set for Large or M1 images, though, you will likely notice some deterioration. In all cases with digital zoom and digital tele-converter, the camera displays the zoom factor on the screen in blue numbers when image deterioration is expected because of the electronic zoom factor.

I prefer to stay away from digital zoom and digital tele-converter and just rely on the optical zoom, but you may find some situations in which it's good to have these options available.

AF-Point Zoom

When you turn this option on, the camera enlarges the area that it uses to focus on the scene. So, for example, if you are using Face AiAF for your focusing mode, it enlarges the face it is focusing on. If you are using Center for the focusing mode, it enlarges the center of the frame, as in the sample image shown

below.

The focus area will not be enlarged if you are using digital zoom, digital tele-converter, Tracking AF, or Servo AF. I find this feature quite helpful, because it lets me see the area being focused on quite clearly, though some people may find it distracting to have the image distorted by the enlargement of a square area in the middle of the scene.

Servo AF

This next feature is similar to Tracking AF, discussed above, except that, with Servo AF, the camera continues to focus on a moving subject after you press the shutter button halfway to evaluate exposure and focus. (With Tracking AF, the camera maintains focus on the subject before you press the shutter button halfway.) So, if you are trying to photograph a child, say, and you don't need to track her with autofocus initially, but you want to wait until the image looks just right for your scrapbook, you can press the shutter halfway and keep the camera trained on her until the perfect moment arrives. Of course, a feature like this uses up the battery rapidly, because the autofocus mechanism keeps working constantly, so don't use it too much unless you have an extra battery at the ready.

AF-assist Beam

This menu option lets you turn on or off the reddish light beam that emanates from the self-timer lamp on the front of the camera.

This beam comes on when the camera is trying to focus in a dark area; the light helps the autofocus mechanism find the patterns and shapes it needs to evaluate in order to achieve proper focus. You should usually leave this setting turned on, but you may want to turn it off when you're taking pictures in a place where the beam could be distracting or annoying to others, or where it might alert the subjects of your candid photography.

MF-Point Zoom

This option is similar to AF-Point Zoom, discussed above. When you turn this feature on through the menu, the camera places an enlarged square in the center of the screen when you are focusing manually, so you can judge the sharpness of the focus more readily. This capability is actually probably more useful with manual focus than with autofocus, because it's up to you to make sure the focus is correct. But, you may prefer not to be distracted by this distortion of the normal image. One way to deal with the situation is just to zoom in the whole picture yourself while focusing, and then zoom back out again after the focusing is done.

Safety MF

When Safety MF is turned on, the camera will "fine-tune" the focus using its autofocus mechanism when you press the shutter button to evaluate the exposure, after you have made the focus as sharp as possible using manual focus. If you turn Safety MF off, then the camera will not assist you with autofocusing in this situation. Whether you use this option or not depends on your particular situation. For example, you may want to start the focusing process manually in order to make sure the camera is focusing on the proper location, but then still have the camera make the final adjustments to get the focus sharp. In that case, leave Safety MF turned on. On the other hand, you may want to get the manual focusing done all on your own, without the possibility that the camera will make it worse by adjusting the focus in a way that is not helpful when you press the shutter button halfway to evaluate exposure. So, evaluate any particular photographic task to see whether this function might be helpful.

Flash Settings

This is one of the menu items whose label is followed by three dots, meaning you have to press the Func./Set button to get access to the next screen, where the specific settings are located. As an alternative, you can get access to this screen directly from shooting mode, by pressing the Flash (right) button, and immediately pressing the Menu button.

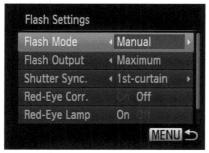

The following six settings can be available on the Flash Settings screen, depending on the shooting mode:

Flash Mode

This option can be a bit tricky to understand, because there

are quite a few different flash settings, several of which could be considered "modes," such as forced off, fill flash, autoflash, Red-eye correction, etc. But the Flash Mode setting on the Recording menu is none of those. This option is only available in two shooting modes—Shutter Priority and Aperture Priority. In all other modes it is automatically set to one or the other, and this menu item does not even appear on the screen. For example, in Auto, Program, Low Light, and most of the Scene mode types, Flash Mode is set to Auto. In Manual exposure mode, only, it is set to Manual. In Shutter Priority and Aperture Priority shooting modes, you have the choice of setting Flash Mode to Auto or Manual.

When Flash Mode is set to Auto, that means that the camera is automatically calculating how much flash to fire to expose the image properly. When Flash Mode is set to Manual, the camera does not make that calculation. Rather, it is up to you to set the power of the flash's output using the next item down on the Flash Settings menu, whose name and function change depending on how Flash Mode is set.

So, if Flash Mode is set to Auto, meaning the flash output is automatically controlled by the camera's exposure system, the next item down on the menu is called Flash Exposure Compensation. That option works in similar fashion to standard exposure compensation without flash. That is, you can dial in an amount of flash exposure compensation up to 2 EV units, in increments of 1/3 EV. When you do that, you are telling the camera, in effect, "Okay, you go ahead and calculate the correct exposure with the flash, but then add in (say) 1 1/3 EV extra, to make the picture brighter."

On the other hand, if Flash Mode is set to Manual, then the flash output is not automatically controlled, and the next item down on the menu changes to an option called Flash Output. This option has three settings: Minimum, Medium, and Maximum. As you can see from the names, in this case, it is up to

you to make an absolute setting of flash power, as opposed to the relative setting that you make using the Flash Exposure Compensation setting. In this case, you are saying to the camera, "Okay, I will tell you how much flash to fire—go ahead and use (say) your Medium setting—that seems about right to me."

Flash Exposure Compensation and Flash Output

These two options are discussed above, in connection with the discussion of the Flash Mode setting.

Shutter Sync.

This option is available only in the Program, Aperture Priority, Shutter Priority, or Manual exposure modes. This setting is one you may not have a lot of use for, unless you encounter the particular situation it is designed for. Shutter Sync. has two settings—1st-curtain and 2nd-curtain. The normal setting is 1st-curtain, which causes the flash to fire early in the process when the shutter opens to expose the image. If you set it to 2nd-curtain, the flash fires later, just before the shutter closes. The reason for having the 2nd-curtain sync setting available is that it can help you avoid having a strange-looking result in some photographic situations. This issue arises when you are taking a relatively long exposure, say one second, of a subject with taillights, such as a car or motorcycle at night, that is moving across your field of view. With 1st-curtain sync, the flash will fire early in the process, freezing the vehicle in a clear image. However, as the shutter remains open while the vehicle keeps going, the camera will capture the moving taillights in a stream that appears to be extending in front of the vehicle. If, instead, you use 2nd-curtain sync, the initial part of the exposure will capture the lights in a trail that appears behind the vehicle, while the vehicle itself is not frozen by the flash until later in the exposure. Therefore, with 2nd-curtain sync in this particular situation, the final image is likely to look more natural than with 1st-curtain sync.

To sum up the situation with 1st-curtain and 2nd-curtain Shutter Sync. settings, a good general rule is to always use the 1st-curtain setting unless you are sure you have a real need for the 2nd-curtain setting. Using the 2nd-curtain setting makes it harder to compose and set up the shot, because you have to anticipate where the main subject will be when the flash finally fires late in the exposure process.

Red-Eye Correction

This option is one of the two measures the PowerShot S95 offers against the scourge of "red-eye"—the red cast to human eyes that results from on-camera flash that lights up the blood vessels on the retina. The name of this option is "Red-Eye Correction," which implies that the red-eye effect occurs, but then is "corrected" digitally. That is, the camera applies digital processing to remove the red tint after the eyes are reddened by the penetrating flash. Therefore, as the user's manual points out, there is some chance that this option will "correct" not only red-eye problems, but also other red patches in your shot, such as reddish makeup on a person's face.

Red-Eye Lamp

This next option is the camera's second approach to solving the red-eye problem. In this case, when you have this option turned on in the menu, before taking a flash picture, the camera fires the reddish lamp near the lens that also serves as the AF-assist lamp. The theory is that the burst from this bright light will cause the subject's pupils to constrict enough to keep the light from penetrating to the retinas, thereby reducing or eliminating the red-eye effect. You can have both this option and the previous one turned on if you want to mount a frontal assault against the ravages of red-eye.

ISO Auto Settings

This selection does not appear on the Recording menu screen

at all unless the Auto ISO setting is available. Therefore, if the camera is set to Manual exposure mode, you won't find this entry on the menu. When you do see it, in other shooting modes, it has three dots after it, meaning there are selections to be made on the next screen after pressing Func./Set. The first of these options lets you set the maximum ISO level that will be set when the camera is set to Auto ISO. You can set this maximum level to ISO 400, 500, 640, 800, 1000, or 1600. You might want to set it to one of the lower levels if you need to avoid the sort of visual "noise" that tends to show up in images taken at higher ISO settings.

The other option available through this menu choice, Rate of Change, is actually a fairly important option, though its function is not obvious from its name or from the discussion in the Canon user's manual. First, note that this option is available only when the camera is set to Program or Aperture Priority mode. In Shutter Priority mode, the ISO Settings menu selection is available, but Rate of Change is not. What the Rate of Change feature does is let you specify a preference for higher or lower ISO settings, resulting in faster or slower shutter speeds. If you set this option to Low, the camera will prefer low ISOs, likely resulting in slow shutter speeds, depending on the available light. Conversely, with the High setting, you are likely to see higher ISO settings, allowing the use of faster shutter speeds. Standard leaves the ISO settings in the moderate range. This option is useful, for example, if you don't mind some added noise, and want to be sure the camera sets a high ISO so you can use a fast shutter speed to avoid motion blur.

Safety Shift

This menu option, like the previous one, does not appear unless the context permits its use. Therefore, you will only see it on the menu when the camera is set to Aperture Priority or Shutter Priority mode. In those modes, if you turn Safety Shift on, the camera will override your setting of aperture or

shutter speed if necessary for a proper exposure. For example, suppose you have the camera in Aperture Priority mode with ISO set to 80 and the shutter speed set to 1/250 second in a relatively dimly-lit room. With Safety Shift turned off, the shutter speed setting will stay as it was set, and the aperture number (2.0 if the lens is zoomed out to wide-angle) will turn orange, indicating underexposure. But, if you turn Safety Shift on in the same situation, the shutter speed will shift to something like 1/4 second, so the image can be exposed properly. Whether to use this setting or not depends on your intentions in a given situation. If you are experimenting with a particular shutter speed or aperture and want to use it whether or not the image will be well exposed, then leave Safety Shift turned off. If you would rather let the camera take over to save the image, turn this option on.

Review

This setting controls whether, and for how long, the image stays on the LCD screen after you first take a picture. The possible settings are Off, any value from 2 through 10 seconds, and Hold. If you select Hold, the image stays on the screen until you press the shutter button halfway down to return the camera to shooting mode. In Hold mode, the image will stay on the screen, but you can't move back or forward to other images. You can, however, change the display of that image using the DISP. button, and you can erase that image by pressing the Trash button (bottom direction button). Using this function can use up battery power somewhat faster than normal; setting it to Off can conserve power. Remember that you can always exit immediately from the Review display by pressing the shutter button down halfway.

Review Info

This next setting determines what information is displayed along with images when they are displayed on the screen immediately after shooting. The choices are Off, Detailed, and

Focus Check. With Off, only the image itself is displayed. With Detailed, the screen shows a lot of information, including shooting settings and a histogram that provides a graphic representation of the dark and light areas in the image.

The Focus Check setting results in a special screen that shows the image in two windows. The larger window shows the overall scene, and the camera places rectangular frames in this window—a white frame where the focus was set, a gray frame on any face that was detected, and an orange frame that acts as an inset to show what area is enlarged in the other large window on the LCD.

If you move the zoom lever to the right, the other window will become active, showing the area within the orange inset frame at large size. You can scroll around within that window to check the focus in that area, while also moving the area around so you can eventually check the entire image through this window. When you are done checking the focus, press the Menu button to return to the original Focus Check display. Then press the shutter button to return to shooting mode.

Blink Detection

This option can be set to either On or Off. When it is turned on, the camera will alert you by displaying an icon of a blinky-faced person if it detects that your subject's picture was taken with his or her eyes closed. This feature can serve as a useful check to see if you need to re-take a shot, because it can be difficult to tell if someone's eyes are closed while you are concentrating on taking the picture, or on examining the small LCD screen after it has been taken. Some users report that the blink detection is rather unreliable, though, so be prepared to use the Focus Check screen or some other method to examine any important images for unwanted eye-blinks.

Custom Display

This option controls the information displayed on the LCD in shooting mode. Using the control dial or the direction buttons, navigate between the two columns with the numbers 1 and 2 at their tops, and press the Func./Set button to add or remove a check mark for any one of the three items listed—Shooting Info, Grid Lines, or Histogram.

Items with check marks will display on that screen, and items with no check marks will not display. For example, with the setup shown above, only the shooting information will show on the first screen; the second screen will display shooting information, grid lines, and histogram. Once you have finished setting up these items as you want them, return to the shooting screen by pressing the shutter button halfway. You can then al-

ternate between the two displays by pressing the DISP, button.

IS Mode

With this option, you can set up the camera's image stabilization system as you want it. The four options are Off, Continuous, Shoot Only, and Panning. You probably should turn IS off when the camera is on a tripod, because the IS system can actually generate image blur in that situation. Continuous is a good setting for everyday shooting, because the system will help reduce the risk of blur from camera motion for all of your shots, and you can gauge the effects of stabilization as you compose the image on the LCD. Shoot Only can be used to save power, because the camera will not stabilize the image while you are viewing a scene; the stabilization system will start to work only at the moment you actually press the shutter button to record the image. The Shoot Only setting also can be useful because it can force you to be more aware of the camera's movement, causing you to hold it as steady as possible. The Panning setting is useful when you are actually moving the camera in a panning motion, perhaps to track a moving object. With that setting, the stabilization system will act to counter vertical motion, but not horizontal motion, so it won't be "fighting" against your intentional panning motion.

Date Stamp

This setting can be used to embed the current date, or the date and time, in the lower right corner of your images.

This embedding is permanent, which means that the information will appear as part of your image that cannot be deleted, other than through cropping or other editing procedures. So, you don't want to use this function unless you are certain that you want the date and time recorded on your images, perhaps for images that are part of a scientific research project. You can always add the date and time in other ways after the fact in editing software if you want to, because the camera always records the date and time internally in each image (if the date and time have been set accurately), so think twice before using this function. When you are shooting with this option activated, the word "DATE" appears in the lower right corner of the screen as you compose your shot. The image on the previous page was taken with this option turned on, with both date and time embedded.

Set Shortcut button

This is a very useful feature that you will probably want to take advantage of. The Shortcut button is the button marked with an S inside a square with an arrow, just to the left of the Play button on the back of the camera. In Playback mode, this control serves as the Print button. I'll discuss that function in Chapter 6. In Recording mode, this button has no function of its own, but it will take on any one of the 19 functions that are available through this menu option. I suggest you try setting it to various ones of the possibilities, and see which ones are the most useful. Also, you may find that setting it to one particular

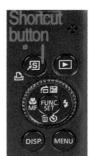

function is especially useful for a certain type of shooting session. To set the button's function, select this menu option, then use the direction buttons or the control dial to navigate to the option you want to set, and press the Func./Set button to assign it.

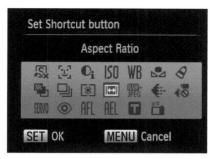

Here are the details on each of the possible settings, starting at the upper left of the chart on the menu screen, and proceeding left to right along each of the three rows:

Unassigned

I can't imagine why you would want to leave the button with no function, but you can do so with this first option.

Face Select

This function is available only if you assign it to the Short-cut button. Once you have assigned it to this button, point the camera in shooting mode at one or more people, and press the Shortcut button. The message Face Select On will appear and the camera will then find a face and place a tracking frame over it. If that is the face you want to track, leave that frame on that face, and let the camera track it until you're ready to take the picture. If you want to track a different face instead, press the Shortcut button, and the frame should find another face to track.

i-Contrast

If you set the Shortcut button to i-Contrast, you can summon that setting directly by pressing the button, rather than having to use the Function menu to get to the options for this feature. I discuss the use of i-Contrast later in this chapter, in connection with the discussion of the Function menu.

ISO Speed

First, I'm not sure about the nomenclature used by Canon for ISO. You don't ordinarily hear the ISO setting referred to as "speed," or at least I don't. I think of it more as a setting or a value. Anyway, Canon calls it a speed, so I'll stick to the official language in this discussion. If you assign this setting to the Shortcut button, pressing it will call up the ISO settings. You can then set ISO to any value (oops, I mean speed) from AUTO up to 3200. (As I discussed earlier, to set it higher than 3200, you have to use the Low Light shooting mode.) Actually, using this button for ISO can be a very handy thing. Many cameras have a dedicated ISO button, and with this setting, your S95 can have one, too.

White Balance

Here again, as with ISO, it is common for more advanced cameras to have a button specifically for calling up the white balance adjustment screen, so this is another very productive way to assign your Shortcut button. I'll discuss white balance later in this chapter, in connection with the Function menu.

Custom White Balance

This possible assignment for the Shortcut button lets you assign one specific white balance setting to the button—Custom White Balance. In a way, this assignment is even more powerful than the previous one, which just gets you into the general white balance setting screen. With this setting, one press of the Shortcut button cuts through the need to navigate through the white balance settings to get to the Custom setting. When you press the Shortcut button with this setting assigned to it, while filling the entire screen with a white or neutral object that is lit by the same light as your scene, you are immediately causing the camera to evaluate the white balance of the lighting for that scene, and you are registering that white balance to the Custom White Balance setting for future use. If you will be shooting in a situation in which the white balance is un-

certain and you may need to evaluate a custom white balance more than once or twice, assigning that function to this button can be a real convenience. I'll discuss white balance further, including Custom White Balance, later in this chapter, in connection with the Function menu.

My Colors

Assigning the Shortcut button to My Colors lets you call up the My Colors settings immediately, rather than having to use the Function menu.

Bracketing

This option lets you call up the Bracketing screen with one press of the Shortcut button, so you can set bracketing with multiple exposure or multiple focusing distances.

Drive Mode

This option gives you the ability to call up single shot, continuous shooting, or continuous shooting with autofocus as your drive mode, without having to use the Function menu.

Light Metering

If you assign the Shortcut button to Light Metering, you can quickly summon the screen with three choices for your metering mode: Evaluative, Center-Weighted Average, and Spot. I'll discuss these modes later in this chapter, along with the Function menu.

Aspect Ratio

This function could be a very useful one to assign to the Short-cut button if you are likely to change the aspect ratio of your shooting fairly often. As I'll discuss more fully in connection with the Function menu later in this chapter, the PowerShot S95 can shoot still images in any one of five aspect ratios: 16:9, 3:2, 4:3, 1:1, and 4:5. One reason it could be useful to change

aspect ratios quickly is that there are some situations in which you are likely to need a particular aspect ratio. For example, if you want to use digital zoom, it is available only when the aspect ratio is set to 4:3. So, if you want to start using digital zoom because of a sudden opportunity for a good shot, it could be helpful to be able to switch quickly into the 4:3 aspect ratio by pressing the Shortcut button and moving right to that setting without delay.

RAW or JPEG

This is another possible assignment for the Shortcut button that is quite useful. In this case, one press of the button takes you directly to the selection screen where you can choose from JPEG, RAW, and RAW+JPEG for your image format. In my case, I prefer to shoot in RAW whenever possible, but if I want to use certain features, such as i-Contrast or My Colors, that are not available with RAW images, it's good to be able to switch quickly into JPEG, so I can use those features.

REC Pixels/Compression

With this option, the Shortcut button takes you directly to the screen for selecting your image size for JPEG images, from L, M1, M2, and S. On the same screen, you can press the DISP. button to get to the screen for choosing between Normal and Standard compression, or image quality. I personally would not use up the single Shortcut button slot for this setting, because, if I'm not shooting RAW, I always shoot Large and Fine JPEG images; I have no reason to use smaller or lower-quality images. However, other photographers easily could have other priorities, especially when taking large quantities of pictures, so this setting might be of use in some situations.

Movie Quality

This setting gets you to the screen for selecting the quality of your movies, from 1280, 640, and 320. Unless you have some reason to shoot movies at various different quality levels, I

would not recommend using up your Shortcut button slot on this setting, which is available only when the mode dial is set to Motion Picture mode.

Servo AF

This option is one that clearly can be of considerable use as a quick-access setting. You might want to switch quickly into Servo AF for your focusing mode when you encounter a subject that is likely to keep moving as you track it.

Red-Eye Correction

I would put this option at or near the bottom of the list of likely candidates for the single Shortcut button slot. This is the feature that alters areas of red in your image in an attempt to fix the red-eye problem. I would prefer to deal with red-eye by using the Red-Eye Lamp, or by fixing the image in software such as Photoshop.

AF Lock

This setting is intended for a situation in which the function in question, Autofocus lock, is not available through the normal control, so you would need to assign it to the Shortcut button. Normally, to lock the autofocus you press the shutter button halfway to focus, then press the MF button (left direction button) to enter manual focus mode, locking the focus at the distance the autofocus mechanism measured. However, when you are using the Stitch Assist category of the Scene mode, manual focus is not available. Therefore, for that one situation, Canon has made it possible for you to assign the AF Lock option to the Shortcut button. If you're using Stitch Assist and want to lock focus, first assign AFL to the Shortcut button, then press that button after pressing the shutter button halfway to find the focus distance. Personally, I have a hard time imagining a time when I would need to do that, because a panorama is likely to be at a long distance from the lens in any event, and focus locking would not likely be necessary. But

there may be some time when this function would be useful.

AEL

With this setting, Auto Exposure Lock, you can lock the exposure as you aim the camera at one object, and then move the camera to a new position with the exposure locked at the initial reading. Ordinarily, to do this you need to press the shutter button down halfway and then press the up direction button to lock the exposure setting. If you save the AEL function to the Shortcut button, you can lock your exposure with one press of that single button, thereby saving a step. This might be useful if you will be encountering repeated situations in which you need to set your exposure by aiming away from your final subject, and then returning to your subject to take the picture with the locked exposure. Note that, when using this setting for the Shortcut button, the exposure lock is cleared when you press the shutter button, just as with the normal AEL function.

Digital Tele-converter

With this option, one press of the Shortcut button sets the camera to the 1.4x setting of the digital tele-converter, and a second press sets it to the 2.3x setting. A third press turns it off. If you have occasion to use the digital tele-converter, it is considerably more convenient to activate it with the Shortcut button than by going in to the Recording menu and navigating to its location on the list of options. One problem, however, is that the digital tele-converter feature is not available unless the camera is set to the 4:3 aspect ratio, the file type is JPEG, and you are not using certain shooting modes, as discussed earlier. So, you may press the Shortcut button and find that nothing happens. But, if you have kept track of your other settings and know that digital tele-converter is available, assigning it to the Shortcut button can be very convenient.

Display Off

This final option provides a quick and easy method to turn off

the camera's display screen. This can be a very convenient way to darken the screen to avoid distracting others, or to conserve power if your battery is running down. To restore the screen, you can press the Shortcut button or any button other than the power button, or you can just rotate the camera vertically or horizontally, which also should wake up the display.

Save Settings

I discussed this option earlier, in connection with the discussion of the Custom shooting mode (the C position on the mode dial). As a reminder, this menu option is what you use when you want to register, or save, a group of shooting settings to the camera's memory, so they can be recalled instantly by rotating the mode dial to that position. The settings that can be saved are the shooting mode (Program, Aperture Priority, Shutter Priority, or Manual); the various shooting settings made through the Function menu or the Recording menu, including ISO, white balance, autofocus frame mode, i-Contrast, and others; the position of the zoom lens; the manual focus setting; and the My Menu settings (custom menu items, discussed later in this chapter).

Here is an example to illustrate the kinds of settings that you might want to save in this way. Let's say you were working on a project to take photographs of some pieces of pottery in a friend's studio. Because of the lighting conditions and arrangement in the studio, you found the best settings to use were Shutter Priority at 1/30th second, with +1.0 EV of exposure compensation added, with the ISO set to 200. Let's say you also were using the self-timer, because you had the camera on a tripod and wanted to minimize camera shake by pressing the shutter button as the picture was taken. (With the self-timer, there would be a 2-second delay before the shutter was tripped, so you would not be touching the camera at that point.) Also, say you're shooting JPEG images of Large size, with a 1:1 aspect ratio, and the lens is zoomed in to the 50mm

point. Finally, you have the camera set to manual focus, at a distance of 10 centimeters (4 inches).

Then, because it would be a nuisance to duplicate all of those settings individually, you had the foresight to use the Save Settings option on the Recording menu to save the above settings to the C slot on the mode dial. Later on, you had the opportunity to go outside and photograph a colorful horse and carriage. For those images, you switched to Program mode, using RAW images with a 16:9 aspect ratio, autofocus, and no selftimer. When you returned to the pottery studio, all you had to do was turn the mode dial to the C setting, and voilà! All of your settings were restored exactly as you needed them. As I said earlier, this is a very powerful feature of the S95—more powerful than similar features on some other cameras in this class—so you should take advantage of it if you have a group of settings that you may need to recall from time to time.

The Function Menu

The other menu system for controlling your settings while shooting images is the Function menu, which is summoned by pressing the Func./Set button, in the center of the control dial, while the camera is in Recording mode. I have already discussed some of the options that are available through this menu, but now it is time to go through each setting in more detail. Note that, as with the Recording menu, the number of items that are available for selection through the Function menu varies according to the current shooting mode. So, for example, if the camera is set to the Auto mode, only two options are available (aspect ratio and image size), whereas virtually the whole range of options is available in Program mode. The Scene mode and Low Light mode have moderate numbers of options available, and Movie mode has only a few. In the following discussion, I will describe all of the options that are generally applicable to recording still images. I won't discuss those specific to certain settings, such as the scene types,

which are selected from the Function menu when the camera is set to Scene mode, or the settings specific to Movie mode, which will be discussed in Chapter 8.

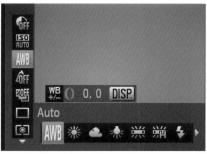

i-Contrast

This is a very useful option that can help you avoid problems with excessive contrast in your images. Such problems arise because digital cameras cannot easily process a very wide range of dark and light areas in the same image—that is, their "dynamic range" is limited. So, if you are taking a picture in an area that is partly lit by bright sunlight and partly in deep shade, the resulting image is likely to have some dark areas in which the details are lost in the shadows, or some areas in which the highlights, or bright areas, are excessively bright, or "blown out," so, again, the details of the image are lost. One approach to this problem is to use High Dynamic Range, or HDR, techniques, in which multiple photographs of the same scene with different exposures are combined into one composite image that is properly exposed throughout the entire scene. I discussed that technique earlier, in Chapter 3.

The i-Contrast setting gives you another way to approach the problem of unbalanced lighting, with special processing in the camera that tries to boost the details in the dark areas and reduce the over-exposure in the bright areas at the same time, resulting in a single image with better exposure than would be possible otherwise. In order to do this, i-Contrast uses two complementary sub-settings, called DR (Dynamic Range)

Correction to reduce highlight blowout, and Shadow Correction to pull details out of the shadows.

The i-Contrast setting process is a bit involved; here are the steps. Press the Func./Set button and highlight this option, the top one at the left of the screen. (Somewhat oddly, when the Function menu first appears, this item is out of sight, above the ISO item; you have to scroll up to reach i-Contrast.) Above the line of icons at the bottom of the screen you should see the words, "DR Correction Off," meaning you are currently working with the DR Correction sub-setting. The Off setting should be highlighted at the bottom left of the screen. Scroll through the other settings using the control dial or the direction buttons: Auto, 200%, and 400%. (The Auto setting will be grayed out and unavailable unless the camera's ISO is set to Auto ISO.) With the Auto setting, the camera will attempt to determine how much processing is needed. The other two settings allow you to choose how much correction is applied.

When you are done with the DR Correction sub-setting, press the DISP. button, and the display switches to let you set the Shadow Correction. In this case, there are only two possible settings: Off and Auto. When you are done with both settings, press the Func./Set button again to return to the shooting screen. An i-Contrast icon will appear in the lower right of the display to remind you that you are using this feature.

Note that i-Contrast cannot be used with RAW images. Also, you can apply i-Contrast to your images after the fact, from the Playback menu, as discussed in Chapter 6. In fact, doing so can be a good way to experiment with various settings to see how well i-Contrast may work in a particular environment.

ISO

Before I discuss how to use this setting, I should explain the importance of ISO. These initials stand for International Stan-

dards Organization. When I first started in film photography a few decades ago, this standard was called ASA, for American Standards Association. The ISO acronym reflects the more international nature of the modern photographic industry.

The original use of the ISO/ASA standard was to designate the "speed," or light sensitivity, of film. So, for example, a "slow" film might be rated ISO 64, or even ISO 25, meaning it takes a considerable amount of exposure to light to create a usable image on the film. Slow films yield higher-quality, less-grainy images than faster films. There are "fast" films available, some black-and-white and some color, with ISO ratings of 400 or even higher, that are designed to yield usable images in lower light. Such films can often be used indoors without flash, for example.

With digital technology, the industry has retained the ISO concept, but it applies not just to film, but to the light sensitivity of the camera's sensor, because there is no film involved in a digital camera. The ISO ratings for digital cameras are supposed to be essentially equivalent to the ISO ratings for films. So if your camera is set to ISO 80, there will have to be a good deal of light to expose the image properly, but if the camera is set to ISO 1600, a reasonably good (but "noisier" or "fuzzier") image can be made in very low light.

The upshot of all of this is that, generally speaking, you want to shoot your images with the camera set to the lowest ISO possible that will allow the image to be exposed properly. (One exception to this rule is if you want, for creative purposes, the grainy look that comes from shooting at a high ISO value.) For example, if you are shooting indoors in low light, you may need to set the ISO to a high value (say, ISO 800) so you can expose the image with a reasonably fast shutter speed. Otherwise, if the camera uses a slow shutter speed, the resulting image would likely be blurry and possibly unusable.

To summarize: Shoot with low ISO settings (around 100) when possible; shoot with high ISO settings (say 400 or higher, up to 1600 or even 3200) when necessary to allow a fast shutter speed to stop action and avoid blurriness, or when desired to achieve a creative effect with graininess.

With that background, here is how to set ISO on this camera. As is discussed in Chapter 5, one good feature of the Power-Shot S95 is that you can make certain important settings, such as ISO, using the control ring. However, you can also set ISO from the Function menu, and this is not a bad way to make this setting. So, especially if you want to use the control ring for other purposes, it's good to know how to get quick access to the ISO setting with this menu.

Press the Func./Set button and move to the ISO icon, the second one down on the left. Then scroll across the menu at the bottom of the screen to select a value ranging from Auto at the left, through 80, 200, and other specific values, to a maximum of 3200 at the right of the scale. If you choose Auto, the camera will select a value from 80 to 1250, but not above that range.

You cannot select Auto ISO in Manual exposure mode; you have to select a numerical value. In Auto shooting mode, Movie mode, and Scene mode, Auto ISO is automatically set, and you cannot adjust it. In Low Light mode, as discussed in Chapter 3, you have access to a range of much higher ISO settings, up to a maximum of 12800; the lowest setting you can use in that mode is ISO 320. Of course, as discussed earlier, with that shooting mode there is a tradeoff in image quality, because the resolution of your images is automatically reduced.

White Balance

This topic needs a bit of background discussion for those users who are new to digital photography. One issue that arises in all photography is that film, or a digital camera's sensor, reacts dif-

ferently to colors than the human eye does. When you or I see a scene in daylight or indoors under various types of artificial lighting, we generally do not notice a difference in the hues of the things we see depending on the light source. However, the camera does not have this auto-correcting ability. The camera "sees" colors differently depending on the "color temperature" of the light that illuminates the object or scene in question. The color temperature of light is a numerical value that is expressed in a unit known as kelvins (K). A light source with a lower kelvin rating produces a "warmer" or more reddish light. A light source with a higher kelvin rating produces a "cooler" or more bluish light. For example, candlelight is rated at about 1,800 K; indoor tungsten light (ordinary light bulb) is rated at about 3,000 K; outdoor sunlight and electronic flash are rated at about 5,500 K; and outdoor shade is rated at about 7,000 K.

What does this mean in practice? If you are using a film camera, you may need a colored filter in front of the lens to "correct" for the color temperature of the light source. Any given color film is rated to expose colors correctly at a particular color temperature (or, to put it another way, with a particular light source). So if you are using color film rated for daylight use, you can use it outdoors without a filter. But if you happen to be using that film indoors, you will need a color filter to correct the color temperature; otherwise, the resulting picture will look excessively reddish because of the imbalance between the film and the color temperature of the light source. With a modern digital camera, you do not need to worry about filters, because the camera can adjust its electronic circuitry to correct the "white balance," which is the term used in the context of digital photography for balancing color temperature.

The PowerShot S95, like most current digital cameras, has a setting for Auto White Balance, which lets the camera choose the proper color correction to account for any given light source. Here is how to make this setting through the Function menu. Once you have highlighted the white balance setting,

which is the third icon down on the left side of the screen, you can scroll across the line of icons at the bottom of the screen, which represent the following choices for the white balance setting, most of them represented by icons: Auto White Balance (AWB); Daylight (sun icon); Cloudy (cloud); Tungsten (round light bulb); Fluorescent (fluorescent bulb); Fluorescent H (same, with letter H); Flash (lightning bolt); Underwater (fish); and Custom (special symbol).

The above settings should be self-explanatory, except for Fluorescent H. That setting is for a type of fluorescent bulb that is meant to be closer to the appearance of daylight than normal fluorescents. You may want to experiment, not just with the fluorescent settings, but with all of the presets, to see if the settings listed above produce the results you want. If not, you'll be better off setting the white balance manually. The images below illustrate the effects of the different preset white balance options, all taken at the same time in an outdoor setting.

To set white balance manually, select the Custom option, at the far right of the line of icons at the bottom of the screen. Aim the camera at a white (or gray) sheet of paper (or a white or gray wall, or other object) under the light source you will be using, and fill the camera's entire screen (not just the focus rectangle, if one is visible) with the image of that surface. (You can zoom using the zoom lever if necessary to fill the screen with the chosen surface.) Press the Menu button to lock in that white balance setting. Now, until you change that setting, whenever you select the Custom white balance icon, the camera's white balance will be set for the value you have just selected through this procedure. This system can be very useful if you often use a particular light source, and want to have the camera set to the appropriate white balance for that source.

If you really want to tweak the white balance setting to the nth degree, after you have selected your desired white balance setting (whether a preset or the Custom setting) press the DISP. button, and you will be presented with a screen for fine adjustments. You will see a pair of axes that intersect at a zero point, marked by a white dot. The four axes are labeled G, B, M, and A for Green, Blue, Magenta, and Amber. You can now use all four directional buttons to move the red dot away from the center toward any of the axes, to adjust these four values until you have the color balance exactly how you want it. If you prefer, you can use the control dial to adjust the G-M axis, and the control ring to adjust the B-A axis. (If you only need to adjust the B-A axis, you can use the control ring to make that adjustment without pressing the DISP. button; just start turning the control ring while you are still on the main white balance screen.) The camera will remember your adjusted white balance value until you alter it again, even if you switch to a different white balance preset.

My Colors

This setting offers great options for altering the colors of your JPEG images as you take them. (The My Colors feature does

not work when you are shooting RAW or RAW+JPEG images.) With the fairly wide variety available with this option, you can add or subtract intensity of colors or work in subtle changes to the look of your images. Of course, if you plan to edit your images on a computer using software such as Photoshop, you can duplicate these effects readily at that stage. But, if you don't want to spend time processing the images in that way, having the ability to alter the color effects in this quick way can add a good deal to the enjoyment of your photos.

Using this feature is easy: Just select My Colors, the fourth icon down on the list of icons on the left, then scroll across the icons at the bottom of the screen until you find the one you want to use. In the pages that follows, I will provide comparison photos showing each setting in action on the same scene, under the same lighting conditions, to illustrate the different effects you can achieve with each variation.

My Colors Off

As a control image, the picture below shows an image of colored pencils with My Colors turned off, and the scene photographed in normal Program mode with no special processing.

Vivid

This setting increases the saturation, or intensity, of all of the colors in the image. As you can see, it calls attention to the scene, though it can easily seem excessive if used in the wrong context. The Vivid setting might work well if you want to em-

phasize the colors in a birthday party scene or a setting of that nature.

Neutral

The Neutral setting can probably be considered the inverse of Vivid. Although it does not drain all color from the scene, it does de-emphasize the colors, ratcheting down the intensity to a more sedate level. You might use this setting to set a mood of calmness or serenity in a scene.

Sepia

When you use the Sepia setting, the image is drained of all of its natural colors, and it is rendered monochromatically, but with the added touch of a light brownish tone, which is somewhat reminiscent of the appearance of old-fashioned photographs. The Sepia setting can be used to convey a sense of the

antique.

B/W

This setting removes all color, converting the scene to black and white. Some photographers use this setting to achieve a gritty look for their street photography.

Positive Film

This setting is similar to Vivid, though the intention was to mimic the "natural" colors of slide film.

Lighter Skin Tone

This setting appears to do just what its name implies—it makes the flesh-colored tones such as pinks somewhat less intense and more neutral in appearance.

Darker Skin Tone

This setting, the opposite of the previous one, subtly darkens the tones in the range of pink, red, violet, and the like.

Vivid Blue

This variant of the Vivid setting affects only the blue tones; therefore, as Canon notes in the user's manual, you can use this setting when you want to emphasize the blues of ocean or sky without increasing the saturation of colors such as red

and yellow.

Vivid Green

This setting places emphasis on the greens of foliage, including grassy fields, tree-covered mountains, and similar features.

Vivid Red

This last of the Vivid settings can be used to increase the intensity of any red objects, including flowers, decorations, clothing, or any other item.

Custom Color

There is no photographic example of this setting here, because it is up to each photographer to develop his or her parameters for this setting. To set those parameters, once you have chosen the icon for Custom Color, press the DISP. button. The camera then presents you with a scale for adjusting contrast; use the control dial or the left and right direction buttons to increase or decrease the contrast setting by as much as two increments on this scale. Then press the up or down direction button to move to the next parameter. In this way, you can dial in adjustments for contrast, sharpness, saturation (color intensity), red color tone, green color tone, blue color tone, and skin tone. Once you have adjusted all of these settings as you want them, they will stay set that way until you return and change them.

It's important to note that, even though this overall feature of the camera is known as My Colors, you can use the Custom Color setting to adjust contrast and sharpness, two values that are not concerned particularly with colors. So, for example if you find your images are too sharp or too "soft," you can decrease or increase your sharpness setting in the Custom Color setting of My Colors, and use that setting for your general photography. Of course, you are giving up the ability to shoot your images in RAW format if you take that route, which many serious photographers would not be willing to do. But it's good to have this setting available as one of the options for tweaking the output of the camera's JPEG processing.

Bracketing

Bracketing is a function that lets you take three pictures with one press of the shutter button, with three different settings, thereby giving you an added chance of getting a good, usable image. The PowerShot S95 provides two types of bracketing: automatic exposure bracketing, shown as AEB on the Function menu, and focus bracketing, abbreviated as Focus-BKT.

Exposure bracketing

First, I'll talk about exposure bracketing, which is the most commonly used and probably the most useful type of bracketing. If you're shooting with RAW quality, exposure is not that much of an issue, because you can adjust it later with your software, but it's always a good idea to get the exposure as correct as possible. Also, using exposure bracketing is an excellent way to take three pictures that can be combined later in software to produce an HDR (High Dynamic Range) composite, which shows clear details and highlights throughout the image by combining the best-exposed parts of each shot.

To use exposure bracketing, the camera must be set to Program, Aperture Priority, or Shutter Priority mode, and the flash cannot be used. Navigate down in the Function menu to the fifth icon, which should look like a stack of images with the word OFF laid on top of it. Use the control dial or the right direction button to move to the icon to the right of that one, on the line of icons at the bottom of the screen. That icon should show three image frames, one white, one dark, and one shaded, indicating three levels of exposure.

With that middle icon highlighted, press the DISP. button, and the camera will display a scale showing EV (exposure value) numbers from -2 to +2, in increments of 1/3 EV, with three orange dots beneath the scale. Use the control dial or the direction buttons to move those dots so they are separated by the amount of EV difference that you want, up to a maximum difference of 2 EV. Then exit from the Function menu by pressing the Func./Set button. You will see the AEB icon on the screen. When you are ready, press the shutter button and hold the camera steady (or use a tripod) while it takes the three exposures. The first picture taken is always at the metered level, or 0 change in EV; the second is at the lower EV (darker), and the third is at the higher EV (brighter). If you have added exposure compensation, the bracketed exposures are taken at three levels relative to the adjusted exposure.

Finally, note that there is an alternative way to get access to exposure bracketing: Press the top direction button to bring up the exposure compensation scale, and you will see the bracketing icon next to the word DISP. Within about 3 seconds, press the DISP. button, and the exposure bracketing screen will appear.

Focus bracketing

The other type of bracketing available with the PowerShot S95 is focus bracketing, which lets you take three pictures with three different focus settings, when you are using manual focus. I don't use this feature often, but it may be useful in some tricky focusing situations, such as extreme close-up photography. This feature works in the same way as auto exposure bracketing; once you have selected the bracket icon in the Function menu, navigate to the icon on the far right at the bottom of the screen, with the letter F on the stack of image frames. Then press the DISP, button, and move the orange dots further apart to set the incremental change in focus among the three shots. When you return to the shooting screen, the camera will take the first shot at the distance you set for manual focus, the second shot with focus set for a farther distance, and the third shot with focus set for a nearer distance.

Focus bracketing, unlike auto exposure bracketing, works with Manual shooting mode as well as with Program, Aperture Priority, and Shutter Priority. It also does not work with flash.

Note that, as with exposure bracketing, there is a second, shorter path to get access to the focus bracketing function. After pressing the left direction button to put the camera into manual focus mode, you will see the focus bracketing icon on the screen, next to the DISP. button. Press that button within about 3 seconds, and you will be taken to the focus bracketing screen.

Continuous Shooting

The next icon down the line on the left side of the Function menu gives you the settings for firing a burst of shots with one press of the shutter button. This feature is known as continuous shooting, and also is sometimes referred to as drive mode, probably because film cameras need to have a motor drive built in or added on in order to fire a rapid stream of shots.

Start by highlighting the sixth icon down on the left of the Function menu. The first icon on the left of the icons at the bottom of the screen is a single white rectangle, which represents the single shot mode, the normal mode when you are taking just one shot at a time. If you navigate over to the middle icon on the bottom of the screen, you will see a stack of white frames, which represents the standard continuous mode. When you select that icon and exit the Function menu, that stack will appear on the screen, indicating that the camera is set for continuous shooting. Now, whenever you hold down the shutter button, the camera will keep taking shot after shot, at a maximum rate of about 1.9 images per second. In this mode, the camera will lock its exposure and focus when you first press the shutter button down halfway, and those settings will not change throughout the continuous shooting. So, if you aim at subjects at different distances from the camera or with varying lighting while shooting, the camera will not adjust its focus or exposure to account for the changing conditions.

This mode is intended to give you the maximum speed for high-quality photographs, but you will get consistently good results only if you are shooting in conditions where changes in lighting and focus will not be an issue. For example, if you are taking photos at a relatively long distance from the subject in daylight, you may not have a problem, because the camera will maintain good focus at that distance and the lighting will not likely change, unless a cloud blocks the sun. On the other hand, if you're indoors at a gathering and want to keep shooting candid photos, the chances are good that some of the im-

ages will be poorly focused or poorly lit, or both, because the focus tolerance is more critical at shorter distances, and the lighting may vary considerably in different parts of a room.

The final continuous shooting mode is represented by the icon on the right of the bottom menu. That icon is a stack of frames with the letters AF on top, representing autofocus. In this mode, the camera will shoot continuously at a maximum speed of about 0.7 frames per second, and will adjust its autofocus for each shot. However, the camera still will not adjust its exposure, which will be locked in when you first press the shutter button down halfway. If you have the camera set for manual focus, the Fireworks setting of Scene mode, or autofocus lock (which involves using the manual focus mode), the continuous AF mode is automatically converted to continuous LV shooting mode, in which the camera fires at about 0.8 frames per second, but still locks focus and exposure with the first shot.

Continuous shooting is not available at all in Auto shooting mode or in modes in which it would not make sense, such as the HDR or Stitch Assist settings of Scene mode.

Note that the maximum shooting speeds will slow down in certain conditions, such as when the light is so low as to require a slow shutter speed, or when the flash is being used. The speed also may slow down as the number of shots increases, as the camera's memory buffer fills up and needs to pause to empty out so more shots can be accepted.

However, in spite of its several limitations, continuous shooting mode can be a very useful tool in some situations, such as when you're shooting scenes with changing action, or people with changing expressions. There's no extra cost involved in taking numerous shots, and you may increase your chances of getting that one priceless image. So you may want to consider using continuous mode on a fairly regular basis, when it might

enhance your photographic results.

Finally, remember that there is a way to get considerably faster continuous shooting from the PowerShot S95—by setting the camera to Low Light shooting mode. In that case, the maximum shooting speed rises fairly dramatically, to 3.9 frames per second. Of course, as I discussed in Chapter 3, there is a corresponding tradeoff in image quality, because the camera automatically sets the image size to Medium in that shooting mode. But, if you need the extra speed, Medium images are still very usable, as long as you don't need huge enlargements. So don't forget that Low Light mode is available when you need to fire off shots in as rapid a sequence as possible.

Metering Method

This option lets you choose among the three patterns of exposure metering offered by the S95: Evaluative, Center Weighted Average, and Spot. This choice tell the camera's automatic exposure system what part of the scene to consider when setting the exposure. With Evaluative, the camera uses the entire scene that is visible on the LCD, though it uses its built-in programming to evaluate whether the scene is lit from behind ("backlit") or otherwise needs adjustments. With Center Weighted Average, the camera still considers all of the light from the scene, but it gives additional weight to the center portion of the image, on the theory that your main subject is in or near the center. Finally, with Spot, the camera considers only the light that is metered within the spot metering area. In that mode, the camera places a small white frame in the center of the LCD, indicating the metered area. With the Spot setting, you can see the effects of the exposure system clearly by selecting Program exposure mode and aiming that small rectangle at various points, some bright and some dark, and seeing how sharply the brightness of the scene in the LCD changes. If you try the same experiment in Evaluative mode, you will still see changes, but much more subtle and gradual ones.

Note, if you choose Spot metering, the white frame you will see is different from the white frame the camera uses to indicate Center autofocus frame mode. If you make both of these settings at the same time, you will see two white frames in the center of the LCD. So, you may need to be careful to recall which one of these settings is in effect, if only one white frame is visible in the center of the screen.

Note, also, in Auto mode and all varieties of Scene mode, the only metering method available is Evaluative.

Aspect Ratio

This setting lets you choose the proportions of the image that you record with the camera. The choices are 16:9, 3:2, 4:3, 1:1, and 4:5. These numbers represent the ratio of the units of width to the units of height. So, for example, in the first setting, the image is 16 units wide for every 9 units of height. The aspect ratio that covers the entire LCD is 4:3; with any other aspect ratio, some of the pixels are cropped out. So, if it matters to you to record every possible pixel, you might want to use the 4:3 setting. That is the setting that is used for all RAW images; you can't set any other aspect ratio when shooting RAW. You should also note that, if you shoot in RAW, or in the 4:3 aspect ratio, you can always alter the aspect ratio of the image later in editing software such as Photoshop, by cropping away parts of the image. However, if you want to have your images in a certain shape, will be shooting in JPEG, and don't plan to do post-processing in software, these aspect ratio settings may be just what you want. The PowerShot S95 is notable for providing more options in this area than many other cameras do, so let's go through the list of possibilities. After each of the aspect ratios discussed below, I am including an image I took at that setting, handheld, from the same location at the same time, to give a general idea of what the different aspect ratios look like.

The 16:9 setting is the first one on the left when you reach the

Aspect Ratio icon on the Function menu. That ratio is normally considered the "widescreen" mode, like that found on many modern HD television sets. You might choose that setting when you plan to show your images on an HD TV set.

The 3:2 setting is the same ratio used by traditional 35mm film, and can be used without cropping to make prints in the common U.S. size of 6 inches by 4 inches (15 cm by 10 cm).

The 4:3 setting is the ratio of the S95's LCD, so, if you want to use the full expanse of the LCD, this may be your preferred aspect ratio. This ratio is important for another reason, also: It's the only ratio available for shooting RAW images or using digital zoom.

The 1:1 ratio represents a square shape, which some photogra-

phers prefer because of its symmetry and because the neutrality of the shape leaves open many possibilities for using the images.

Finally, the 4:5 aspect ratio, the only setting available that is taller than it is wide, may be well-suited for portraits and other scenes with a narrow or tall subject. Of course, you can achieve a similar effect by holding the camera with its right side in the air, so you are shooting with the long side of the frame held vertical. In that case, though, you would have to rotate the images to view them comfortably.

The Aspect Ratio setting is available in all shooting modes except Low Light and a few of the Scene types (HDR, Nostalgic, Fish-eye, and Stitch Assist).

Image Type

This setting, just below Aspect Ratio on the Function menu, is one of the most important ones you can make. (The menu does not label this choice "Image Type," that's just a name I chose for convenience in discussing this option.) The choices are JPEG, RAW, and RAW+JPEG. Before I discuss this option, though, I need to mention two other settings that are closely related to this one. The next icon down on the left side of the Function menu, which is the last icon at the bottom of the menu, is a capital letter L, M (with a number 1 or 2), or S, preceded by a quarter-circle shape, either smooth or jagged. That icon, in its two parts, represents image size (Large, Medium, or Small), and quality (smooth for Fine and jagged for Normal). All of these settings go hand-in-hand to determine several attributes of your images.

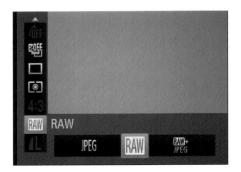

Here are some guidelines about these settings and what they mean. First, you need to choose between RAW and JPEG images. RAW files are larger than other files, so they take up more space on your memory card, and later, on your computer, than JPEG files. But RAW files offer some great advantages over JPEG files. When you shoot in the RAW format, the camera records as much information as it can about the scene before it, and preserves that information in the file that it saves to the memory card. Then, when you open the RAW file later on your computer, you will have the ability to extract that information in various ways. What this means, for example, is

that you can actually change the exposure or white balance of the image when you edit it on the computer, just as if you had changed your settings while shooting. In effect, the RAW format gives you what almost amounts to a chance to travel back in time to improve the settings that you didn't get quite right when you pressed the shutter button.

RAW is not a cure-all; you can't fix bad focusing or really excessive under- or over-exposure. But you can improve exposure-related issues such as brightness and white balance very nicely with your RAW-processing software. (You can use the Digital Photo Professional software that comes with the PowerShot S95, or any of several other software packages, such as Adobe Photoshop or Photoshop Elements, or Apple Aperture. Using RAW may have some disadvantages as well, depending on your needs. As noted above, the files take up a lot of storage space on your memory card or computer; some RAW images I recently took with the camera were between 12 and 14 megabytes (MB) in size, while Large IPEG images I took at the same time were only about 3 MB each, Also, RAW files have to be processed on a computer; you can't take a RAW file and immediately send it by e-mail or print it on photo paper; you first have to use RAW-processing software to convert it to JPEG, TIFF, PSD or some other standard format for printing and manipulating digital photographs. If you are pressed for time, you may not want to take that extra step. Finally, as noted earlier in this book, some features of the PowerShot S95 are not available when you are using the RAW format, including the Auto, Low Light, or Scene shooting modes, or the digital zoom, i-Contrast, My Colors, or aspect ratio settings.

If you're undecided as to whether to use RAW or JPEG, you have the option of selecting RAW+JPEG, the third option on the right of the line of icons on the Function menu. With that setting, the camera records both a RAW and a JPEG image when you press the shutter button. The advantage with that system is that you have a RAW image with the highest quality

and with the ability to do extensive post-processing manipulation of some settings, and you also have a JPEG image that you can use more quickly for viewing, e-mailing, printing, and the like. The disadvantage is that this setting consumes your storage space more quickly than saving your images in just RAW or JPEG format.

If you decide not to use RAW, the only other option for image type is JPEG files, which are compressed; that is, some information is digitally "squeezed" out of them, in a way that reduces their size so they don't take up too much storage space on a memory card or computer hard drive, but that does not remove crucial information. JPEG images can be of excellent quality, although they do not carry with them the possibility for after-the-fact corrections of exposure problems, at least not nearly to the extent that RAW Files do. (An experienced user of Photoshop or similar software can still do wonders in improving the appearance of a JPEG image, just not to the same degree as with a RAW file.) If you do decide to use JPEG files, you still have a few more choices to make about the size and quality of your images, as discussed next.

Image Size and Quality

Your final option on the Function menu lets you choose the size and quality of your JPEG images, when you have chosen either JPEG alone or RAW+JPEG for your image type on the previous item. If you have decided to use RAW images only, there are no other choices to make. RAW files come in one size and one quality only. So, if you select RAW on the previous Function menu item, you will see that the next menu item below that one becomes grayed out and unavailable.

If you decide to use JPEG images (either alone or with the RAW+JPEG setting) and are concerned more with quality than with storage space, you should probably choose the largest size and quality for those images. You will gain the ability

to store more files if you choose the smaller sizes and the lower quality for your JPEG files, but, unless you are absolutely certain that you won't want to crop the images to emphasize just a small part of them, or to make large prints from them, you might as well use the best-quality settings you can. If you take a picture in a small, low-quality file, you can never recover the quality you would have realized from using the higher-quality settings.

You set the size and quality of JPEG files using the bottom option on the left side of the Function menu. When you first highlight that icon, you will likely see the menu on the bottom of the screen listing the file sizes from left to right: L, M1, M2, and S, for Large, Medium 1, Medium 2, and Small. Once you have scrolled through those settings and made your selection, press the DISP. button, and the camera will replace the menu of image sizes with a choice of two levels of quality, represented by the smooth quarter-circle shape and the jagged one, representing Fine quality and Normal quality, respectively. With Fine quality, the compression of the JPEG file is kept to a minimum; with Normal quality, the file is compressed further, resulting in a loss of additional information from the file, and a corresponding reduction in the quality of the image.

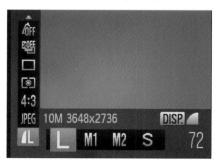

To get an idea of the relative sizes of the files that result from these settings, look at the chart at page 77 of the Canon Camera User Guide. The chart shows that, using a 4 GB memory card (a relatively modest size nowadays), you can store 1,471

Large images, 2,320 Medium 1 images, 6,352 Medium 2 images, or 20,116 Small images, all at Fine quality. So, clearly you are not likely to run out of space on your memory card very quickly, even if you are shooting JPEG images at the largest size and highest quality.

In short, your best bet in terms of preserving the quality of your images and your options for post-processing and fixing exposure mistakes later is to choose RAW files. However, if you would prefer to let the camera do more of the work and process the files in the camera, using features such as i-Contrast, the Scene mode shooting types, and others, which are not available with RAW files, then choose JPEG. If you do choose JPEG, I strongly recommend that you choose the Large size and Fine quality, unless you have an urgent need to conserve storage space on your memory card or on your computer.

My Menu

There is one other menu system to be discussed at this point; three others, the Playback, Print, and Setup menus, will be discussed in Chapters 6 and 7. Right now it's time to talk about My Menu, a special system for setting up your own menu with up to 5 of your own favorite settings, for quick access.

The My Menu system occupies its own place on the menu screen, and is available only when the camera is in Recording mode. My Menu is designated by a 5-pointed star at the top of the menu tab on the right of the screen. When the camera first comes from the factory, if you select this menu tab you will find only one entry, called My Menu settings. If you select that menu item by pressing the Func./Set button, you will be taken to a sub-menu, with two active lines: Select items and Set default view.

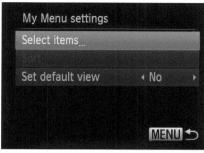

When you highlight Select items and press Func./Set, you are taken to a sub-menu with 20 items, from which you can choose any 5 (or fewer) to include on your list of "favorites" for the My Menu screen. The items on this list are AF Frame, AF Frame Size, Digital Zoom, AF-Point Zoom, Servo AF, AF-assist Beam, MF-Point Zoom, Safety MF, Flash Settings, ISO Auto Settings, Safety Shift, Wind Filter, Review, Review Info, Blink Detection, Custom Display, IS Mode, Date Stamp, Set Shortcut Button, and Save Settings.

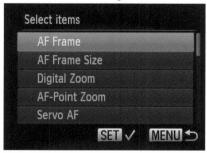

Just scroll through this list, and press Func./Set when any item you want to select is highlighted. A check mark will appear to the left of the item. One slightly odd feature of this setting screen is that some of the items on the list may be grayed out, making them appear unavailable, but you can still select them for your My Menu collection. Apparently, the camera shows them as grayed out to remind you that these items are not currently available, because of the current settings of the camera. In fact, if you select an item that is grayed out, when you later go to the My Menu screen, that item will not appear on the list

at all, if it is not available for selection at the time you go to the My Menu list.

Once you have your selection of up to 5 items entered for the My Menu Screen, you can get quick access to them at any time (if they are available under current conditions) by pressing the Menu button and navigating to the My Menu tab at the right of the menu tabs. You can also sort the My Menu list in order to get your most-used items nearer the top of the list; just select the Sort option from the My Menu screen, then highlight any item on your list and press Func./Set. You will see a pair of up and down triangles appear at the right of the item's selection bar, indicating that you can now use the up and down direction buttons to move that item to a different position on the menu.

If you want to have the options on your My Menu list as readily available as possible, select My Menu Settings, and then select Set default view, the last option on that settings screen. Use the direction buttons to set this option to Yes; from then on, when you press the Menu button while in Recording mode, you will go immediately to the My Menu screen.

Finally, don't forget that you can use the Custom shooting mode to store a particular set of My Menu settings. So, if it's important to you to have a group of up to five menu settings within quick reach on this menu, but you sometimes use other settings for My Menu, you can quickly restore your favorite group of My Menu settings by saving it to the Custom mode, and you can then recall it just by turning the shooting mode dial to the C position.

Chapter 5: Other Controls

he PowerShot S95, like many very compact cameras, does not have a great many physical controls. It relies to a large extent on its system of menus to give you the ability to change settings. But the S95 is at the upper end of the scale of high-quality compact cameras, and one aspect of its quality is that it has more actual controls than many cameras of this size. More advanced photographers generally prefer to be able to make settings with a knob or a dial whenever possible, for speed of access. In this chapter, I'll discuss each of these controls and how they can be used to best advantage.

Mode Dial

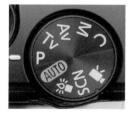

The mode dial, located at the right side of the camera's top, has just one function—to change the camera from one shooting mode to another. The shooting modes were discussed in Chapter 3.

Shutter Release Button

The shutter release button is the single most important control on the camera. When you press it halfway down in most shooting modes, the camera evaluates exposure and focus (unless you're using manual focus). Once you are satisfied with the settings, you press the button all the way down to take the picture. This button also starts and stops video recording. When the camera is set for continuous shooting, you hold this button down while the camera fires repeatedly.

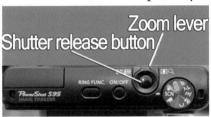

Zoom Lever

The zoom lever is a small ring with a short handle, surrounding the shutter button. Its primary function is to change the focal length of the lens between its wide-angle setting of 28mm and its telephoto setting of 105mm. If you have the camera set for digital zoom or digital tele-converter, the lever will take the zoom to higher levels, up to a maximum of 420mm with digital zoom. (As discussed earlier, that impressive-sounding zoom amount is illusory, because the image will be badly distorted by the electronic enlargement of the pixels.) If you have the step zoom feature turned on by assigning it to the control ring with the Ring Function button, you can zoom to a specific focal length with each click of the control ring: One click to the left zooms to 35mm, the next click to 50mm, then 85mm and finally 105mm, the limit of the optical zoom. Even if you are using the step zoom feature, though, you can still zoom to other intermediate settings using the zoom lever. You also use the zoom lever to reach higher focal lengths using the Digital

Zoom or Digital Tele-converter options.

In Playback mode, moving the zoom lever to the left produces index screens with increasing numbers of images, and moving the lever to the right enlarges your current image. These operations are discussed in Chapter 6. The zoom lever also is used to make adjustments to the settings in the Miniature Effect category of Scene mode.

Power Button

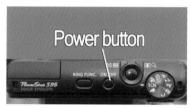

This button, located in the middle of the camera's top is useda to turn the camera on and off. If you press and hold the Func./ Set button while turning the camera on, the camera's built-in digital clock of rotating cubes will display. Press the Func./Set button again to cancel that display and proceed to Recording mode. Note that, once the lens is retracted in Playback mode, you can also turn the power off by pressing the Playback button.

Control Ring and Ring Function Button

I will discuss these two items together, because their functions are intertwined. The control ring is the very useful ridged circle of plastic that surrounds the lens. As I noted earlier, it is a sign of a more advanced camera to have physical controls that let you make adjustments without navigating through menus. This particular control is of great use, first, because it is large, so it is easy to find and turn by feel, and, second, because you have the option of assigning various functions to it, so it will

suit your particular needs as a photographer.

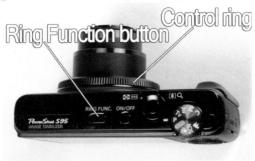

The ring function button, on top of the camera to the left of the power button, lets you select the function or functions assigned to the control ring. The functions available for the ring vary according to the shooting mode that is set on the mode dial. In addition, when you change the setting for the control ring, the setting for the control dial, on the back of the camera, will change as well in some cases.

In Auto, Movie, Low Light, and Scene mode settings (except for Nostalgic), the control ring is set to control the step zoom function, which lets you change the focal length of the lens in defined steps, rather than continuously. In the Nostalgic scene setting, the control ring is used to change the intensity of the Nostalgic effect's fading of the scene's colors.

In all of the other shooting modes (Program, Aperture Priority, Shutter Priority, and Manual), you can set the function of the control ring using the ring function button on top of the camera. There are 9 possible settings for the ring function button: Standard, ISO, Exposure Compensation, Manual Focus, white balance, step zoom, i-Contrast, Aspect Ratio, and Custom. These settings have somewhat different effects in different shooting modes; see the chart at page 102 of the Canon Camera User Guide for the complete list of those effects.

For example, with the ring function button set to its Standard

(STD) setting, in Program mode, the control ring controls ISO and the control dial controls exposure compensation. In Aperture Priority mode, however, the control ring controls the aperture and the control dial controls exposure compensation. In Shutter Priority mode, the control ring controls the shutter speed and the control dial controls exposure compensation. In Manual mode, the control ring controls aperture and the control dial controls shutter speed.

If you change the ring function button's setting to ISO, then, in the P,A,S,M modes, the control ring controls ISO. The control dial controls aperture, shutter speed, or exposure compensation, depending on what is controlled by the control ring.

If you change the ring function button's setting to its last possible value, C, for Custom, then you are presented with a screen that lets you choose which of the 9 available functions is assigned to the control ring for each of the four P,A,S,M shoot-

ing modes.

For example, you could set up the C value so that, when you select C from the ring function button's menu, the control ring controls manual focus in Manual mode, ISO in Aperture Priority mode, white balance in Shutter Priority mode, and step zoom in Program mode.

The control ring also has some subsidiary functions that are not set using the ring function button. For example, when you are fine-tuning white balance using the four color axes, you

can begin adjusting the colors along the blue and red axes by turning the control ring, without first pressing the DISP. button to get access to the adjustment screen.

The great thing about the control ring and its accompanying ring function button is that these controls give you many options for effectively setting up your own set of physical controls. In my case, I am very pleased to be able to adjust aperture with the control ring and shutter speed with the control dial when using Manual exposure mode, so I tend to leave the ring set at its Standard setting, but I'm also glad to have available the option of assigning different functions to the ring in other situations.

Lamp

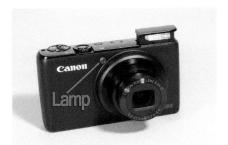

The small lamp on the front of the camera next to the control ring has numerous functions. Its reddish light blinks to signal the operation of the self-timer, smile detection, the wink self-timer, and the face self-timer. It also turns on in dark environments to assist with autofocusing, and it serves as the red-eye reduction lamp by lighting up to constrict your subject's pupils, thereby cutting down on the risk of red reflections of the flash burst from his or her retinas. You can control the use of the lamp for autofocusing and red-eye reduction through the Recording menu.

Shortcut Button

This button, marked with an S, has two distinct identities. As the Shortcut button, it lets you quickly call up any one function that you have assigned to the button using the Recording menu. I discussed all of the possible assignments for the button in Chapter 4. The button's alter ego is the Print button; a small printer icon is located below and to the left of the button. This function is

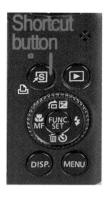

used when the camera is in Playback mode and you are printing images directly from the camera to a PictBridge-compatible printer, as discussed in Chapter 6.

Playback Button

This button, marked with a small blue triangle, is used to put the camera into Playback mode, which allows you to view your images on the LCD and lets you get access to the Playback menu. It also can be used in slightly different ways, depending on the context. For one thing, you can use this button instead of the power button to turn the camera on, placing it immedi-

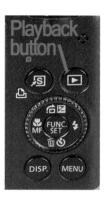

ately into Playback mode, with the lens retracted. Whenever the lens is retracted, either because you turned on the camera with the Playback button or because the camera entered Playback mode and the lens has therefore retracted automatically, pressing the Playback button will turn the camera off. If the lens is not retracted, pressing the Playback button will put the camera into Playback mode, and pressing it again will put it back into Recording mode. When the camera is in Playback mode, you can always press the shutter button down halfway to change into Recording mode.

Display Button

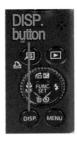

The button marked DISP, at the lower left of the camera's back, is used to switch among the various displays of information on the camera's LCD screen, in both Recording and Playback modes. As I discussed in Chapter 4, you can change the contents of the Recording mode screens to some extent using the Custom Display setting on the Recording menu.

The DISP. button is also used to switch to supplemental settings from some menu screens. For example, when you are setting white balance on the Function menu, you can press the DISP. button to get access to a supplemental screen for finetuning the white balance setting along four axes for color adjustments, and, when you are setting the image size through the Function menu to Large, Medium, or Small, you can press the DISP. button to get access to the setting for image quality to Fine or Normal. In addition, after pressing the top direction button to call up the exposure compensation scale, pressing the DISP. button will switch the camera into exposure bracketing. Similarly, after you press the left direction button to invoke manual focus mode, pressing the DISP. button will switch into focus bracketing.

You can also use the DISP. button to adjust the brightness of the LCD, as an alternative to using the LCD Brightness setting on the Setup menu. Just press and hold the DISP. button for more than one second, and the screen will increase to its maximum brightness. Press and hold it again to restore it to the prior brightness setting.

And, if you hold down the DISP. button while turning the camera on, you can disable the camera's normal operational sounds, so you can keep the camera quiet from the outset.

Menu Button

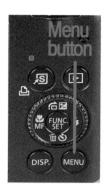

The Menu button, at the lower right of the camera's back, is quite straightforward in its basic function. Press it to enter the menu system, and press it once more to exit back to whatever mode the camera was in previously (Recording mode or Playback mode). The button also cancels out of sub-menus, taking you back to the main menu screen for items that have sub-options, such as Sound Options on the Setup menu. There are some other variations as well. For ex-

ample, if you want to get quick access to the Flash Settings sub-menu, press the Flash button (right direction button) and then quickly press the Menu button; this action takes you directly to the sub-menu for setting items such as Flash Mode, Shutter Sync., etc.

The Menu button takes on other functions in connection with some menu items. For example, when you use the Function menu to set ISO, you can press the Menu button to get to further settings, for Maximum ISO Speed and Rate of Change.

Control Dial and its Buttons

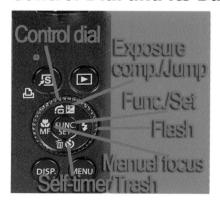

The main set of controls on the back of the camera is contained within the perimeter of the control dial, the ridged wheel that includes several icons in its interior. In the center of the wheel is the Func./Set button, which is a much-used control.

At the four direction-points of the wheel (up, down, left, and right), the wheel functions as a button. That is, if you press down on the wheel at any of those four points, you are, in effect, pressing a button. The function of each such button is indicated by one or more icons on that position. I will discuss each of these various controls in turn.

Control Dial

This wheel is one of the most versatile controls on the camera. In many cases, when you are able to choose a menu item or a setting, you can do so by turning this dial. In some cases, you have the choice of using this dial or pressing the direction buttons. One very helpful feature of the S95 is that it places a green icon on the screen representing the control dial when there is a value that can be adjusted at that point by the dial. For example, in the first image below, the icon, which looks like a green disk with holes around its perimeter, is positioned next to the value for exposure compensation. This indicates that you can turn the dial to adjust exposure compensation.

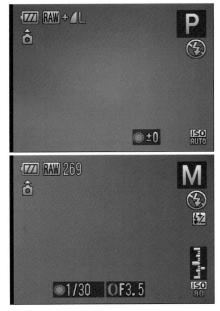

The next image shows the camera in Manual exposure mode, in which the icon for the control dial is next to the shutter speed, indicating that you can adjust the shutter speed by turning the control dial.

The control dial also has many other functions. When you are on a menu screen, you can navigate up and down through the lists of options by turning the dial. When you are adjusting items using the Function menu, you can navigate across the menu at the bottom of the screen with the dial. When you are using manual focus, the control dial is used to adjust the focus. In Movie mode, when you have locked exposure using the up direction button, you can then use the control dial to dial in exposure compensation on a scale, as discussed in Chapter 8.

Also, as noted earlier in the discussion of the control ring, when you use the ring function button to change the functions of the control ring, in some cases you automatically change the functions of the control dial. So, for example, if you want to use the control dial to adjust aperture instead of shutter speed in Manual exposure mode, use the ring function button to change the function of the control ring to Exposure Compensation, which causes the control ring to be used to adjust shutter speed and the control dial to be used to adjust aperture.

In Playback mode, the control dial is used to navigate from one image to the next on the LCD. If you turn the dial rapidly, the images scroll by in a format called Scroll Display, discussed in Chapter 6. (That option can be disabled through the menu system, as discussed in that chapter.) The dial is also used to jump ahead to specified groups of images, and to select images when using functions such as protecting, erasing, and marking images as favorites, all of which are discussed in Chapter 6.

Func./Set Button

This button serves many purposes. On menu screens that have additional options, such as the Flash Settings screen, this button is used to get to the next screen. It also serves as a selection or "set" button when you choose certain options. For example, after you press the left direction (MF) button and then navigate to your desired focus option, you press the Func./Set button to confirm your selection.

The Func./Set button is also used to get access to the Function menu. Press this button once, and that menu appears along the left and bottom edges of the screen. Then, after you navigate to the setting you want, you can select it or confirm by pressing this button to use its Set operation.

This versatile control also can produce one screen all on its own—the clock display, which shows the time through rotating cubes bearing digits for the hours, minutes, and seconds. You can summon this display by pressing and holding the Func./Set button. Press it again briefly to cancel the clock display. When the camera is powered off, you can bring up the clock display by holding the Func./Set button while pressing the power button to turn the camera on. If you rotate the camera to a vertical position while the clock is displayed, the year, month, and day are added to the information displayed.

Direction Buttons

Each of the four directions—top, bottom, left, and right—on the control dial is also a "button" that you can press to get access to a setting or operation. This is not immediately obvious, and sometimes it can be tricky to press in exactly the right spot, but these four direction buttons are very important to your control of the camera. You use them to navigate through menus and through screens for settings, whether moving left and right or up and down.

You also use them in Playback mode to move through your images and, when you have enlarged an image using the zoom

lever, to scroll around within the magnified image.

In addition to these navigational duties, the direction buttons are used for several miscellaneous functions in connection with various settings. For example, when you are using the Scene mode's Color Swap function, you use the left and right direction buttons to select the source and target colors for the swap. With the Color Accent operation, only the left direction button is needed, to select the single color to be left in the image while the rest of it is converted to black and white. Also, in order to lock exposure, you press the top direction button after pressing the shutter button halfway to evaluate the exposure.

Finally, each of the direction buttons has its own separate identity, as indicated by the one or two icons that appear on or near each of the buttons, as discussed below.

Top Button

Exposure Compensation/Filtered Playback/Histogram. When not acting as the top direction button, this control has two identities. In Recording mode, it serves as the exposure compensation button. As I discussed in Chapter 3, you press this button to bring up an EV scale on the screen, and then use the control dial to adjust the value. Or, depending on the settings for the control dial and control ring, you may be able to bypass this button and just use the control dial or the control ring to adjust exposure compensation.

Also, in Recording mode, you can use this button to lock the exposure setting that the camera has made, which is sometimes known as the AEL (auto exposure lock) function. You might want to do this if you want to make sure your exposure will be calibrated for a particular object that is part of a larger scene, such as a painting on a wall. You could move close to the painting, and lock the exposure while aiming the camera only at it, then move back to take the overall picture of the wall

with that locked exposure, ensuring that the painting will be properly exposed. To do this, while aiming just at the painting, press the shutter button down halfway until the aperture and shutter speed appear on the screen. Then, while still holding the shutter button in that position, press the top direction button. You will hear a beep, and an asterisk (*) will appear on the screen, indicating that exposure lock is in effect. Now you can move back (or anywhere else) and take your photograph using the exposure setting that you locked in.

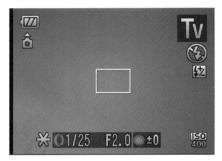

And, there is one more feature you can use at this point, called Program Shift, but only if the camera is set to Program mode. Once you have the exposure locked, you can turn the control dial on the back of the camera, and a pair of matched dials will appear, showing apertures on top and shutter speeds on the bottom. As you turn the control dial, you will see the two dials move together, and the green line they pass through will show matched pairs of values that are equivalent to the value that was originally locked in.

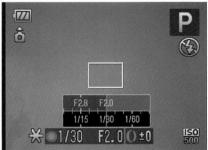

In other words, the camera lets you "shift" the original exposure to any of the matched pairs that appear as you turn the control dial while AEL is in effect. For example, if the original exposure was f/2.0 at 1/30 second, you will see equivalent pairs of f/2.2 at 1/25, f/2.5 at 1/20, and f/2.8 at 1/15, among others.

Why would you want to do this? You might want a slightly faster shutter speed to stop action better, or a wider aperture to blur the background more, or you might have some other creative reason. Of course, if you really are interested in setting a particular shutter speed or aperture, you probably are better off using Aperture Priority mode or Shutter Priority mode. However, having the Program Shift capability available is a good thing for a situation in which you're taking pictures quickly using Program mode, and you want a fast way to tweak the settings somewhat.

In Playback mode, pressing the top button operates the filtered playback control. As I'll discuss in Chapter 6, that option takes you to a screen that lets you choose one of several possible methods of selecting a filtered subset of your images to view—filtered by favorites, date, category, and other criteria.

Finally, this button has one other specialized function in Playback mode. When you are viewing images in the detailed information display, which shows a standard histogram, pressing the top button produces an additional RGB histogram, which breaks down the brightness values for each of the primary colors—red, green, and blue. This color histogram appears on the right side of the screen, in place of the detailed shooting information. Press the same button again to switch back to the information display.

Right Button: Flash Settings

When the camera is in Recording mode, pressing the right button brings up a small menu showing the options for setting the behavior of the flash unit. Depending on the shooting mode, these options may include autoflash, forced on, slow synchro, and forced off, or possibly just two or three of those. If you would prefer to go quickly to the full menu screen for Flash Settings, you can press this button and then quickly, within about a second, press the Menu button to call up the Flash Settings screen from the Recording menu.

One important point to note about the Flash button is that you have to use the button to bring the flash unit up into firing position, and to send it back down into the camera. With some cameras, there is a physical button to pop up the flash, and the flash unit can just be pushed back into place inside the camera. That is not the case with the PowerShot S95—you have to use the settings on the little menu that comes up when you press this button. Don't try to force the flash unit back down into the camera by pushing on it.

Bottom Button: Self-timer/Trash

In Recording mode, press this button to bring up a small set of icons for turning the self-timer on or off. Navigate with the direction buttons to select the on or off position for the self-timer, and then, if you've turned it on, use the control ring to set the number of seconds for the delay before it fires, and use the left and right direction buttons to set the number of shots to be taken when the self-timer triggers the shutter.

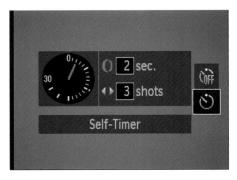

The self-timer is useful for occasions when you need to be the photographer and also appear in a group photograph, because you can set the S95 on a tripod, set the timer for 10 seconds or so, and possibly for

several shots, and then move around to place yourself in the group before the shutter clicks. The self-timer also is helpful in other situations, though, such as whenever you are taking a picture under conditions in which you don't want to cause blur by jiggling the camera as you press the shutter button. For example, when you're taking a macro shot very close to the subject, the focusing can be very critical, and any bump to the camera could throw off the focus. Using the self-timer means the camera has time to settle down after the shutter button is pressed, before the image is actually recorded.

Also, don't forget that the camera has several other potentially very useful timer functions, completely separate from the self-timer. Those features are included within the Smart Shutter setting of Scene mode, as discussed in Chapter 3: the Smile self-timer, the Wink self-timer, and the Face self-timer.

In Playback mode, when you are displaying a single image, pressing this button produces a message asking if you want to erase that picture; you can then select Cancel or Erase using the direction buttons or the control dial, and confirm the operation with the Func./Set button.

Left Button: Focus Options

This final button is labeled with the MF icon and an image of a tulip, representing macro (close-up) focusing mode. When you press this button in Recording mode, a string of the three icons for focusing modes appears near the top center of the screen. You can navigate among them using the control dial or the direction buttons, and either confirm your choice with the Func./Set button or just do nothing, and let the camera use the icon that you highlighted. The three choices are, left to right, macro autofocus, normal autofocus, and manual focus.

Indicator

It isn't really a "control," but the little light above and to the

left of the Shortcut button that Canon calls the "Indicator" is worth discussing because its information can be important to understand.

The light can glow steadily or blink, in either green or orange. If it blinks green, that means that image data is being sent to or from a memory card, or being transmitted by an Eye-Fi card. A steady green glow means either that the camera is ready to take pictures (that is, focus has been achieved) or that the display has been turned off, and the light is there to let you know that the camera is still powered on.

If the light blinks orange, that is a warning that camera shake could be a problem under the current conditions. That is, the camera has set a slow shutter speed, presumably because of dim lighting, and you should use a tripod or find some other firm support to avoid blurring of your images from a shaky camera. The blinking orange light does not mean that camera shake is actually taking place, only that it's a risk. A steady orange light means that the camera is ready to take pictures, when the flash is being used; that is, the flash has recycled and is ready to fire, and focus has been achieved.

Chapter 6: Playback and Printing

I f you're like me, you import the images you've shot into a computer, where you manipulate them with software, then post them on the web, print them out, e-mail them, or do whatever else the occasion calls for. In other words, I don't spend a lot of time viewing the pictures in the camera. But it's still useful to know how the various in-camera playback functions work. Depending on your needs, there may be plenty of times when you take a picture and then need to examine it closely in the camera. Also, the camera can serve as a viewing device like an iPod or other gadget that is designed, at least in part, for storing and viewing photos. So it's worth taking a good look at the various playback functions of the PowerShot S95. We'll also take a look at options for printing your images.

Normal Playback

Let's start with a brief rundown of basic playback techniques. First, you should be aware of your setting for the Review function, which is found on the Recording menu. This setting determines whether, and for how long, the image stays on the screen for review when you take a new picture. If your major concern with viewing images in the camera is to check them right after they are taken, this setting is all you need to be concerned with. As discussed in Chapter 4, you can leave Review turned off, set it to any time from 2 to 10 seconds, or set it to

hold the image on the screen until you press the shutter button halfway down to return the camera to Recording mode.

If you want to control how your images are viewed later on, though, you need to work with the settings that are available in Playback mode. For plain vanilla review of your images, the process is very simple. Just press the Playback button, marked by a blue triangle, to the right of the Shortcut button on the back of the camera. Once you press that button, the camera is in Playback mode, and you will see the most recent image saved to the memory card that is in the camera. To move back through older images, press the left direction button or turn the control dial (the dial on the back on the camera). (You can also move through images using the control ring, but that process works differently; I'll discuss it later in this chapter, in connection with the discussion of filtered playback and "jumping" through images.) To move back to the more recent images, use the right direction button or turn the control dial to the right. If you hold down either of these direction buttons to move through the images, you will move through them quite rapidly, but they will be displayed in a lower-resolution format, without appearing sharply focused as they speed by.

Index View and Enlarging Images

In normal Playback mode, you can press the zoom lever on top of the camera to view an index screen of your images or to enlarge a single image. When you are viewing an individual image, press the zoom lever once to the left, and you will see a screen showing four images, one of which is outlined by an orange frame. You can then press the Func./Set button to bring up the outlined image as the single image on the screen, or you can move through your images with the four-image index screen by pressing the left and right direction buttons or turning the control dial (on the back of the camera).

If you press the zoom lever to the left once more, the camera

will display an index screen of 9 images; another press brings 36 images; and a last press brings a 100-image index screen (assuming in each case that you have that many images; if not, there will be blank spaces on the screen). You can maneuver through any of these screens to select a single image for viewing. If you want to reduce the number of images per screen, just press the zoom lever to the right repeatedly to reverse the progression of index screens.

Once you are again viewing a single image, another press of the zoom lever to the right enlarges that image. You will then see a display in the lower right corner of the image showing an inset white block that represents the portion of the image that is now filling the screen in enlarged view.

If you press the zoom lever to the right repeatedly, the image will be enlarged up to maximum of about 10 times normal. While it is magnified, you can scroll around within it using the four direction buttons; you will see the inset white block move

around within the white rectangle that represents the whole image. To reduce the image size again, just press the zoom lever to the left as many times as necessary. To move to other images while the display is magnified, turn the control dial.

Scroll Display

If you use the control dial to move through your images, you will notice that, if you turn the dial rapidly, the display changes, so that the images become smaller and begin to flow in a fluid stream, similar to what happens on an iPod when viewing the images of album covers.

This feature is what Canon calls Scroll Display. It lets you move very quickly through your images, and it also places the date on the screen, along with a pair of up and down triangles, indicating that you can press the up or down direction button to move to another date and scroll through images from that date. If you press the Func./Set button while in the Scroll Display mode, the camera returns to the normal single-image display mode. You can disable the Scroll Display setting by turning it off in the Playback menu.

Different Playback Screens

When you are viewing an image in single-image display mode, pressing the DISP. button repeatedly cycles through the four different screens that are available: just the full image with no added information; the full image with basic information, in-

cluding date and time it was taken, image number, and image size and quality; a reduced-size image with detailed recording information, including aperture, shutter speed, ISO, recording mode, white balance, and other data, plus a histogram; and the focus check screen, which lets you examine the image closely to check for sharp focus. When the histogram screen is displayed, if you press the up direction button, the display switches to show a histogram that includes separate information for the red, green, and blue values in the image.

A histogram is a graph, or chart, representing the distribution of dark and bright areas in the image that is being displayed on the screen. The darkest blacks are represented by vertical bars on the left, and the brightest whites by vertical bars on the right, with continuous gradations in between.

If you have a histogram in which the chart of brightness values is clearly bunched towards the left of the scale, that means there is an excessive amount of black and dark areas (high points on the left side of the histogram), and very few bright and white areas (no high points on the right). The histogram of the image below illustrates this degree of underexposure.

A histogram with its high points bunched on the right side of the screen would mean just the opposite—too many bright and white areas, as in the image at the top of the next page.

A histogram that is "just right" would be one that has its high points arranged more evenly in the middle of the chart. That sort of pattern, as illustrated by the image below, indicates a good balance of whites, blacks, and medium tones.

The RGB histogram, shown below, which appears when the top direction button is pressed, includes the standard information for blacks and whites as well as similar information for the three basic colors, red, green, and blue.

The histogram is an approximation, and should not be relied

on too heavily. It may be useful to give you some feedback as to how evenly exposed your image is likely to be. Also, there may be instances in which it is appropriate to have a histogram skewed to the left or right, for intentionally "low-key" (dark) or "high-key" (brightly lit) scenes.

The focus check screen, as seen in the image below, is a special display that gives you an opportunity to examine an image very closely for sharp focus.

The screen presents the image in two windows. The large window at the upper left shows the whole image, and the camera places two or more rectangular frames in this window—a white frame where the focus was set, a gray frame on any face that was detected, and an orange frame that acts as an inset to outline the area that is shown enlarged in the other window on the lower right of the LCD.

If you then move the zoom lever to the right, the window on the right becomes active and assumes the larger size, displaying the area contained within the orange inset frame in the other window. You can now use the direction buttons to scroll around within the right-side window to check the focus in that area, while moving the inset area around so you can eventually check the entire image through this window. If you want to check the focus within a different inset rectangle, press the Func./Set button to change to another rectangle, and proceed in the same way to check focus. When you are done checking the focus, press the Menu button to return to the original

focus check display. Then press the shutter button halfway to return to shooting mode.

Filtered Playback and Jumping

If you have a lot of images saved on your memory card and would like to view them according to their dates, image numbers, or some other criteria, the PowerShot S95 has a function for doing so called "filtered playback" or "jumping" to a set of images. Here is how this works. When you are viewing images in Playback mode, press the DISP. button until you are viewing the image in any display other than the detailed information display, with the histogram. (If you're viewing that display, filtered playback does not work, because the top direction button, which you use to start filtered playback, has another function with that screen: It calls up the color histogram.)

Once you are viewing an image with the non-detailed display, press the top direction button. You will then see a line of icons along the left side of the screen, each one accompanied by a curved arrow. Those icons represent filters, or selection criteria, for choosing images to view. From the top, those icons represent Favorites, Shot Date, My Category, Still/Movie, a jump of 10 images, and a jump of 100 images. You scroll through this list using the up and down direction buttons and highlight the filtering choice you want.

If you chose Favorites, once you have highlighted one of these

selections, just start using the direction buttons to start viewing the images that are a match for the selected criteria. That is, if you press the right direction button or turn the control dial, the camera will display the first image that is marked as a Favorite. A number such as 1/7 will display in the upper right corner, indicating that that image is the first of 7 Favorite images. (Of course, if you haven't marked any images as Favorites, no images will be displayed.) You can then keep moving through all of the images marked as Favorites.

If you highlighted jump 10 or jump 100, press the right direction button to move 10 or 100 images forward (if there are enough images, of course). You can also move back 10 or 100 images by pressing the left direction button. If you use the control dial instead of the direction buttons, you can move through your images one at a time, in either direction.

If you highlighted Shot Date, the second icon down on the list at the left of the screen, then you need to press the left or right direction button to select a date for the images to be displayed. Once you press either direction button (assuming you have some images on multiple dates saved on the memory card), you will see a display of columns at the lower left of the screen.

The columns will vary in height from zero, shown as a dash, to taller bars, indicating the relative number of pictures for each date. As you press the direction buttons, different columns are highlighted by turning orange, and the date for that group of images appears below the columns. When you have highlight-

ed the column for the date you want, press the Func./Set button to choose that date. The camera then places a yellow frame around the first image from that date. You can then turn the control dial to move through all images from that date. As a shortcut to this process, you can just start turning the control dial once the date you want is displayed on the screen. In that case, the camera does not display the yellow frame.

If you selected the icon for My Category or Still/Movie, the process is the same as for Shot Date. You can use the direction buttons to select a filter (a category of images for My Category, or Still or Movie for Still/Movie), then press Func./Set to choose that filter and view the images with yellow frames around them, or just turn the control dial to view images matching the filter of the current image. (I will discuss the various categories and how they work later in this chapter.)

Once you have finished viewing your images using the filtered playback procedure, press the up direction button again, and the camera will announce that filtered playback settings have been cleared. Press the Func./Set button to clear that message and return to normal playback. (If you just used the control dial to view your images, and did not bring up the yellow frame around your images, then you need to press the Menu button to return to normal playback.)

There is one more way to jump ahead in your images—by using the control ring on the front of the camera, surrounding the lens. In single-image playback mode, turn the control ring and the camera will display a message showing a jump option along with up and down triangles, indicating that you can select a different jump option with the up and down direction buttons. For example, the camera may display the Jump 100 images message, and show that you can press the up and down buttons to switch to jumping by 10 image, by Favorites, or by shot date. (With the control ring, you can't select jumping by My Category or by Still/Movie.)

In this mode, if you have selected jumping by shot date, if you keep turning the control ring, you will move to different dates. You can then move through the images on a given date using the control dial or the left and right direction buttons. The images will not be filtered, so you will eventually move to images on other dates; you have just "jumped" to the selected date.

If you use the control ring to select jumping by Favorites or 10 or 100 images, you then need to keep turning the control ring to move through your images by the selected number of images, or to move through the Favorites. In this case, if you use the control dial or the direction buttons, you will move through your images one at a time, rather than jumping.

The Playback Menu

The other options that are available for playback on the Power-Shot S95 appear as items on the Playback menu. You get access to this menu by pressing the Menu button when the camera is in Playback mode. You enter Playback mode by pressing the playback button when the camera is turned on in Recording mode. Or, if the camera is turned off, you can turn it on in Playback mode by just pressing the playback button instead of the power button.

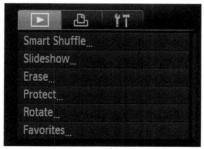

The following discussion covers each item that appears on the Playback menu.

Smart Shuffle

This option is really a novelty, probably best suited for entertaining your family and friends when you're viewing the images from your camera on a large-screen TV. When you select the Smart Shuffle option from the menu, the camera displays five images selected at random, one of which is in the center of the screen at a large size, and the other four of which are shown as small thumbnails at the four sides of the large one. You can then press any of the direction buttons to select which one of the small images to display in large size, and keep repeating the process as long as you want to. When you're done, press the Func./Set button or the Menu button to return to single-image view.

Slideshow

This feature lets you set your images to play back automatically in sequence, at an interval you specify and with transitions that you can choose. When you select this menu item, the next screen has three options that you can set: Repeat, Play Time,

and Effect.

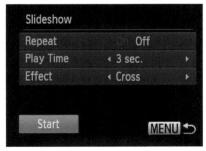

Repeat can be set either on or off. If it is turned on, the show will keep repeating; otherwise it will play only once. Play Time, which controls how long each image stays on the screen, can be set to any interval from 3 to 10 seconds; 15 seconds; or 30 seconds. The Effect setting lets you choose what transition, if any, marks the change from one image to the next. If you turn effects off, then each image just "cuts" to the next. The other possibilities are Fade, Bubble, Cross, Letterbox, Scroll, and

Slide. (If you choose Bubble, which "floats" the images across the screen in circle shapes, you cannot set the playing time.)

Once the options are set, navigate to the Start box at the bottom of the screen using the control dial or the direction buttons, and then press the Func./Set button to start the show. You can pause and restart the show with the Func./Set button, and move forward or back through the images with the left and right direction buttons. Hold those buttons down to fast-forward or fast-reverse through the images. You stop the show by pressing the Menu button.

There is one other way to start a slideshow, without having to go into the menu system at all. Press and hold down the Func./Set button, and, while holding it down, press the Shortcut button. The show will start quickly, using the last settings that were made in the menu system.

Here's an important note for setting up slideshows. There is no setting in the Slideshow menu option for selecting what images to include in the show. If you want to show only certain images, you have to select them first, and then set them to play back using filtered playback. Once you have the filtered playback setting in effect, then you can go to the Slideshow menu and set up your show; only the images in the filtered playback set will be displayed in the slideshow. So, for example, you can set up a show with only your images marked as Favorites, or only images from a certain date or from a certain category. You can set up three user-defined categories, as discussed later in this chapter, and you could use one of those categories to select the images for your slideshow if you wanted. (Or, you could set up all three categories for images to be seen in three different slideshows.) When you are done with the slideshow, don't forget to clear the filtered playback setting by pressing the top direction button.

Erase

The erase command is available for you to use when you want to delete multiple images from your memory card in one operation. (If you just want to delete a few images, it's easier just to display each image on the screen, then press the Trash button and confirm the erasure.) When you select the Erase command, the menu offers you the choices of Select, Select Range, and All Images. If you choose Select, the camera displays an image, along with a trash can icon, an empty black box, and a zero in the upper left corner.

If you want that image to be erased, press the Func./Set button. An orange check mark will appear in the black box, and the number 1 will appear in place of the zero, indicating that there is now 1 image to be erased. You can then scroll through your remaining images, marking those that you want to be erased. If you change your mind about any images, you can press the Func./Set button again to remove the check mark. When you are finished marking images, press the Menu button, and the camera will take you to a screen asking you to confirm the operation. Here, you can highlight the OK block and press Func./ Set to confirm, or highlight Stop to abort the operation.

If you choose Select Range, the camera gives you a screen with blocks for two small images and a white dash in between the blocks. You need to select a range of images to be erased, based on their image numbers. The first block will be filled with an image. Press the Func./Set button while that first block is highlighted, and then scroll through your images until you find the

first image in the range to be erased. The words "First image" will appear in the upper left of the screen as you scroll. When you find the first image to be erased, press the Func./Set button while it is displayed. The camera will then take you back to the selection screen with two blocks, with that image now filled in as the first image in the range to be erased. Now you need to use the right direction button to move to the second block, and press Func./Set to activate the selection process for the last image in the range to be erased. Then scroll through your images until you find that image. Note that the last image has to have a higher image number than the first one, or you will get an error message. Of course, it's also important to note that this process will delete all images in the selected range, including the first one, the last one, and all of those in between. So, be certain that all of those images are ones you want to erase.

Once you have pressed Func./Set to select the last image to be erased, the camera will fill the second block with that image. At that point, you can highlight the Erase block on the screen and press Func./Set to confirm, or you can press the Menu button to cancel and return to the menu screen.

Finally, you can select All Images from the Erase menu. If you make this choice, on the next screen you will see a message asking you to confirm the operation, and letting you cancel if you have changed your mind. If you highlight and confirm with the OK selection, all images on the card will be erased except any that have been protected using the Protect function, discussed below.

Protect

With the Protect feature, you can "lock" selected images so they cannot be erased with the normal erase functions, including using the Trash button and using the Erase option on the Playback menu, discussed above. However, if you format

the memory card using the Format command, all data will be erased, including Protected images.

To protect images using this menu option, the procedure is the same as for erasing images, discussed above. You have the same three options of selecting images individually, selecting a range, or selecting all images, before confirming the protect operation. Any image that is protected will have a key icon in the lower left corner, which will be visible when the image is viewed with the detailed information screen or the basic information screen; the icon will not appear in the image-only view or in the focus-check view.

Rotate

With the Rotate option, you can rotate any image in 90-degree increments, and save that new orientation with the image. Once you have selected Rotate from the Playback menu, you will see a screen showing an image with the word "Rotate" in the upper left corner. Scroll through your images using the direction buttons or the control dial until you find the first image you want to rotate. When that image is displayed, press the Func./Set button. The image will rotate 90 degrees clockwise each time you press that button. When the image is in the position you want to leave it in, you can continue scrolling through images to find others to rotate. When you have finished rotating images, press the Menu button to return to the menu screen. The images that you rotated will remain in their rotated orientations, unless you use the Rotate command again to change their orientation.

Favorites

The Favorites menu item lets you mark any or all of your images, up to a maximum of 500, as Favorites. Once they are marked, you can use the filtered playback or jump option, or view them in a slideshow. This menu option does not provide procedures for selecting a range of images or selecting all im-

ages; you have to scroll through your images individually and mark those that you want to classify as Favorites by pressing the Func./Set button for each chosen image.

My Category

The My Category menu option provides you with a powerful way to tag any or all of your images with one or more categories. Once the images are categorized in this way, you can use those groupings in several ways. You can view the images from any category using the filtered playback or jump option; you can view a slideshow of images from any category; and you can select images to erase or protect based on a category.

There are a few points you need to know about categories in general before I discuss the procedure for assigning images to categories. First, the camera automatically places some images into categories that are set up without your input. Those categories are the following.

People

All images that include faces detected by the camera and that were shot in Portrait or Kids & Pets modes. The icon for this category is a pair of faces.

Scenery

All images that are detected by the camera in Auto shooting mode as sunsets, dark landscapes, or dark scenes with people in them (see page 179 of the Canon user's manual), as well as all scenes shot in Landscape or Foliage mode. The icon for this category is a scene of mountains with clouds above.

Events

All images shot in Beach, Underwater, Snow, or Fireworks mode. The icon for this category is a tennis racket with a ball.

The other categories, which are left for you to assign to images if you choose to, are called Category 1, Category 2, Category 3, and To Do. The icon for each of the three numbered categories is what looks like a three-leaf clover with a number 1, 2, or 3 inside it. The icon for the To Do category looks like a list of items with check marks on it.

Second, you can remove any image from a category even if the camera assigned it to that category, and you can assign any image to any category, including those that are automatically assigned.

Here is how to use this feature. When you select My Category from the Playback menu, the camera shows you a screen with two options: Select and Select Range. These options work in the same way as the similar options for Erase and Protect, discussed above. If you choose the Select option, the camera proceeds to display an image, with the words My Category at the upper left and the icons for the various categories displayed on the left of the image. There is a triangle at the bottom of the list of icons, indicating that you will have to press the down direction button to scroll through the complete list of icons. If the camera has automatically assigned the image to any category, you will see a check mark beside the icon for that category. You can now scroll down through the list of icons and clear any check mark from an icon, or add a check mark for an icon, using the Func./Set button. When you are done with that image, you can continue scrolling through your other images with the direction buttons or the control dial and assigning or unassigning categories for each image. When you are done, press

the Menu button to return to the menu screen.

Once images are assigned to categories, you can take advantage of those assignments whenever you need to deal with a particular group of images. For example, if you have just finished taking pictures of a valuable collection of antiques and you want to protect those images from accidental erasure, you can use the My Category menu option to assign each of those images to a category, such as Category 1. (You could use any category for this purpose, even one such as Scenery or Events, but it might make more sense in this case to use a generic one like Category 1.) Then, use the filtered playback procedure by pressing the up direction button and filtering by Category 1. Next, while the filtering is in effect (with the yellow frame surrounding each image), select Protect from the Playback menu, and from the sub-options, select All Filtered Images. When you have finished, all of your photos of the antique collection will have the key icon, indicating their protected status.

Part of the power of the My Category feature is that you can assign images to multiple categories. Therefore, you can establish various sets of images that overlap each other. For example, if you want to set up one slideshow for your close relatives that includes all of your photos from a vacation trip, and another slideshow for your co-workers that includes only some of the more scenic photos from that trip, you can assign all of the trip photos to, say, Category 1, and then assign just the more scenic trip photos to Category 2. Some images will be assigned to both categories, but you can select one category or the other for a given slideshow, and only the images from that category will be shown.

i-Contrast

This feature gives you a way to apply some post-processing to your images in the camera, to correct situations in which an image is too dark or lacking in contrast. To use this process, select i-Contrast from the Playback menu. At this point, the camera will display the term "i-Contrast" in the upper left corner of the screen. Scroll through your images until you find one that seems as if it would benefit from this sort of processing, and press the Func./Set button while that image is displayed. You will then see the same screen, except that the bottom line of the screen will display the word Auto, Low, Medium, or High at the left. You can then use the control dial or the left and right direction buttons to select one of those settings. When your desired setting is highlighted, press the Func./Set button to confirm and apply the processing. The camera will then prompt you to save the new image by highlighting and selecting OK, or to cancel. If you select OK, the camera will process the adjustments to the highlights and contrast, and save the image with a new file name, so the original image is not overwritten or deleted. When you are done applying i-Contrast processing to your images, press the Menu button and the camera will ask if you want to have the new image displayed. If you say yes, the camera will display the adjusted version of the last image that you applied changes to. You can then scroll back to any earlier images you corrected with this feature.

Note that you can also use this feature when recording photos, as discussed in Chapter 4. Also, of course, you can apply post-processing of this sort using software such as Photoshop and Photoshop Elements. Note also that you cannot use this feature to adjust RAW format photos.

Red-Eye Correction

This option, like i-Contrast, discussed above, lets you apply editing in the camera to fix a specific type of problem—in this case, the redness in human eyes that comes from the flash reflecting off people's retinas. There are no sub-options to be selected. Just highlight and select this menu item, and the camera displays the first image. You can then scroll through your images until you find the first one you want to apply cor-

rection to. When that image is displayed, press the Func./Set button, and the camera will attempt to apply correction. If it does not find what it considers to be correctable red-eye areas, it will show an error message, saying the image cannot be modified. The camera will also display a similar error message for any RAW image, because this sort of correction cannot be applied to RAW files. If the camera does find and correct red-eye, it will then place a frame around the corrected area, and ask if you want to save a new file or overwrite the existing one. I don't recommend ever overwriting your original file, because it cannot later be restored. In fact, I don't recommend using the red-eye correction feature at all, because such corrections can be better accomplished in post-processing software, including the software that comes with the PowerShot S95.

As was discussed in Chapter 4, this feature also is available from the Flash Settings screen of the Recording menu, for applying correction as you are taking your pictures.

Trimming

The Trimming option allows you to perform a certain amount of cropping of your images in the camera. Here is the procedure. Select Trimming from the Playback menu, and the camera displays the first available image, with the word Trimming at the upper left. Scroll through your images using the control dial or the direction buttons until you find an image you want to trim. Press the Func./Set button, and the camera puts two yellow frames on the screen.

The frame on the upper left shows the area of the original image that will remain after trimming. You can change the size of that frame using the zoom lever on top of the camera, and you can move the frame around within the original image with the four direction buttons. You can change the frame to a vertical orientation by pressing the DISP. button. The larger yellow frame on the right contains the enlarged view of the image as it will look after the trimming. When you are satisfied with how the trimming frame is arranged, press Func./Set to carry out the operation. The camera will then prompt you to save the new image or cancel. If you confirm the trim, the camera will save the new image. You can then move on to trim other images if you want to. When you are done, press the Menu button. The camera will then ask if you want to display the last new image that was trimmed.

This option will not work on RAW images or images that are already at the smallest sizes. The new images that result from trimming will have lost resolution, because the trimming reduces the number of pixels in an image. I personally tdo not use this feature, and I recommend you steer clear of it unless you have some sort of emergency that requires its use, such as a need to present a slide show when you don't have access to a computer to do proper editing. But the Trimming function can provide a rough-and-ready sort of editing if nothing else is available.

Resize

This feature lets you save a copy of an image in a smaller size. It does not alter the appearance of the image; it just saves it in a smaller size, which may be more convenient to send as an attachment to an e-mail message or to store on a cellular phone, for example. To do this, select the Resize option from the Playback menu, then scroll to find the image to resize. When that image is displayed, press Func./Set, and, depending on the size of the original image, the camera gives you up to three options

at the lower left of the screen: M2, S, and XS. Select the size you want to resize the image to by turning the control dial or pressing the left and right direction buttons, and then press Func./Set to confirm. As with other features discussed above, you can then move on to other images, or press Menu to end the Resize operations. At that point the camera will ask you if you want to display the last new image that was saved.

This option does not work with RAW files or with files that have already been saved to the XS size using this operation.

My Colors

In Chapter 4, I discussed the use of the My Colors option on the Function menu, which lets you apply a broad range of color effects to your images as you record them. The My Colors option on the Playback menu lets you apply those same effects to your images after the fact, in the camera, rather than applying them as the images are recorded. To use this function, select it from the Playback menu, then scroll to an image you want to apply one of the My Colors effects to. When your chosen image is displayed, press the Func./Set button, and the camera will display a line of the My Colors icons along the bottom of the screen. Scroll through those icons for the various color settings using the control dial or the left and right direction buttons. As you move from one icon to another, the displayed image will change to reflect the use of the setting represented by that icon. When you have highlighted the icon you wish to select, press Func./Set again to apply it. The camera will ask you if you want to save the new image with that color setting; select OK to proceed or Cancel to abort. You can then move through other images to carry out the same process; press Menu when you are finished with all images, and the camera will ask if you wish to display the last changed image.

I ordinarily don't like to use this sort of post-processing function in the camera. However, I do like the My Colors process for one purpose. If you are taking photographs in a particular situation and you have the time to experiment a bit, you can take one image without any My Colors settings, then display it on the screen, and call up the My Colors feature in Playback mode. At that point, as discussed above, you can scroll through the various My Colors settings, and instantly see how the image would be altered with each of those settings. Then you can go back and take some new pictures using the My Colors settings that you tested in Playback mode. This feature works only with JPEG images, not RAW files.

Scroll Display

I have mentioned this feature a couple of times previously. When you are scrolling through your recorded images using the control dial, if you start scrolling rapidly, the images will shrink in size and start to flow in a stream. In addition, the camera will show the date of the images below the central image, along with two triangles, so you can switch to images from a different date by pressing the up or down direction button. If you find this display distracting, you can disable it with this menu option. Just set this option to off, and no matter how fast you turn the control dial, the images will stay at their full size and scroll in the normal fashion.

Resume

This option has two possible settings: Last seen and Last shot. If you set it to Last seen, then, whenever you enter Playback mode, the camera will display the last image that you viewed on the screen. If you choose Last shot, then the camera will first display the last image that was recorded with the camera.

Transition

This menu option lets you set what sort of transition is used between images when they are displayed on the LCD screen in single-image playback. The choices are Off, which means they will just "cut" from one to the next; Fade; Scroll; and Slide.

Note that this transition setting is different from the setting for slideshows, which is set independently through the Slideshow option, discussed above.

Printing Images from the Camera

There is a lot of variation among photographers with respect to how often they print their photographs on a printer. Some people are content to view their images on the camera's screen; many save them to a computer and share them on sites such as Flickr and Facebook; others send them to friends by e-mail.

If you want to produce copies of digital photographs on paper, there are various ways to do so. You can import the images into a program such as Adobe Photoshop or Photoshop Elements, or use the software supplied by Canon with the S95, or any of many other programs that are available for photo editing. Once you have edited the images to your satisfaction, you can print the finished products from that software.

However, in some cases you may not want to spend the time to edit the pictures in software before printing them. You may have access to a printer that will connect directly to the camera, and you may prefer to print out copies on photo paper without going through the time-consuming process of transferring the images to a computer first. Or, you may want to try a service that will take your memory card and produce high-quality prints directly from that card. The following discussion covers the high points of these procedures.

Printing Directly from the Camera

The PowerShot S95 uses the PictBridge printing protocol, which lets it communicate directly with a wide variety of printers. The basic procedure is quite simple: Just plug the gray USB cable that came with the camera into the mini-USB port inside the door on the right side of the camera. (This is the lower

of the two ports in that location.) Then plug the other end of the cable into the USB port of a PictBridge-compatible printer. (This USB port is different from the one for the cable that connects the printer to a computer: This one is rectangular; the port for the cable to the computer has more of a square shape.) The printer does not have to be made by Canon; I plugged the S95 directly into my HP Photosmart C6180 printer, and the two devices communicated with no problems.

Once the connection is made, press the Playback button on the camera to display images, and use the various techniques discussed earlier in this chapter to display the image you would like to print. The camera will display a special screen that appears only when it's connected to a PictBridge printer, giving you various options for selecting landscape or portrait orientation, paper size, number of copies, and other options. For complete details about these settings, see Canon's Personal Printing Guide, which is available for download in PDF format from http://www.usa.canon.com/cusa/support/consumer.

Once you have all the settings as you want them, press the Func./Set button on the camera to print out the photograph. If you want to select multiple images before sending them to the printer, use the DPOF (Digital Print Order Format) function, which is built into the camera. That system lets you mark images on your memory card to be added to a print list, which can then be sent to your own printer. Or, you can take the memory card to a print shop to print out the selected images.

There are two ways to add images to the DPOF print list. First, when you are displaying an image on the camera's screen, press the Shortcut button on the back of the camera, which is also the Print button; a printer icon appears below and to the left of the button. Press this button whenever an image you want to add to the print list is displayed. (You cannot select RAW images or movies.) The camera will display the message, "Add to Print List?" If you want to print more than one copy

of that image, use the up direction button to change the number appearing in a box in the lower right corner of the image. When the number is correct, highlight the Add block and press Func./Set. You can then keep browsing through your images and adding (or subtracting) them from the print list.

The Print Menu

When you have finished selecting images to be printed, press the Menu button and highlight the tab for the Print menu, headed by a printer icon.

You can then set several options for printing, including Standard or Index (that is, whether to print whole-page images or indexed thumbnails), whether to print the date, and others.

In the alternative, you can start the DPOF process of specifying images to be printed from the Print menu, using the Select Images & Quantity item near the top of the menu screen.

Once you have added all of the chosen images to the print list and set the settings as you want them, you can either connect the camera to a PictBridge-compatible printer and print them out by selecting Print from the top of the Print menu, or take the memory card to a photo store or printer who can handle this process, and have the photos printed there.

Chapter 7: Setup Menu

In previous chapters I discussed the options available to you in the Recording, Function, Playback, and Print menu systems. The last system to discuss is the Setup menu. (I'll discuss menu options for Movie mode in Chapter 8.)

The Setup menu gives you various choices for housekeeping matters like screen brightness and operational sounds. As a reminder, you enter the menu system by pressing the Menu button. The available menus change depending on whether the camera is set to Recording mode or Playback mode. However, no matter what other options are available, you can always enter into the Setup menu. After pressing the Menu button, use the direction buttons to select the wrench and mallet icon.

Once that icon is highlighted, use the control dial or the up and down direction buttons to navigate through the various options on the menu. I'll discuss those choices in turn.

Mute

This first option on the menu is a quick way to silence the beeps and chirps that sound off when the camera performs actions such as turning on, achieving focus and exposure, having a control button pressed, or having the shutter pressed to take a picture. When you turn the Mute option on, the camera becomes very silent; there is a faint click when the shutter is pressed to take a picture. There still will be some mechanical sounds, like a soft whirring when the flash pops up or down, or a slight clicking when the flash is fired, but no sounds of any magnitude. So, the Mute feature is useful when you want to take pictures without attracting attention, such as for candid photography or photography in a museum or other quiet area.

What if you suddenly find yourself in a place where you need to be quiet, but haven't yet activated the Mute option? You can keep the camera completely silent in that situation by holding down the DISP. button while turning the camera's power on. (If the camera was already on, you can turn it off first; it does not make any electronic sounds when turning off.)

Volume

This option is grayed out when Mute is turned on. If Mute is not on, then you can use the Volume menu item to adjust the loudness of camera sounds on a scale of 1 to 5, with 1 being quiet and 5 being loud. The four categories that can be adjusted are Start-up Volume, Operation Volume (beeps that accompany presses of controls), Self-timer Volume, and Shut-

ter Volume.

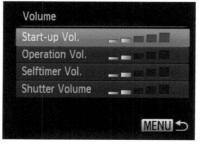

Sound Options

With this item, you can choose the electronic sounds that the camera uses in the four categories discussed above, under Volume. You can choose among a variety of clicks, beeps, and chirps; as you move the highlight from one numbered option to another, you will hear a sample of the chosen sound, so you can customize the audio experience in using the camera.

Hints & Tips

This option can be turned either on or off. When it is turned on, the camera uses one line at the bottom of each menu screen for a brief statement about the function of the menu item that is currently highlighted by the selection bar. For example, when the orange bar rests on the Sound Options menu line, the Hints & Tips area at the bottom of the screen says "Sets various camera sounds." For some menu items it takes two lines to fit all of the words in the tip; in those cases, the camera displays one line at a time, and scrolls from one to the next. For all items, the hint disappears after displaying for about 10 or 15 seconds. If you want to see the hint again, you have to move the highlight bar off the item and then back on again.

LCD Brightness

This menu item lets you adjust the brightness of the LCD display. When you select this option, you can set the brightness at any level from 1 (dimmest) to 5 (brightest). The standard setting is 3. If you can manage with the dimmer settings, you can save some battery power by turning down the brightness. You may need to use the brightest setting when you are shooting outdoors in sunlight.

If you need to increase the brightness of the screen temporarily without having to use the menu, you can press and hold the DISP. button for more than one second; that will boost the screen to its brightest level (if it wasn't already set there). You can reverse this operation by pressing and holding the DISP.

button one more time. The increased brightness setting will last only until the camera is powered off.

Start-up Image

When the camera comes from the factory, the image it shows as it turns on is a multi-colored picture of a blurry globe, with the PowerShot S95 logo superimposed over it. This menu option gives you a way to change the start-up image to either of two standard ones provided by Canon, to one of your own images, or to no image at all.

To use one of your own images, the image must be on the memory card that is in the camera. Set the camera to Playback mode, and then select the Start-up Image option from the Setup menu. On the Start-up Image menu screen, select image number 3, and then navigate through the images on your memory card; the words "Start-up Image" will appear at the upper left of the screen during this process. When you find the image you want, press the Func./Set button to select it. That image will then appear every time you start up the camera, unless you change it again using the same process.

Format

This is one of the more important menu options. Choose this process only when you want or need to completely wipe all of the data from a memory storage card. When you select the Format option, the camera will ask you to confirm that you want to format the memory card. If you reply by selecting OK, it will proceed to do so, and the result will be a card that is empty of images and is properly formatted to store new images from the camera. With this procedure, the camera will erase all images, including those that have been protected from accidental erasure with the Protect function on the Playback menu. It's a good idea to save your good images and videos to your computer or other storage device and then reformat your memory card from time to time, to make sure it is

properly set up to start recording new images and videos. You should certainly format any new memory card before using it in the camera, and some photographers format their card after transferring the images from it to a computer.

File Numbering

This option gives you control over the way in which the camera assigns numbers to your images and videos. There are two choices: Continuous and Auto Reset. If you choose Continuous, then the camera continues numbering where it left off, even if you put a new memory card in the camera. For example, if you have shot 112 images on your first memory card, the last image likely will be numbered 100-0112, for the folder number (100, the first folder number available), and 0112 for the image number. If you then switch to a brand new memory card with no images on it, the first image on that card will be numbered 100-0113, because the numbering scheme continues in the same sequence. If you choose Auto Reset instead, the first image on the new card will be numbered 100-0001, because the camera resets the numbering back to the first number. Each folder can hold up to 2,000 images, and the camera can number the images up to 9,999. It's important to note that the Auto Reset function may not work properly if the new card you use already contains images, and is not newly formatted before being placed in the camera. With Auto Reset, the image numbers will also reset if you create a new folder, as discussed below.

Create Folder

With this option, you can choose how often the camera creates new folders for storing your images and videos—daily or monthly. Which one works best for you may depend on how often you shoot, and how many images you shoot at a time. If you shoot large numbers of images at a time, you may want to choose the Daily option, so you will have a separately numbered folder for each shooting date. If you take photos only

occasionally, the Monthly choice may make more sense. Of course, if you are in the habit of saving your new images to your computer and organizing them using software such as Canon's ImageBrowser or Adobe Photoshop Lightroom, you don't need to worry too much about how the image folders are numbered on the camera.

Lens Retract

This menu option gives you control over the behavior of the lens-retraction mechanism. With the normal setting, when you switch the camera from Recording mode into Playback mode, the lens will retract after about one minute, on the theory that you aren't using the lens, and it might as well be pulled back inside the camera's housing for protection if you don't need it at the moment. If you want, you can change this setting to 0 seconds, so the lens retracts immediately when you change into Playback mode.

Power Saving

With the settings available through this menu item, you can control whether the camera will stay powered up or will turn itself off if you don't touch the controls for a period of time, and you can specify how long the camera will sit idle before the display blanks out to save power. These functions are controlled by two sub-options of the Power Saving item on the Setup menu: Auto Power Down and Display Off, which work independently of each other. They work somewhat differently in Recording mode and Playback mode.

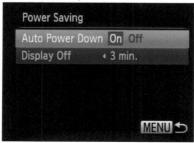

When the camera is in Recording mode, if you leave Auto Power Down turned on, the camera will turn itself completely off after about 3 minutes of inactivity, regardless of the setting for the Display Off option. You have no control over the 3-minute time; this option can be set only on or off. You can set the Display Off option to 10 seconds, 20 seconds, 30 seconds, or 1, 2, or 3 minutes. You cannot turn this option off.

Whenever the display goes blank, you can restore it by pressing the shutter button halfway. However, once the camera has powered down, you have to turn it back on to resume your operations; you can't revive the camera just by pressing the shutter button or some other control.

When the camera is in Playback mode, the Display Off option has no effect. However, the camera will turn itself off after about 5 minutes of inactivity, if the Auto Power Down option is turned on in the menu. If that option is turned off, the camera will stay powered on as long as the battery holds its charge, just as it will in Recording mode. (Of course, if you're using an AC adapter, it will stay powered on indefinitely if that option is turned off. However, even with an AC adapter plugged in, the Auto Power Down option will shut down the camera after the prescribed time if that option is turned on.)

It may be convenient at times to turn the Auto Power Down option off, but you then run the risk of running the battery all the way down fairly quickly, if you forget to turn the power off when you're done using the camera. So, it may be a good idea to leave Auto Power Down turned on, and to just remember to press a control button every couple of minutes if you want the camera to stay powered up for the time being.

Time Zone

This menu option lets you set two time zones, labeled Home and World, so you can switch back and forth between them

if you travel, and thereby keep your camera's date and time settings accurate for local conditions. To use this feature, select the Time Zone option on the Setup menu, and then select Home on the next screen by pressing Func./Set. On the next screen, use the left and right direction buttons or the control dial to move the yellow highlight through the world map until your home time zone is highlighted and its name appears in the lower left of the screen. Then press Func./Set to accept that setting, and repeat this operation for the World time zone. Once those two time zones are set, and the date and time are set accurately for the local time zone, whenever you travel you can just use the Time Zone screen to select either Home or World, depending on your present location. Any photographs you take using those settings will include accurate date and time information in the image files.

Date/Time

Here is where you set the current date and time, which will be recorded with your images in data that can be read by your Canon software and by many other programs, such as Adobe Photoshop and Photoshop Elements. (The date and time will not appear on the images unless you take further steps to make that happen, either by using the Date Stamp function from the Recording menu or by selecting that option when printing from the camera.) To set the date and time from this menu item, adjust each highlighted value by using the control dial or the up and down direction buttons, then move to the next item using the right direction button. The last item on the right is the setting for Daylight Savings Time. If you set that block to ON, the time will move one hour later. When you have adjusted all items to the correct values, press the Func./ Set button to save them.

Distance Units

This option gives you the choice of meters and centimeters or feet and inches for the units of distance used by the camera. The only time these units are displayed is when you are using manual focus, and even then, the measurements shown on the camera's display are not all that precise, so this setting is not especially critical. However, it may be nice to use units you are familiar with, so this setting is available to use if you wish.

Video System

This item gives you the option of selecting the appropriate system for the television to which you are connecting the camera by means of the audio-visual cable. There are only two options available: NTSC and PAL. NTSC is the system used in the United States, Canada, most of South America, South Korea, Japan, Taiwan, and some other countries; PAL is used in Europe and most other areas. A third standard, SECAM, used in some countries, is not available on the PowerShot S95.

CTRL via HDMI

This setting is of use only when you have connected the camera to an HD (high-definition) TV set, and you want to control the camera with the TV's remote control, which is possible in some situations. If you want to do that, set this option to Enable, and follow the instructions for the TV and its remote control. Saee the list of items that can be controlled at pages 130-131 of the Canon Camera User Guide.

Eye-Fi Settings

This menu option does not appear at all unless you have an Eye-Fi card installed in the PowerShot S95. As I discussed in Chapter 1, an Eye-Fi card is a special type of SD memory card that contains a built-in transmitter that can transfer images from the card directly to your computer over a wireless (Wi-Fi) network. Ordinarily, you should not need to change the settings on the menu.

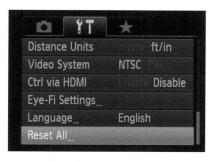

The first sub-option for this item is Eye-Fi transmission Enable/Disable. You may be able to save some battery power if you have an Eye-Fi card installed in the camera but don't currently need to transmit images to a computer. According to Canon's user's manual, using this option to disable the card is not sufficient to comply with warnings against using transmission devices, such as on airplanes in flight or in hospitals; you may have to remove the card from the camera in those situations.

The second menu sub-option, Connection Info, reports details about the Eye-Fi card's current connection to a wireless network, if any. For example, this menu item may report the name of your network and a message such as "Transferring" or "Connected." This information may help you diagnose a problem with the functioning of your Eye-Fi card.

Language

This option gives you the choice of language for the display of commands and information on the camera's LCD screen. Once you have selected this menu item, scroll through the numerous language choices using the control dial or the direction buttons and press the Func./Set button when your chosen language is highlighted.

If you prefer a quicker route to the Language option, you can press the Playback button, then press the Menu button while

holding down the Func./Set button, to take you directly to the Language screen.

Reset All

Choose this menu option when you want to reset all of the camera's settings back to their original (default) values. This action can be useful if you have been playing around with different settings, and you find that something is not working as expected. It will give you a fresh start with known values for all of the major settings on the menus and for shooting. There are a few settings that will not be reset, including items such as date and time, time zone, language, video system, and the scene type chosen in Scene mode. The complete list is at Page 50 of the Canon Camera User Guide. Also, although this item is not listed in the user's manual, it appears that the Reset All option does not wipe out the settings you saved to the C slot on the mode dial.

Chapter 8: Motion Pictures

owadays it seems that it's a necessity for any advanced compact digital or DSLR camera to include movie-making capabilities. Most recently, it's become standard practice for camera manufacturers to incorporate high-definition (HD) video recording into their premium cameras, and the PowerShot S95 is one example of that trend. Although the S95's video abilities are not at the top of its class, they do provide you with a substantial tool for capturing motion clips in high definition, along with a few refinements. I will go through the various options for movie-making in this chapter. Before I get into the specific settings you can make for your movies, I'll begin with a brief overview of the process.

Movie-making Overview

If you've used other recent models of digital cameras for movie-making, you may have seen various approaches to recording movies. With some cameras, you can press a Movie button at any time, no matter what shooting mode the camera is set to; with others, you have to set the camera to a specific Movie mode before you can record any motion pictures. There also is considerable difference among models as to what menu options and other settings are available when you record movies. With the PowerShot S95, Canon takes the specific-mode approach. That is, as I've discussed earlier, there is a dedicated entry on the mode dial for movie-making, represented by an

icon of a movie camera. The camera will not record any motion sequences unless the mode dial is turned to that icon.

Once you have selected Movie mode with the mode dial, you can proceed to a large extent in the same way as you do when shooting still images. That is, you can adjust various settings, though not as many as in Program mode, using the camera's physical controls as well as the Recording menu and the Function menu. Not surprisingly, the items that are available for adjustment on those menus are different from the items that are available in Program and other still-shooting modes.

Finally, you should note that the PowerShot S95 has built-in limitations that prevent it from recording any sequence longer than just under 30 minutes for HD footage, or about one hour for normal-quality footage. You can, of course, record multiple sequences adding up to any length, depending on the amount of storage space available on your memory cards. If you plan on recording a significant amount of HD video, you should get one of the highest-capacity and fastest memory cards you can find. For example, a 16 GB card can hold about one hour and 43 minutes of HD video, about 3 hours of standard-quality (640), or about 8 hours of the lowest quality (320). If you want to fit both still images and HD video sequences on a card, you might be better off with a 32 GB card, or even with an SDXC card having a capacity of up to 128 GB.

Quick Guide to Recording a Movie Clip

One drawback to having a dedicated movie mode is that, when you want to record a movie, you can't just set the camera to Auto shooting mode and fire away—if you select Auto mode, the camera will record still pictures, not movies. So, you need to be somewhat aware of the current settings, even if you just want to capture a brief clip of a scene during your vacation. Here are some suggested guidelines for quick settings when you just want to record the scene, and you don't care about

fine-tuning the settings. I'll discuss these steps with a bit of extra detail, in case you have turned to this section before mastering the camera's various controls and menus.

1. With the camera powered on, turn the mode dial on the top right of the camera to the Movie position, marked by a movie camera icon.

2. Press the Func./Set button (the round button in the center of the control dial on the back of the camera) to call up the Function menu. Use the up and down direction buttons, if necessary, to highlight the movie camera icon at the left side of the screen. Then use the left and right direction buttons, if necessary, to highlight the plain movie camera icon, labeled Standard, at the bottom of the screen.

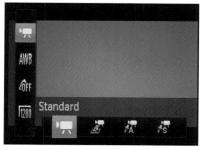

- 3. Use the up and down direction buttons, if necessary, to highlight the white balance icon, the second icon down on the left side of the screen. Make sure the AWB icon is highlighted at the bottom of the screen; use the left and right direction buttons to highlight it, if necessary.
- 4. Using the same procedure as above, check that the next icon down, My Colors, has the Off setting selected.

5. Using the same procedure again, check that the bottom icon on the left is the 1280 icon.

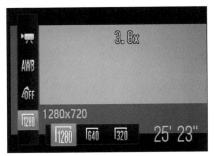

- 6. Press the Menu button at the bottom right of the camera's back to call up the menu system. Use the direction buttons, if necessary, to highlight the leftmost (Recording) menu, marked by a camera icon. Scroll down through that menu, using the control dial or the direction buttons, until you reach the IS Mode item, near the bottom of the menu. Use the left and right direction buttons, if necessary, to set that mode to Continuous, as opposed to Off, so the image stabilization system will be activated. (You can leave the other menu settings as they are, for now.)
- 7. In the upper right corner of the LCD you should see a white movie camera icon; in the upper left you should see a battery icon, the 1280 icon, and a time in minutes and seconds, showing how much recording time is available with these settings.

If you don't see those items, press the DISP. button, at the lower left of the control area on the camera's back, until you do.

- 8. Make sure you do not see the letters MF next to the movie camera icon in the upper right. If you do, press the left direction button (marked by a tulip and an MF icon), and then, when you see a group of icons on the screen, press the left direction button to highlight the center one, an icon showing a pair of mountains and a person, indicating normal autofocus.
- 9. Aim at your subject and use the zoom lever on top of the camera to frame the scene as you want, zooming in or out as needed. Press the shutter button halfway down until you hear a beep, to let the camera evaluate the exposure and focus. Then, whenever you're ready to begin recording the video, press the shutter button completely down to start the recording. Then take your finger off the button and hold the camera as steady as possible (if you're not using a tripod).
- 10. Continue to hold the camera steady, and pan (move from side to side) slowly and smoothly if appropriate to take in the scene before you. When the scene has ended, press the shutter button again to end the recording.

Other Settings for Movies

The steps outlined above will get you started recording video with the PowerShot S95 using the highest quality recording format and standard settings for white balance, autofocus, and other options. Once you have got the hang of the basic steps for movie-making, though, you may want to experiment with some of the other available settings. There are not all that many items that can be adjusted for motion pictures, but there are a fair number, some of which are unique to movies, and some of which are similar to, but not identical to, their counterparts for still photography. I will discuss these settings below according to which menu they appear on.

Recording Menu

When you press the Menu button to enter the Recording menu, you will notice that there are not that many items on the screen—just enough to fill one full screen with one item left over that you need to scroll down for.

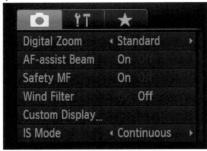

I'll discuss them all below; I won't spend much time on the items that work in the same way as they do for still pictures.

Digital Zoom

Digital zoom, the first item on the menu, is one of the more important ones for Movie mode, because of the way the zoom function works when you're recording a video clip. Before you start recording your movie, you can use the zoom lever to change the optical zoom factor, but once you have started recording, you cannot use the optical zoom. At that point, you can use the digital zoom, if you have activated that feature using this menu item. In other words, during the video recording process, digital zoom is the only zoom available. This point is not all that obvious, because, when you press the zoom lever to zoom in on your subject, you will see the image get larger, just as with the optical zoom. However, if you look at the lens, you will see that it is not moving—the zoom is completely electronic in this situation.

Now, I have to say that I don't have much of a problem with this limitation of the S95. My own preference is to zoom in, if necessary, before starting the recording. I try to avoid zooming while shooting a video if at all possible, because I find that the zooming motion can be unsettling to the viewer. In addition, with the S95 you cannot adjust the focus while recording video, and you would very likely need to re-focus after zooming in, because a zoomed shot has a more narrow depth of field than a wide-angle shot.

But, of course, there may be situations in which you are recording video of an event and you need to zoom in on a speaker or on some important activity. Just be aware that, if you think you may have to zoom during movie recording, you need to turn on the digital zoom feature on the Recording menu ahead of time.

Some final notes on zoom: The digital zoom option has only two possible settings when the camera is in Movie mode: Standard and Off. There is no digital tele-converter setting, as there is for still photography. Also, digital zoom is available only in the Standard movie mode, not in the three specialized modes, which I'll discuss later in this chapter. And, when you're in Movie mode, the control ring controls only step zoom; it can't control anything else. (And, of course, it controls step zoom only before the recording starts; once it has started, the control ring is disabled.)

AF-assist beam

This menu option, which turns on or off the red light that helps the autofocus mechanism focus in dark areas, works the same for movie recording as it does for shooting stills. What you need to remember with movies, though, is that you cannot use the focus mechanism (either autofocus or manual focus) once the recording has started; if you want to use autofocus, you need to press the shutter button halfway down before you start shooting the video. If you want to use manual focus, you need to turn it on and adjust your focus manually before you start shooting.

Safety MF

This option, which lets you use the autofocus mechanism to fine-tune your manual focusing, works just as it does when shooting still images. However, as with other focus-related functions, this one works in movie mode only before the camera has begun recording; you can't use it during the recording.

Wind Filter

The wind filter option is the one menu item that exists only in Movie mode; it does not appear on the menu screen unless the mode dial is set for video recording. Its purpose is to reduce the hiss or other noise that can occur when recording in windy conditions. It's worth trying in those situations; it's best to disable it when there is no wind, because Canon warns that the recording could sound "unnatural" in that case.

Custom Display

This option works in much the same way as it does when the camera is recording still images—that is, it lets you select the items that appear on the two screens that result from pressing the DISP. button. The difference when the camera is in Movie mode is that the only options available are grid lines and shooting information; the histogram option is not available in this situation.

IS Mode

With this option, you can control the PowerShot S95's image stabilization system, just as you can when shooting still photos. However, in Movie mode, the menu only gives you two choices: either Continuous or Off. You can't select Shoot Only or Panning, as you can in other shooting modes.

Set Shortcut Button

Finally, Canon presents you with this menu option in Movie mode, which lets you assign any one of 19 settings to the Short-

cut button, but discourages you by putting "negative" symbols (circles with lines through them) over 13 of the options, namely, those that do not function during video recording, such as ISO, continuous shooting, and digital tele-converter. If you go ahead and set one of these items anyway, it won't function during video recording, but if you later switch to a shooting mode in which it does function, the item will be active when you press the Shortcut button while the camera is in that mode.

Function Menu

When you press the Func./Set button while in Movie mode, you will see that there are only four settings that you can make, arrayed up and down the left side of the screen. I'll discuss these in turn below.

Movie Mode

Within the main Movie recording mode, there are four submodes or types of movies. The first icon at the top of the menu on the left side of the screen lets you choose one of these: Standard, Miniature Effect, Color Accent, or Color Swap. Standard, of course, is the normal mode, and the one I would expect is the most appropriate to use 90% of the time, if not more. It is the only one of these modes in which you can use the digital zoom feature.

Miniature Effect

Miniature Effect works very much the same as the similar function for still photography, which was discussed in Chapter 4. Once you have selected this effect, press the DISP. button to activate the controls that adjust the white box on the screen that will contain the non-blurred part of the image. You then can use the zoom lever to make the white box larger or smaller. Everything inside that box will stay in sharp focus; the areas outside of it will be blurry. Also, you can use the up and down direction buttons to move the white box to cover the part of the image that you want to stay in focus.

When the camera is recording video, though, there is one further option. Press the Menu button, and the camera gives you a choice of three options at the bottom of the screen: 5x, 10x,

and 20x.

Use the control dial or the direction buttons to highlight one of these choices, and then press the Menu button to go back to the other display to adjust the white box, if necessary. When all settings are adjusted as you want them, press the shutter button to start the recording. When you go to play it back, it will whiz by on the screen very rapidly, at either 5, 10, or 20 times normal speed, according to the setting you chose.

The end result of all of these settings is a moving-picture version of an image with the "miniaturized" effect that is available for still images from the Scene mode selections. Because of the blurred edges of the scene and the speeded-up action, this effect gives the impression that the real-life subjects of the video were actually scale models, such as those found in a model train layout or a miniaturized village.

Color Accent and Color Swap

These other two movie modes behave in the same way as their still-image counterparts, discussed in Chapter 3. With Color Accent, you select one color to remain in the scene, while all other colors are converted to black-and-white. With Color Swap, you select one color to substitute for another color in all parts of the scene.

White Balance

The next option on the Function menu for movie shooting, white balance, behaves in the same way as it does for still images, except that it does not include the ability to make fine adjustments of amber, blue, green, and magenta, as with still shooting. White balance is available for adjustment only when the Movie mode is set to Standard—you can't adjust white balance if you are using the Miniature Effect, Color Accent, or Color Swap option.

My Colors

The My Colors settings are completely available when shooting movies, but only in Standard mode. You can use any of the various color effects, including Vivid, Sepia, and the others, as well as setting a Custom Color selection by adjusting contrast, sharpness, saturation, red, green, blue, and skin tone to your own specifications.

Image Quality

The final option on the Function menu for movies provides three choices for the image quality, or pixel resolution, of your videos: 1280 X 720 pixels, which is a high-definition (HD) setting; 640 X 480, which is a standard-quality setting, sometimes referred to as VGA, for the standard resolution of a traditional (non-widescreen) computer monitor; and 320 X 240, which records with the smallest number of pixels at a reduction in quality in order to allow more footage to fit on a storage device. On the Function menu, these three selections are listed simply as 1280, 640, and 320.

Deciding on one of these settings should be relatively easy, because there are not too many considerations involved. If you want the highest quality, then the clear choice is 1280. If quality is not a major issue, because the video is just to record something such as an inventory of possessions or of items being donated, then 640 is a good choice. I would not choose

320 unless I was faced with an emergency situation, in which storage space was at a premium and I had to record the footage with the available memory card.

Other Settings and Controls

I have discussed all of the Recording menu and Function menu items that can be set for recording movies. There are still a few other items that can be set or adjusted, apart from the options on those menus. These items are discussed below.

Exposure Compensation and Exposure Lock

When you are shooting movies with the PowerShot S95, you don't have a lot of control over the exposure—the camera automatically adjusts the exposure for you. It does a good job of varying its settings as the lighting changes, so you can just rely on the camera's exposure automation in many instances. However, you do have a limited amount of exposure control available to you—before you actually start shooting.

Here are the two exposure-related things you can do. First, you can dial in a limited amount of positive or negative exposure compensation, if you believe that the camera's automatic exposure will otherwise result in footage that is too bright or too dark. To do this, once the camera is set to Movie mode, but before you have started recording the video, you can press the exposure compensation button (top direction button on the control dial), and then turn the control dial to the right or left to increase or decrease the exposure, relative to the automatic exposure the camera calculates. The exposure compensation scale that appears in the lower left of the screen in Movie mode is different from the one that appears when you're shooting still images.

The Movie mode scale is shorter, and has no numerical markings. You just use the control dial to move the green dot below the scale to the right for brighter exposure or to the left for darker exposure. When you press the shutter button to start recording the movie, the scale stays on the screen, but you cannot make any adjustments to it while the camera is recording.

Second, you can lock in a particular exposure so it stays set throughout the recording session. You might want to do this if you want the light and dark areas in your scene to appear naturally light and dark, rather than having the camera continuously adjust the exposure in an attempt to even out the lighting for all subjects that you record. Or, you might want to lock in a particular exposure for a creative reason, such as filming a "day for night" scene by making the daylight appear to be more like twilight.

Here are the steps to lock an exposure in this way. While the camera is in Movie mode, but before you have started recording, press the shutter button down halfway until you hear a beep, meaning the camera has evaluated the exposure and focus. Then release the shutter button and, within a second or two, press the up direction button. You will see the exposure compensation scale appear on the screen. Now you can move the camera to any new location and the exposure will remain locked as you set it. You can also adjust the exposure (before starting the video recording) by turning the control dial to move the green marker along the exposure compensa-

tion scale in either direction. When you are ready, press the shutter button fully down to start the movie recording with the locked exposure setting.

Self-timer

The self-timer functions normally when the camera is set to Movie mode, except that, naturally enough, you cannot set a number of shots as you can when taking still pictures. You can set the timer to delay for any number of seconds up to 30 before the shutter is tripped, starting the recording. Of course, you have to return to the camera to press the shutter button again to stop the recording at the appropriate time.

Control ring

In Movie mode, the control ring around the lens can be used only for step zoom—that is, to zoom the lens to one of 5 specific focal lengths: 28mm, 35mm, 50mm, 85mm, or 105mm. You cannot set the ring to have any other function in this mode.

Movie Playback

As with still images, you have the option of transferring your movies to your computer for editing and playback, or playing them back right in the camera, for displaying either on the camera's LCD or on a TV, when the camera is connected via the standard A/V cable or an optional HDMI cable.

If you play your movies in the camera, there are several options and controls available to you. First, as I discussed in Chapter 6, you can use the Jump feature to find your movies. To do this, while in Playback mode, press the up direction button which brings up the Jump/Filtering screen. Scroll down to the fourth icon on the left side of the screen, for choosing movies or stills. Use the right direction button, if necessary, to change the displayed category from Stills to Movie. Once the Movie category is displayed, turn the control dial to scroll through the movies until you find the one you want to watch.

Press the Func./Set button when your chosen movie is on the screen, and its first frame will be displayed, overlaid with a line of playback controls.

Those controls provide the following functions, from left to right: Exit back to group of movies; Play; Slow Motion; First Frame; Previous Frame; Next Frame; Last Frame; and Edit. To use any of these controls, scroll through the line of icons using the control dial or the direction buttons (which wrap around from end to end on the line of icons). When the highlight box is on your chosen icon, press the Func./Set button to activate it. In a few cases, mentioned below, you can hold down the Func./Set button to change the speed.

Several of these controls are self-explanatory, but a few need additional explanation. The Play button is used either to start the movie playing or to pause playback at any time. When you choose Slow Motion, you will see a scale at the upper right of the screen showing the speed of the playback; use the direction buttons or the control dial to change that speed. The Previous Frame control also acts as a Rewind control if you hold down the Func./Set button instead of just pressing it; the Fast Forward control acts the same way in the other direction.

Finally, the last icon, Edit, needs some further discussion. This icon can be used to mark the film for rough editing of a portion of the beginning or end of the film. To do this, after selecting the Edit icon, you will see a new panel of icons in the

upper left of the screen, from top to bottom: Edit Beginning; Edit End; Play; Save; Exit.

Start by using the direction buttons to highlight either of the top two icons, to trim either the start or the end of the video sequence. Then use the left and right direction buttons or the control dial to move the orange marker along the editing bar at the bottom of the screen to the point where you want to trim, either from the beginning or the end of the film. Watch for a white scissors icon to appear; when that icon appears beside the bar, you have reached a valid editing point. (If you don't stop at a scissors-marked point, the camera will use the nearest such point anyway.) Now you can use the down direction button to highlight the Play icon in the upper left set of icons, to see how the trimmed video will look. If necessary, you can then edit again. When you're satisfied, highlight the Save icon. You are then prompted to select New File, Overwrite, or Cancel. If you select Overwrite, the trimmed clip will overwrite and erase the original one; I recommend vou select New File unless you are really certain you won't ever need the full clip again.

Certainly, this editing function is rudimentary, and is no substitute for proper editing on a computer. If you're in the field and have no other way to edit, though, this operation may be better than nothing.

Chapter 9: Other Topics

Macro (Closeup) Shooting

acro photography is the art or science of taking photographs when the subject is shown at actual size (1:1 ratio between size of subject and size of unenlarged image) or slightly magnified (greater than 1:1 ratio). So if you photograph a flower using macro techniques, the image of the flower will be about the same size as the actual flower. You can get wonderful detail in your images using macro photography, and you may discover things about the subject that you had not noticed before taking the photograph.

The PowerShot S95, like many modern digital cameras, is quite capable of shooting macro photographs. For example, the above shot was taken with the lens at its wide-angle setting, as close as it could get to the subject, using macro autofocus mode. As noted earlier, you set the autofocus system to macro focus as follows: Press the left direction button on

the control dial to bring up the little menu of three icons, and press the left direction button again to move to the left-most choice, the tulip icon, indicating macro autofocus mode.

With the PowerShot S95, setting the autofocus system to macro mode does not amount to a major change. No matter whether the autofocus mode is set to macro or normal autofocus, the camera is able to focus as close as 2 inches (5 centimeters) from the subject, when the zoom lever is pushed all the way to the left for the wide-angle setting. With the lens zoomed in to the full extent of optical zoom, the camera can focus as close as 12 inches (30 cm). According to the Canon user's manual, when the camera is in macro mode, it can only focus out to 20 inches (50 cm), whereas, in normal mode, it can focus out to infinity. In practice, the main difference between macro focus and normal focus that I have noticed is that, in macro mode, the camera will not focus at a distance when zoomed in for a telephoto shot. It appears to focus properly at a distance for a wide-angle shot, even in macro mode. However, because focus results may vary under different conditions, it is best to limit the use of macro autofocus mode to shots at a distance of no more than about 20 inches (50 cm) from the lens.

You might ask what the benefit is of using the macro setting at all, given that the camera can focus down to 2 inches (5 cm) even in the normal autofocus mode. The answer is not entirely clear; based on what Canon says in the user's manual, it appears that the camera may focus "more reliably" using the macro setting. But this does not mean that you can't focus at that range using the normal setting. I recommend that you try focusing at close range with the normal focus setting unless you encounter problems, and only then change to macro mode to see if that helps the camera achieve sharp focus.

You don't have to use either the macro autofocus setting or the normal autofocus setting to take macro shots; if you set the camera to manual focus by choosing the MF icon, you can also

focus on objects very close to the lens. You do, however, lose the benefit of automatic focus, and it can be tricky finding the correct focus manually.

When shooting extreme close-ups, you should use a tripod, because the depth of field is very narrow and you need to keep the camera steady to take a usable photograph. It's also a good idea to take advantage of the self-timer. If you take the picture using the self-timer, you will not be touching the camera when the shutter is activated, so the chance of camera shake is minimized. You should also leave the built-in flash retracted, (set to forced off) so it can't fire. Flash from the built-in unit at such a close range would likely be of no use. If you need the extra lighting of a flash unit, you might want to consider using a special unit designed for close-up photography, such as a ring flash that is designed to provide even lighting surrounding the lens. Some photographers have good success using off-camera slave flash units, such as those discussed in Appendix A.

I don't know of a ring flash designed for use with the Power-Shot S95, but there are undoubtedly flash units that could be used or adapted for this purpose. There are also other creative solutions to the problem of providing even lighting for closeup photography. For an excellent discussion of this and other issues, see Closeup Shooting by Cyrill Harnischmacher (English translation published by Rocky Nook 2007).

Using RAW Quality

We've discussed RAW a couple of times. RAW is a setting in the PowerShot S95's Function menu. It applies only to still images, not to motion pictures. When you set the image type to RAW, as opposed to JPEG, the camera records the image without any in-camera processing; essentially, it just takes in the "raw" data and records it.

There are both advantages and drawbacks to using RAW in

this camera. First, the drawbacks. A RAW file takes up a lot of space on your memory card, and, if you copy it to your computer, a lot of space on your hard drive. Second, there are various functions of the PowerShot that won't work when you're using RAW. The functions that don't work with RAW mode include digital zoom, My Colors, i-Contrast, aspect ratio, Redeye correction, Date Stamp, and certain options on the Playback menu, including Resize, Trimming, and DPOF (printing directly to a photo printer). Third, you may have problems working with RAW files on your computer, though those can be overcome.

Let's talk about the advantages, and how much (or little) to worry about the drawbacks. The main advantage is that RAW files give you an amazing amount of control and flexibility with your images. When you open up a RAW file (those from this camera have a .cr2 extension) in a compatible software program, the software gives you the opportunity to correct problems with exposure, white balance, color tints, and other settings.

For example, the image above is shown as it is being opened in Adobe Camera Raw, before being opened in Photoshop. If you had the aperture of the camera too narrow when you took the picture, and it looks badly underexposed, you can manipulate the Exposure slider in the software and recover the image to a proper exposure level. Similarly, you can adjust the white balance after the fact, and correct color tints. You can even change the amount of fill lighting. In effect, you get a second chance at making the correct settings, rather than being stuck with an unusable image because of unfortunate settings when you pushed the shutter button.

Therefore, the drawbacks are either not too severe, or they are counter-balanced by the great flexibility RAW gives you. The large size of the files may be an inconvenience, but the increasing size of hard drives and SD cards, with steadily dropping prices, makes file size much less of a concern than previously. I have heard some photographers grumble about the difficulties of having to process RAW files on the computer. That could be an issue if you don't regularly use a computer. I use my computer every day, so I don't notice. I have had problems with RAW files not loading when I didn't have the latest Camera RAW plug-in for Adobe Photoshop or Photoshop Elements, but with a little effort, you can download an updated plugin and the software will then process and display your RAW images. The PowerShot S95 comes with Digital Photo Professional, a computer program for processing RAW files and converting them to JPEG or other formats that you can use for sending photos by e-mail and manipulating them with editing software.

The bottom line is you certainly don't have to use RAW, but you may be missing some opportunities if you avoid it.

Using Flash

As I discussed earlier, the Flash Settings item on the Recording menu gives you access to the various settings for the built-in flash unit on the PowerShot S95. You can also get access to that sub-menu screen by pressing the Flash button (aka the right

cursor button) followed quickly by the Menu button. Or, if you need access only to the basic setting of flash modes, including auto, forced on, slow synchro, and forced off (depending on the shooting mode), you can just press the Flash button to bring up a small menu with icons for the currently available flash modes.

Here are some general guidelines on the use of flash with this camera. If you decide to allow the use of flash, either by selecting Auto shooting mode or setting the flash mode to auto flash, you may have some further decisions to make, depending on which shooting mode you're using. If you're using Auto shooting mode, your flash decision-making is done. In that recording mode, the camera automatically selects auto mode for the flash, and the camera will determine whether or not to fire the flash, and, if so, whether to use slow synchro for the flash mode. For example, if the camera detects a scene that is appropriate for the Landscape variety of Scene mode, it is likely to set the flash mode to slow synchro, so the background scenery will be exposed by the existing light, while the foreground subject is illuminated by the flash. With the HDR scene type, the flash is forced off and cannot be fired; this makes sense, because the point of HDR shooting is to balance the exposure through in-camera processing in difficult lighting conditions; using flash addresses the lighting situation in a completely different way.

With most of the scene types, you have the option of setting the flash mode to either auto flash, forced on, or forced off. You cannot turn on slow synchro yourself with any of these settings, except one—Stitch Assist. However, as indicated above, when you select the Landscape setting, the camera will turn on slow synchro mode to ensure that the background is illuminated as well as possible by existing light.

When you're shooting in Program mode, you have complete control over the behavior of the built-in flash unit. You can set

the flash mode to any of its four possible modes: auto flash, forced on, slow synchro, or forced off. In the Manual, Shutter Priority, and Aperture Priority modes, you can select only either forced on or forced off. Finally, in Low Light shooting mode, your only choices for the flash setting are auto flash or forced off.

To consider the full range of flash options, let's assume you're shooting in Program mode. Now you have to decide whether to choose auto flash, forced on, or slow synchro, or forced off.

Let's start with forced off, probably the easiest choice to make. It's very useful to have this setting available, so you can be certain that the flash will not fire. Obviously, in certain environments it would be embarrassing or worse to have a flash go off, such as in a museum that allows cameras but not flash, or in a church or other religious setting. Also, you may prefer not to risk having the harsh lighting that often results from on-camera flash units, or you just may prefer to exercise your creative skills as a photographer to avoid the easy solution of lighting up the scene with flash.

A harder question to answer may be why you would want to use the forced on setting, ensuring that the flash will fire, when you could use the auto flash setting and let the camera decide whether it's needed. One case is when there is enough backlighting that the camera's exposure controls could be fooled into thinking the flash isn't needed. If, in your judgment, the subject will be too dark for that reason, you may want to force the flash to fire. Another such situation could be an outdoor portrait for which you need fill-in flash to highlight your subject's face adequately.

What about slow synchro? With this option, the camera sets a relatively slow shutter speed, so that the ambient (natural) lighting will have time to register on the image. In other words, if you're in a fairly dark environment and fire the flash

normally, it will likely light up the subject (say a person), but because the exposure time is short, the surrounding scene may be black. If you use the slow synchro setting, the slower shutter speed allows the surrounding scene to be visible also. The two images below were taken by the S95 with identical room lighting and identical camera settings, except that the top image was taken with the flash forced on, resulting in an exposure of f/2.8 at 1/60 second, and the bottom one was taken with the flash set to slow synchro, resulting in an exposure of f/2.8 for 1 full second. In the first image, the flash illuminated the foreground, but the background, especially the room beyond the glass doors, is dark. In the second image, the farther room is illuminated by ambient light, because of the much longer shutter speed.

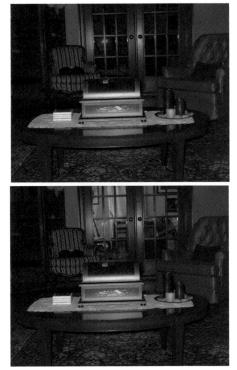

Finally, in the Program shooting mode you have the option of

setting the Flash mode to auto. Auto flash gives the camera a chance to use its programming to determine the best setting. You might want to take that route when you want to use some of the advantages of Program mode, such as the ability to use the RAW format or the My Colors settings, or to adjust the ISO, white balance, metering method, or My Colors settings, but would like to let the camera decide when and if to use flash.

Other Flash Settings

Apart from the main flash modes, there are several other flash settings that you can take advantage of, all of which were discussed in Chapter 4 in connection with the Flash Settings item on the Recording menu: Flash Mode (Auto or Manual), Flash Output (Minimum, Medium, or Maximum), Shutter Sync. (1st-curtain or 2nd-curtain), Red-Eye Correction (On or Off), Red-Eye Lamp (On or Off), and Safety FE (On or Off).

In addition to those settings, there is one other flash-related setting to discuss—FE lock, or Flash Exposure lock. This option is similar to AE lock (Auto Exposure lock), discussed earlier, which locks in a metered exposure so you can aim the camera at a different subject with the locked exposure settings. However, FE lock works when you will be using flash.

To use FE lock, set the camera to Program shooting mode, and set the flash to forced on, using the Flash button. Then, aim at your subject and press the shutter button down halfway to evaluate the exposure. While still holding down the shutter button, press the top direction button. The flash will fire so that the camera can evaluate the exposure with the flash, and you will see an asterisk (*) on the LCD screen, to the left of the shutter speed, as shown in the image on the next page.

The exposure indicated on the LCD will now be locked in, and you can move the camera to another subject (or leave it aimed at the same subject) to take the picture using the locked-in exposure setting, with the flash firing.

There are a great many considerations that go into the use of flash. The best advice I can give you is to consult an expert if you want to explore the subject further. An excellent book about the use of flash is Mastering Digital Flash Photography, by Chris George (Lark Books, 2008).

Infrared Photography

In a nutshell, infrared photography involves finding a way for the camera to record images that are illuminated by infrared light, which is invisible to the human eye because it occupies a place on the spectrum of light waves that is beyond our ability to see. In some circumstances, cameras, unlike our eyes, can record images using this type of light. The resulting photographs can be quite spectacular, producing scenes in which green foliage appears white and blue skies appear eerily dark.

Shooting infrared pictures in the times before digital photography involved selecting a particular infrared film and the appropriate filter to place on the lens. With the rise of digital imaging, you need to find a camera that is capable of "seeing" infrared light. Many cameras nowadays include internal filters

that block infrared light. However, some cameras do not, or block it only to a relatively small extent. (You can do a quick test of any digital camera by aiming it at the light-emitting end of an infrared remote control and taking a photograph while pressing a button on the remote; if the remote's light shows up as bright white, the camera can "see" infrared light at least to some extent.)

The PowerShot S95 is quite capable of taking infrared photographs. In order to unleash this capability, you need to take a few steps. The most important is to get a filter that blocks most visible light, but lets infrared light reach the camera's light sensor. (If you don't, the infrared light will be overwhelmed by the visible light, and you'll get an ordinary picture based on visible light.)

As with most experimental endeavors, there are multiple ways to accomplish this. For example, if you search on the internet, you will find discussions of how to improvise an infrared filter out of unexposed but developed (i.e., black) photographic slide film.

A more certain, if more expensive way to make infrared photographs with the PowerShot S95 is to purchase an infrared filter, along with an adapter that lets you attach the filter securely to the camera. There is an adapter available from a company called Lensmate, which makes several accessories for the PowerShot S95. This adapter is not ideal, because you have to glue it onto the camera. However, the Lensmate company provides detailed instructions for attaching the adapter carefully, and for removing it without adverse effects later on if you need to do so. Once the adapter is in place, you can then attach any filter or accessory lens with a 37mm diameter that screws on. (I discuss this adapter in more detail in Appendix A.)

The infrared filter I have seen most often recommended is the Hoya R72, and that is what I use. It is a very dark red, and

blocks most visible light, letting in mainly infrared light rays in the part of the spectrum that tends to yield interesting photographs.

The next question is to figure out matters of exposure. Again, photographers have different approaches, and time spent looking on the internet for discussions of those approaches will be rewarding. For the image shown below, I set a custom white balance, using brightly sunlit green foliage as the base. That is, I used the camera's white balance menu setting in the Function menu, and, in the screen for setting a custom white balance, I aimed the camera at the bright green foliage and pressed the Menu button. The results were essentially what I expected from infrared photography; scenes with tree leaves and grass that look white, and other unusual, but pleasing effects. (This image was taken in late winter, when there was not as much green foliage as at other times of the year; this sort of infrared photography often is more successful in the spring or summer, when there is a richer variety of green subjects

available.)

For exposure, I set the camera to shoot in Program mode and let it select the shutter speed, which was slightly long because of the dark filter. I set the camera on a tripod and disabled the image stabilizer, because it is not needed when the camera is on a tripod. The PowerShot did the rest, exposing the image for 1/25 second at f/2.0, with an ISO setting of 800. You can often get interesting results if you include a good amount of green grass and trees in the image, as well as blue sky and

clouds.

Street Photography

One of the reasons many users prize the PowerShot S95 is because it is very well suited for street photography—that is, for shooting candid pictures in public settings, often without the subject being aware of your activity. The camera has several features that make it well-suited for this type of work—it is small, lightweight and unobtrusive in appearance, so it can easily be held casually or hidden in the photographer's hand. Its 28mm equivalent wide-angle lens is excellent for taking in a broad field of view, for times when you shoot from the hip without framing the image carefully on the screen. Its f/2.0 lens lets in plenty of light, and it performs well at high ISO settings, so you can use a relatively fast shutter speed to avoid motion blur. You can make the camera almost completely silent by turning off the beeps and shutter sounds.

What are the best settings for street shooting with the PowerShot S95? If you ask that question on one of the online forums, you are, naturally, likely to get many different responses. I'm going to give you some fairly broad guidelines as a starting point. The answer depends in part on your own personal style of shooting, such as whether you will talk to your subjects and get their agreement to being photographed before you start shooting, or whether you will fire away from across the street with a palmed camera and hope you are getting a usable image.

Here are a couple of approaches you can start with and modify as you see fit. One way that some photographers like is to shoot in RAW, and then use post-processing software such as Photoshop or Lightroom to convert your images to black and white, along with any other effects you are looking for, such as extra grain to achieve a gritty look. (Of course, you don't

have to render your street photography in black and white, but that is the usual practice.) If you decide to shoot in RAW, you can't use settings such as My Colors or i-Contrast. You can, however, play around with your basic exposure settings. I recommend you shoot in Shutter Priority mode at a fairly fast shutter speed, say, 1/100 second or faster, to stop action on the street and to avoid blur from camera movement. You can set ISO to Auto, or possibly use a high ISO setting, in the range of 800 or so, if you don't mind some visual noise. You may want to set the aspect ratio to 16:9 in order to take in a wide field of view for street scenes.

In the alternative, you can set the image type to JPEG, at Large size and Fine quality, to take advantage of the camera's image-processing capabilities. To get the gritty "street" look, try using the My Colors B&W setting, with ISO set somewhat high, in the range of 800 or above, to include some visual grain in the image while boosting sensitivity enough to stop action with a fast shutter speed. Or, you might try turning the mode dial to the Scene setting and using the Nostalgic scene type, with its intensity dialed all the way up to the maximum using the control dial, to get a completely desaturated (black and white) image with some built-in grainy effect. Of course, when you're using a Scene mode setting, you don't have as many other settings available, but if this mode gives you the effect you're looking for, it's worth trying.

Also, consider turning on continuous shooting, so you'll get several images to choose from for each shutter press.

You also might consider using Low Light mode, especially if it's a cloudy day, or you're shooting at night. You can't shoot in black and white in that case, but you can convert your images to monochrome later, in software, if you want to. You may be able to stop action with fast shutter speeds and high ISO settings that are available in this mode, and you may not mind the graininess that likely will result. Also, you get the advan-

tage of the fastest continuous shooting available with the S95, although, of course, your images are reduced to the Medium resolution.

When you're ready to start shooting, go into manual focus mode and set the focus to approximately the distance you expect to shoot at, such as 6 feet (2 meters) on the MF scale. Then, when you're ready to snap a picture, press the shutter button halfway to make a quick fine-tuning of the focus. (Make sure that Safety MF is turned on in the Recording menu. I would also turn off MF-point Zoom, because the enlarged area on the screen could make it hard to compose the shot.) Some street photographers maintain that this method is faster and more efficient than relying on the autofocus system. Of course, for any of this sort of shooting, you leave the lens zoomed back to its full wide-angle position, unless a specific situation comes up when you can hold the camera very steady and zoom in on a specific subject.

Making 3D Images

There's been a lot of attention paid to three-dimensional (3D) movies and images lately, with the advent of 3D televisions and the renaissance in 3D movies. Some digital cameras have appeared recently that have special features for creating 3D panoramas and other stereoscopic images, including the Sony NEX-3 and NEX-5, and the Fujifilm FinePix Real 3D W3. The

PowerShot S95 has no such built-in capability. But why should its users feel left out of the 3D wave? It's not that hard to create 3D images using just the S95 (well, okay, or any other camera, for that matter). Anyway, for you experimental types, here is one way to get into 3D with the S95.

First, you need to take two pictures of the same scene from two different positions, separated by a short distance. What I did for the image shown here was set up two tripods next to each other at the same height, about 8 inches (20 cm) apart, with the subject about 8 feet (2.4 m) distant. Then I took two pictures of the mailbox scene, first one from the right tripod, then one from the left. The camera needs to be facing straight ahead each time, not angled in toward the subject. I used manual exposure at f/5.6 with a shutter speed of 1/200 second and set the ISO to 125, to get good quality with no variation between the two exposures. I took the images in RAW format, but then converted them to JPEG in Photoshop without doing any manipulation of the exposure or white balance, and saved the images as JPEG files.

Next, I used a Windows program called Stereo Photo Maker, which can be downloaded free at http://stereo.jpn.org/eng/ stphmkr. From the program's File menu I selected Open Left/ Right images. I opened my two JPEG images with this command, which lets you load multiple images at once. Then, I went to the Stereo menu and, with both images appearing on the screen, I selected Color Anaglyph, and, on the sub-menu that appeared, Dubois (red/cyan). The program produced the single image shown on the next page, which looks blurry to the naked eye, with red and blue lines characteristic of 3D images you may have seen in comic books or other printed materials. (If you're using a Mac, there are other programs available, though I haven't used them. One possibility is Anabuilder, at http://anabuilder.free.fr. You also can use Photoshop, but you'll need to experiment a bit, or find instructions on the web.)

That's all there is to it! If you follow these steps with images that are properly aligned and taken from a good distance apart, the resulting image should be ready for viewing, either on screen or on paper, using old-fashioned red/blue 3D glasses. (The red side goes over the left eye.) If it doesn't pop out as a 3D image when viewed through the glasses, go to the Adjustment menu and try various adjustments, including Auto Alignment, Easy Adjustment, and others, until it looks good. (I had to use those commands to adjust the images that I worked with.)

Oh, by the way, if you can't find a pair of 3D glasses, I have a deal for you. Go to my web site at whiteknightpress.com, and search for "3D glasses" to find the page where I offer a cardboard pair for sale for \$1.00, including shipping. They're not fancy, but they work.

Connecting to a Television Set

The PowerShot S95 is quite capable when it comes to playing back its still images and videos on an external television set. The camera comes with an audio-video cable as standard equipment. The cable has a mini-USB connector at one end and two composite, or RCA, connectors at the other end. The red and white RCA plugs are for stereophonic audio, left and right; the yellow plug is for composite video.

To connect the cable to the camera, you need to open the little door on the right edge of the camera (when held in shooting position) and plug the small (mini-USB) connector into the lower one of the two ports inside the door.

Then connect the yellow, red, and white plugs to the composite video and audio inputs of a television set. You may need to set the TV's input selector to Video 1, AUX, or some other setting so it will switch to the input from the camera.

Once the connections are set and the TV is turned on with the correct input selected, turn on the camera in Playback mode, and you can play back any images or video you have recorded. HD video will play back with no problems on a standard television set. You may need to switch the camera's aspect ratio to achieve the proper result on screen.

You can also purchase an optional HDMI cable to connect the camera to an HD television set. You can purchase Canon's official HTC-100 cable, or you can use any generic HDMI cable, as long as one end has a mini-HDMI male connector, and the other end has a standard HDMI male connector.

Once you have connected the camera to a TV set, the camera operates very much the same way it does on its own. Of course, depending on the size and quality of the TV set, you will likely get a much larger image, possibly better quality (on an HD set), and certainly better sound. This difference will be especially noticeable in the case of slide shows; the music sounds much better through TV speakers than from the camera's minuscule speaker.

When the camera is connected to a TV with the standard video cable, it can not only play back recorded images; it can also record. When it is hooked up to a TV while in recording mode, you can see on the TV screen the live image being seen by the camera. In that way, you can use the camera as a video camera of sorts, and you can use the TV screen as a large monitor to help you compose your photographs. (This capability is not available when the camera is connected to the TV by an HDMI cable.)

APPENDIX A: Accessories

Then people buy a new camera, especially a fairly expensive model like the PowerShot S95, they often ask what accessories they should buy to go with it. I will hit the highlights, sticking mostly with discussing items I have experience with. For example, I won't provide any details about the Canon waterproof case, model number WP-DC38, because I don't have any experience with that item.

Cases

There are endless types of camera cases on the market. In selecting a case for my PowerShot S95, I looked at many different types. I came to the realization that, at least for me, there is no single "perfect" case for the S95. The type of case I use with this camera depends on what activity I am involved in, and what my purpose is for carrying the camera at a given time. For example, when I am engaged in day-to-day non-photographic activities but want to have a good camera handy in case a photographic opportunity presents itself, I usually put the S95 into a Lowepro Volta 20 case, shown below.

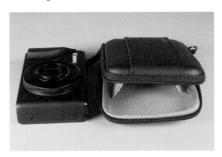

This soft black case is very compact, with just enough room to fit the camera comfortably inside and zip shut securely, even with a custom hand grip attached. There is not much room for extra batteries, memory cards, or other accessories, but that's the way I like it. After all, one of the great virtues of the S95 is its small size, so it doesn't make sense to stick the camera into a large, bulky case with a lot of additional items when you're just keeping the camera handy in case you see a good picture and want to grab it.

When I'm going on a trip that's specifically oriented to photography, I put the camera in a larger case, though I usually also leave it inside the Volta 20 case, at least at the outset, for extra protection. I have tried a fairly wide variety of cases; I recently enjoyed a photo day trip using the Lowepro Passport Sling bag, which hangs on my shoulder comfortably, and has several compartments that easily accommodate the S95, an extra battery, an external flash unit, and filters, and still has plenty of room for items such as trail mix, bottled water, and a guide book for the day's hike. I have also had good success with a waist pack made by Kata, model number DW-491, which is smaller than the Passport Sling, but still has room for the camera, some accessories, and a couple of small water bottles.

Batteries

Here's one area where you should go shopping either when you get the camera or right after. I use the camera pretty heavily, and I find it runs through batteries quite quickly. You can't use disposable batteries, so if you're out taking pictures and the battery dies, you're out of luck unless you have a spare battery (or an AC adapter and a place to plug it in; see below). The model number of the official Canon battery is NB-6L. Currently, the list price for these batteries in the United States is about \$60.00, and they are being sold at Amazon.com for about \$32.00, or as low as \$20.00 by third-party Amazon Marketplace sellers. You don't necessarily have to buy a Canon-

branded battery; there appear to be other brands out there that will do just as well. For example, various generic replacements for this model of battery are currently on sale at Amazon.com for less than \$10.00, with many positive user ratings. However, you do need to use some caution and common sense; there probably are some "super-cheap" batteries that are not a good idea to use. I rely on the dealer's reputation to avoid shoddy merchandise in that sort of situation. I have had excellent online shopping experiences with B&H Photo-Video, 17th Street Photo, and Amazon.com, among others.

AC Adapter

The other alternative for supplying power to the S95 is the AC adapter kit, Canon model number ACK-DC40. There is not too much to say about this accessory. It works well for what it does, in terms of providing a constant source of power to the camera. It consists of three parts: a standard-sized AC cord that you plug into a power brick and into an AC outlet; the fairly large power brick, which is attached to a long cable ending in a small connector that plugs into the camera; and an item called a DC coupler, which is exactly the size of the camera's battery, and fits into the battery compartment in place of the battery.

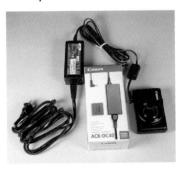

The DC coupler has a small jack into which you plug the cord that comes from the power brick. Each of the two power cables is about 79 inches (2 meters) long, so the whole AC adapter as-

sembly gives you about 13 feet (4 meters) of distance between the power outlet and the camera.

The one tricky aspect of connecting the adapter to the camera is that, once you have the DC coupler inserted into the battery compartment and have closed the door to that compartment, you have to open up a small flap in that door, so you can insert the power cord's connector into the DC coupler's jack. It's not obvious how to do this; what you have to do is pull up on a small rubber flap in the battery compartment door. That little flap stays up while the power connector is in the jack.

I should emphasize that providing power to the camera is all this adapter does. It does not act as a battery charger, either for batteries outside of the camera or for batteries while they are installed in the camera. It is strictly a power source for the camera. It may be useful if you are doing extensive indoor work in a studio or laboratory setting, to eliminate the trouble of constantly charging and replacing batteries. It also could be useful if you are recording a long movie in a setting where you have access to AC power. However, the AC adapter's cables and power brick are considerably bulkier and heavier than the camera itself, so using the adapter is quite inconvenient. If you don't have a real need for this setup, I recommend you invest in one or more extra batteries, and perhaps even an extra battery charger, so you can always have a couple of charged batteries ready for action. In short, the AC adapter should not be considered a high-priority purchase for most photographers.

Hand Grip

Some photographers find it difficult to get a good grip on the smooth surface of the PowerShot S95. To address this situation, an ingenious equipment designer, Richard Franiec, has developed a custom-fitted grip made of black anodized aluminum that glues securely onto the front surface of the camera, giving you a raised ridge that provides extra leverage for holding the camera tightly. The grip does not extend out beyond the lens, even when the lens is retracted, so the grip does not appreciably increase the bulk of the camera.

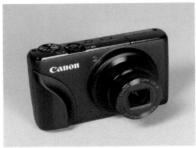

According to the instructions, the grip can be removed without damage to the camera. Personally, I find that the camera handles very well without the grip, but the grip integrates with the camera's body very nicely, and does give an added measure of security in holding on to the S95. For more information, including installation instructions, go to lensmateonline.com and look for the accessories for the PowerShot S90 and S95.

Add-on Filters and Lenses

There is no way to attach a filter or other add-on item, such as a close-up lens, directly to the lens of the PowerShot S95, as you can with DSLRs and other larger cameras, whose lenses are threaded to accept filters and auxiliary lenses. With the S95, in order to add such accessory items, you need to get an adapter. There is no such adapter made by Canon, but, again,

as with the hand grip discussed above, enterprising inventors have stepped into the breach. You can obtain a very workable adapter from Lensmate, at lensmateonline.com.

The adapter consists of two parts. The first is a very small plastic ring called the "receiver" that you glue onto the front of the lens barrel. This piece stays in place and does not interfere with the lens or the automatic lens cover. When you want to use a filter, you attach a larger piece, the "filter holder," which bayonets onto the receiver. Then you screw any 37mm diameter filter or other auxiliary lens into the holder. The receiver is said to be readily removable if you later want to take it off the lens, though I have not tried that procedure.

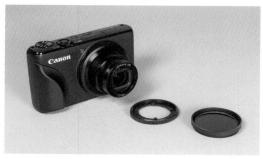

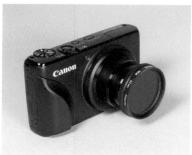

As you might expect, this system is not as sturdy as the natural screw-on capability of other cameras, because everything depends on a small plastic ring that is glued in place. So, don't expect to attach large items such as teleconverters or anything heavier than a standard 37mm filter. Just having the ability to

attach filters, however, enhances the usefulness of the camera considerably. You can use a neutral density filter when you want to force the camera to use a wide aperture to blur a background, or use a slow shutter speed to cause a waterfall to appear smoothed out because of the long exposure. You can use infrared filters, UV (ultraviolet filters), polarizers, or any of a wide assortment of close-up lenses, as well.

Flash

Clearly, Canon did not consider the use of external flash units to be a high priority for users of the PowerShot S95, because the camera does not have an accessory flash shoe on top, as many other advanced compact cameras do. This decision by Canon makes perfect sense for this camera, because one of the great virtues of the S95 is its very small size. It would defeat the purpose of designing such a compact camera to load it up with a bulky flash unit that would necessarily make the camera topheavy. Also, it may well be concluded that this camera really does not need a very powerful flash, for a couple of reasons. First, it has a sensor that is very capable of taking excellent pictures in low light, with ISO settings reaching up to 3200 in normal conditions, and up to a dark-penetrating 12800 in the special Low Light shooting mode.

Second, even apart from the S95's dim-light shooting prowess, for everyday snapshots that are not taken at long distances, the built-in flash should suffice. It works automatically with the camera's light-metering controls to expose the images well, and it is even capable of illuminating bursts of continuous exposures. It is limited by its low power, though. According to Canon, at the wide-angle focal length, the range of the built-in flash is about 21 feet (6.5 m), and, at the telephoto setting, about 9.8 feet (3 m), not very strong.

So, if you will often use the camera to take photos of groups of people in large spaces, or otherwise need additional power

from your flash, you may need to supplement the built-in unit. Fortunately there are some options. There is only one unit specifically designated by Canon to work with the PowerShot S95. That is the HF-DC1 High-Power Flash, a small unit that fits well with the camera in terms of looks and function.

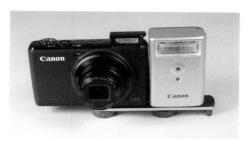

This flash comes with a bracket that attaches to the underside of the camera, using the tripod socket. The flash is then screwed into the bracket, right up against the camera. The HF-DC1 operates as a "slave" unit, meaning that its flash is triggered by the flash from the camera's built-in unit. The HF-DC1 provides more power than the built-in flash (its guide number is 18, meaning its maximum range at ISO 100 is about 18 meters, or 59 feet), and communicates automatically with the camera in the same way that the built-in flash does.

One limitation of the HF-DC1 is that it is a single unit with no rotating flash head, so that, if you mount it right next to the camera on its bracket, there is no possibility of bouncing the flash off of the ceiling or pointing it anywhere other than where the camera is pointing. However, because there is no direct connection between this flash unit and the camera, the flash can be mounted away from the camera, at any location within about 20 feet (6 meters). So, you can place the flash, with its bracket, on a separate tripod, or even hold it in your hand and aim it at the ceiling for a bounce effect.

One reported issue with this unit is that, if you are in a location where other photographers may be firing off flashes from Pow-

erShot cameras, your flash may be triggered by those flashes. In that event, you can set the HF-DC1 to Manual mode, in which case the flash will not fire unless you hold down the red Test button on the flash while pressing the shutter button on your camera. This system is designed to let you avoid having your flash accidentally triggered by those other flashes.

In my experience, I have had the best results with the HF-DC1 unit using it with the camera set to Manual exposure mode, and taking several test shots until I found the correct exposure. If you would like to consider other options for flash, the other arrangement I have used with the S95 is to set up an external flash unit with a separate optical slave trigger.

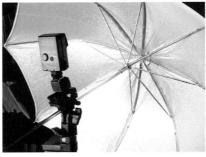

With that system, the external flash is attached to the hot shoe on the optical slave device, and aimed at your subject (or, as in the images shown here, positioned to fire into a flash umbrella, which diffuses the flash out toward your subject). Then, when you press the shutter button on the S95, its built-in flash trig-

gers the optical slave, which fires the external flash. With this system, at least in my experience, you need to use an external flash that has a Manual setting, and leave it on that setting. You then need to set the S95 to Manual exposure mode, and experiment until you find the correct exposure. The images on the previous page show a setup of this type, using the SYK-2, an inexpensive optical slave unit sold by Cowboystudio, purchased from Amazon.com, attached to a Panasonic DMW-FL220 flash, which has a Manual mode. The flash umbrella is attached to the light stand using an FU SOB Umbrella Mount Bracket, sold by JJC Photography Equipment Company.

The obvious advantage of using a generic optical slave unit is that you can use many different types and brands of flash unit, provided the unit is compatible with the optical slave and has a Manual mode. (Not all flash units are compatible, so you may want to check with the maker of the optical slave unit before deciding what flash to use.)

Finally, the Vivitar S4000 flash is a unit that is advertised as working with the PowerShot S90, and that should also work with the S95. This unit uses the built-in optical slave function in the same way as the HF-DC1. I have not tried this unit myself.

APPENDIX B: Quick Tips

In this section, I'm going to list some tips and facts that might be useful as reminders, especially to those who are new to digital cameras like the PowerShot S95. My goal here is to give you small chunks of information that might help you in certain situations, or that might not be obvious to everyone. I have tried to put down bits of information that might be helpful, but that you might not remember from day to day, especially if you don't use the S95 constantly.

Use continuous shooting. I recommend that you consider turning continuous shooting on as a matter of routine, unless you are running out of storage space or battery power, or have a particular reason not to use it. In the days of film, burst shooting was expensive and inconvenient, because you had to keep changing film, and you had to pay for film and processing. With digital cameras like the S95, it just gives you more options. Even with stationary portraits, you may get the perfect fleeting expression on your subject's face with the fourth or fifth shot. So, press the Func./Set button to call up the Function menu, scroll down to continuous shooting, and turn it on. (Remember that continuous shooting is not available in Auto shooting mode. Also recall that you can shoot more rapidly if you set the camera to Low Light mode, but you lose resolution if you do that; the camera automatically switches your image size to Medium.)

Avoid the Recording menu. You can't completely avoid it, but you can speed up your access to needed settings by placing them on your My Menu list. In some cases, as with flash settings, you can press a button (the Flash button) to get access to the features you need. Also, set the Shortcut button to call up

an often-used option. When you do use the Recording Menu, speed through it by using the control dial to move rapidly, and wrap around to reach items that are far from your current position. And use the Custom shooting mode to set up your most important group of settings. For example, right now I have the C shooting mode slot set up for my latest settings for street photography: ISO = 800; JPEG Large Fine; My Colors BW; lens at full wide-angle setting; Mute on; aspect ratio 16:9; continuous shooting on.

Watch for the DISP. button's extra functions. There are several options on the PowerShot S95 that can be tweaked with extra settings by pressing the DISP. button. In those cases, the DISP. icon will appear on the LCD next to a hint about what setting can be made by pressing the button, but it can be easy to overlook that icon on the small LCD. Here are the places to watch for these extra settings: white balance; image size and quality; exposure compensation; and manual focus.

Use macro shooting for subjects other than nature. Many photographers create beautiful images using the macro ability of the S95, shooting insects, flowers, and other natural items. But, with its focusing down to 2 inches (5 cm), its wide-angle lens, and its low-light performance, the S95 can serve you in many other ways with its macro shooting. If you need a quick copy of a shopping list, memo, driving directions, sales receipt, or cancelled check, it might make sense to set the S95's focus mode to Macro, maybe boost the ISO to 800 or so, and snap a quick image of it. When you get to your destination, you can display it on the LCD and enlarge it using the zoom lever, then scroll around in the document with the cursor buttons. The S95 becomes a pocketable copy machine, if you need it to.

Don't forget the camera's audio capability. While we're on the subject of possible business-related and other non-photographic uses of the camera, here is one to consider: Although the camera's audio features are not that strong, it does have a

built-in stereo microphone that is quite capable of recording voices clearly. So, if you need an audio recorder to record a spoken memo or to keep a record of a meeting, set the S95 to Movie mode at the 320 resolution (to give more recording time and use less space on the memory card). Try to aim the voices at the two small holes for the stereo microphone, on the front of the camera on either side of the lens.

Play your movies in iTunes, and on iPods, iPhones, and iPads. Because the S95's movies files are in the .mov format, which uses Apple Computer's QuickTime software, they are compatible with iTunes. So, it's very easy to play these movies on your computer, if you have downloaded Apple's free iTunes software. Just open a window on your computer to display the icon for a movie file (using Windows Explorer or Macintosh Finder), open iTunes on the same computer, and drag the .mov file from the Explorer or Finder window to the panel for the Library in iTunes. You can then play the movie from iTunes. If you want to play it on an iPod, iPhone, or iPad, you will need to take a few more steps: Select the video in iTunes, then select Advanced from the iTunes menu, and, from that menu item, choose Create iPod or iPhone version, or iPad or AppleTV version, as appropriate. Then you can sync iTunes with your device, and the movie will play very nicely on that device.

Explore the S95's creative potential. The PowerShot S95 is a very sophisticated camera, with several advanced features that give you the ability to explore experimental photographic techniques. Here are a few suggestions: Use Manual exposure mode with its shutter speeds as long as 15 seconds to take night-time shots with trails of lights from automobiles, storefronts, and other sources. Use shutter speeds as fast as 1/1600 second to freeze moving motorcycles, track runners, and other speedy subjects in mid-motion. Try "camera tossing," in which you toss the camera in the air, set to a multi-second shutter speed, to capture trails of light and color as the camera spins around. (But be sure to catch it on the way down!)

Try panning or otherwise steadily moving the camera during a multi-second exposure. Use long exposures (on a tripod) to turn night into day. Take HDR images with partly blurred subjects, such as blowing flags.)

Adjust the camera's color settings. The PowerShot S95 has several settings that let you fine-tune them with further color-related adjustments: white balance, two of the Scene mode varieties (HDR and Nostalgic), and the Custom setting for the My Colors feature. Try different settings for each of these until you find color combinations that convey what you would like to express with your images. With white balance, you can achieve unusual effects by purposely setting a custom white balance while aiming at a colored surface, rather than a white or gray one.

Take advantage of the RAW format. If you haven't previously used a camera that shoots RAW files, get to know the benefits of this capability and use them to improve your images. Install and use the Digital Photo Professional software that comes with the S95, or use other software, such as Adobe Photoshop or Photoshop Elements, to "develop" the RAW images. Learn how to fix problems with white balance, exposure, and other issues after the fact, using the flexibility of RAW shooting.

Use a neutral density (ND) filter for some shots. There are some times when you want a slow shutter speed, but, in bright light, you can't achieve it, because the aperture can only go as narrow as f/8 (or somewhat narrower for movies). One solution is to get the Lensmate adapter (discussed in Appendix A) that permits the use of filters, and use an ND filter over the lens to cut down on the light reaching the sensor, resulting in slower shutter speeds. (You can try just holding the filter in front of the lens, if you don't want to purchase the adapter.) You might want to do this to slow down the rush of a waterfall to a smooth, blended look, or to achieve a motion blur in a shot of a passing runner or walker.

Diffuse your flash. If you find the built-in flash produces light that's too harsh for macro or other shots, some users have reported success with using translucent plastic pieces from milk jugs, other food containers, or broken ping-pong balls as homemade flash diffusers. Just hold the plastic up between the flash and the subject. Another approach you can try when using fill-flash outdoors is to use the flash exposure compensation setting to reduce the intensity of the flash by -2/3 EV.

Use the self-timer to avoid camera shake. The S95 has a solid self-timer capability that is very easy to use; just press the down cursor button and choose your settings. This feature is not just for group portraits; you can use it whenever you'll be using a slow shutter speed and you need to avoid camera shake. It also can be useful when you're doing macro photography, digiscoping, or astrophotography (see below). And don't forget that you can set the self-timer to take multiple shots, which can increase your chances of getting more great images.

Set zone focusing. If you're doing street photography or are in any other situation in which you want to set the camera on manual focus for a specific zone or general distance, here is a quick way to do so. Set the focus switch to autofocus, then aim the camera at a subject that is approximately the distance you want to be able to focus on quickly. Once focus has been confirmed, press the left direction button and then select MF from the focus icons that appear on the screen, to select manual focus. Now you will have locked in the manual focus at your chosen distance, and you're ready to shoot any subject at that distance without the need to re-focus.

Keep your LCD clean. This tip is more mundane than the others, but I find that it helps me to keep the LCD screen as clean and bright as possible. The best way I have found to do this is to try to keep a small micro-fiber cloth within easy reach, in my camera bag or even in a pocket. A few swipes with one of these cloths will restore the shiny surface to its pristine glory.

(And, of course, you should also keep your lens clean!)

Experiment with astrophotography and digiscoping. In my books about some other camera models, I discussed this topic in the main text, but for the PowerShot S95 I'm just including it here in the Quick Tips. That's because this camera is not all that well suited for connecting to a telescope for photographing planets and stars (astrophotography), nor for connecting to a spotting scope for photographing wildlife (digiscoping).

Although you can obtain an adapter from Lensmate to attach lightweight items such as filters, the adapter is glued on to the lens barrel, and not screwed on as with some other cameras, so it would not be a good idea to rely on that glued piece of plastic to hold the weight of the camera when it's attached to a scope's eyepiece. If you're very careful, it might work, but I don't recommend it. You can also try taking pictures through a scope's eyepiece by just holding the camera up to the eyepiece. I have tried that approach, with only limited success, but if you're persistent and patient you may be able to get some usable results. The image of the moon shown here was taken with the S95 by holding it up to the eyepiece of a Meade ETX-90AT telescope. I used manual exposure mode, with settings of f/4.0, 1/100 second, at ISO 250.

APPENDIX C: Resources for Further Information

Books

visit to any large general bookstore or a search on Amazon.com will reveal the vast assortment of books about digital photography that is currently available. Rather than trying to compile a long bibliography, I will list a few especially useful books that I consulted while writing this guide.

- D. Pogue, Digital Photography: The Missing Manual (O'Reilly Media, Inc., 2009)
- C. George, Mastering Digital Flash Photography (Lark Books, 2008)
- C. Harnischmacher, Closeup Shooting (Rocky Nook, 2007)
- J. Paduano, The Art of Infrared Photography (4th ed., Amherst Media, 1998)
- B. Daum, The Canon Camera Hackers Manual (Rocky Nook, 2010)

Web Sites

Since web sites come and go and change their addresses, it's

impossible to compile a list of sites that discuss the PowerShot S95 that will be accurate far into the future. One way to find the latest sites is to use a good search engine such as Google or Bing and type in "Canon PowerShot S95." I just did so in Google and got more than 4 million results.

Another approach can be to go to Amazon.com, search for the product, and read the users' reviews, though you have to be careful to weed out the reviews by people who are disgruntled for reasons that don't have anything to do with the product itself. You can also visit a reputable dealer's site, such as that of B&H Photo Video, and read the users' reviews of the camera there. I will include below a list of some of the sites or links I have found useful, with the caveat that some of them may not be accessible by the time you read this.

Digital Photography Review

http://forums.dpreview.com/forums/forum.asp?forum=1010

This is the current web address for the "Canon Talk" forum within the dpreview.com site. Dpreview.com is one of the most established and authoritative sites for reviews, discussion forums, technical information, and other resources concerning digital cameras.

Reviews of the PowerShot S95

The links below lead to reviews of the PowerShot S95 by CNET. com, dpreview.com (comparison review with other advanced compact cameras), cameralabs.com, imaging-resources.com, and others.

http://reviews.cnet.com/digital-cameras/canon-powershots95/4505-6501_7-34154931.html

http://www.dpreview.com/reviews/q42010highendcompact-group/

http://www.cameralabs.com/reviews/Canon_PowerShot_ S95/

http://www.imaging-resource.com/PRODS/PS95/PS95A. HTM

http://www.digitaltrends.com/digital-camera-reviews/canon-powershot-s95-review/

http://www.dcresource.com/reviews/canon/powershot_s95-review

http://www.canon-powershot-s95.net/

http://www.dphotojournal.com/canon-powershot-s95-reviews-sample-photos/

http://www.digitalcameratracker.com/canon-powershot-s95-reviews-ratings-sample-photos/

The Official Canon Site

The United States arm of the Canon company provides resources on its web site, including the downloadable version of the user's manual for the PowerShot S95 and other technical information.

http://www.usa.canon.com/cusa/support/consumer/digital_cameras/powershot_g_series/powershot_s95/

Flickr Discussion Group

This site hosts a discussion forum about the PowerShot S95; 240

there also are photos taken by the camera posted in other parts of the site.

http://www.flickr.com/groups/canonpowershot_s95/discuss/

Ken Rockwell

This site of photographer Ken Rockwell provides helpful tips about the use of the S95 and provides some good examples of photographs taken with the camera.

http://www.kenrockwell.com/canon/s95.htm

Infrared Photography

This site provides some helpful information about infrared photography with digital cameras.

http://www.wrotniak.net/photo/infrared/

Kleptography

This site provides information about the custom-made hand grip for the PowerShot S95 and its predecessor, the S90.

http://www.kleptography.com/rf/#camera_s90

Lensmate

This is the site for Lensmate, a company that sells accessories for the PowerShot S95 and other cameras, including an adapter for attaching filters.

http://www.lensmateonline.com/

CHDK: Experimental Tinkering

If you are of a deeply curious, scientific bent and don't mind digging into computer programming and other somewhat geeky pursuits, you can delve into, and change, the inner workings of your Canon compact camera with the information at this site. CHDK stands for "Canon Hack Development Kit." The activities discussed at this site require a good deal of detailed work with programming, and they conceivably could cause some damage to the camera; see the FAQ at the site before attempting any alterations to the camera's firmware.

http://chdk.wikia.com/CHDK

Index

Symbols

1st-curtain sync 87 2nd-curtain sync 87 3D glasses 219 3D photography 217 procedures for 218 .mov files 42

A

AC adapter 24, 182 Canon ACK-DC40 224 connecting to camera 225 Adobe Camera Raw software 206 Adobe Photoshop 44, 65, 69, 110, 125, 126, 173, 183, 206, 218 Adobe Photoshop Elements 60, 69, 125, 173, 183 AEL (Auto Exposure Lock) 143 as Shortcut button setting 100 AF Frame 31 AF Lock as Shortcut button setting 99 Anabuilder software 218 Aperture 46 Aperture Priority mode 46, 145 and Flash Mode setting 86 use of Safety Shift with 89 Aperture Priority Mode 52 Apertures availablity at various zoom settings 50 Apple Aperture software 125 Aspect ratio 20, 28, 121 as Shortcut button setting 97 for RAW images 121 Astrophotography 237 Audio-video cable 219 Auto flash 211

Autofocus modes 30 Auto ISO setting maximum level 89 Auto mode 14, 37, 44, 77 limitations with 44,75 scene detection in 44 use for taking pictures 26 Auto Power Down 181 B Battery charging 18 extra 223 inserting and charging 17 Battery charger 17 Blurred background 48 Bokeh 48 Bracketing 115 as Shortcut button setting 97 auto exposure 36, 45 C Camera cases 222 Canon PowerShot S95 general features 14 general weaknesses 15 Canon user's manual 89, 134, 186 Connecting camera to TV set 219 Continuous shooting 118 Continuous AF mode 119 Continuous LV mode 119 faster in Low Light mode 71, 120 Contrast adjusting with Custom Color setting 115 Control dial 35, 139, 140 green icon 140 green icon representing on screen 36 using to adjust exposure compensation 35 using to adjust manual focus 35 Control ring 49, 52, 53, 133, 135, 141

244

using for Step Zoom 132
using to jump to images 158
using to set ISO 106
using when recording movies 200
Cowboystudio optical slave unit 231
Custom shooting mode 72, 101
Custom white balance
as Shortcut button setting 96

D

Date and time setting on camera 24 Day for night video 199 DC Coupler 224 Depth of field 47 Digiscoping 237 Digital Photo Professional software use with RAW images 125 Digital Tele-converter 81, 133 as Shortcut button setting 100 Digital Zoom 80, 133 digital tele-converter setting 81 inability to set 81 need to have aspect ratio set to 4:3 98 Direction buttons 140, 142 Display button 138 using to adjust LCD brightness 138 using to disable sounds when powering on 138, 177 Display Off 181 as Shortcut button setting 100 DPOF (Digital Print Order Format) 174 DR (Dynamic Range) setting 103 Drive mode as Shortcut button setting 97

E

Enlarging images 133, 151 Erasing an image 147 EV (Exposure Value) with Auto Bracketing 116

Exposure general settings 33 Exposure bracketing 116 alternative way to select 117 Exposure compensation 33 Exposure compensation button 54 Exposure Value (EV) 34 ExpressCard/34 Slot 21 Eye-Fi card 22, 23, 148, 184 using with RAW files 22 F Face Select setting 95 Face self-timer 60 Favorites 156, 161 FE (Flash Exposure) lock 211 Filter adapter 213, 227 Filtered playback 145, 156, 161 Filters 226 Flash built-in 37, 146 diffusing 236 external 228 Canon HF-DC1 High-Power Flash 229 Panasonic DMW-FL220 231 using with optical slave unit 230 Vivitar S4000 231 forced off 209 forced on 209 guidelines for using 207 slave unit 205 Cowboystudio optical slave 231 Slow Synchro 209 using with Auto mode 208 using with Program mode 208 using with Scene mode 208 Flash button 37, 145 Flash options 37,85 in Low Light mode 70 Focal length 47

Focus choosing focus options 30 Focus bracketing 117 alternative way to select 117 Focus Check setting 91, 153, 155 Focus lock 32, 78, 99 **Format** memory card 23 Formatting a memory card 179 F-stop 49 Func./Set button 141 using to display clock 142 Function menu 56, 102 G Grid lines displaying 92 H Hand grip 226 HD (high-definition) video 20, 39 HDMI cable 220 HDR (High Dynamic Range) 37, 63, 103, 116 HF-DC1 High-Power Flash 15 Histogram 91, 92, 153 definition of 153 illustrations 153 RGB (red, green, blue) 145 Hoya R72 infrared filter 213 I i-Contrast 103 as Shortcut button setting 95 Image quality 124, 126 in Low Light mode 70 Image size 126 in Low Light mode 70 Image stabilization 63 Image type 124

iMovie software 42 Index screens 133, 150 Indicator light 24, 147 Infrared filter 213 Infrared photography information and procedures 212 setting white balance for 214 ISO Auto ISO 71, 89, 106 Rate of Change setting 89 considerations in setting 105 general information 104 how to set 106 setting to 12800 71 ISO Auto Settings 88 ISO Speed setting as Shortcut button setting 96 J JPEG files 126 sizes 127 JPEG images 44, 46, 124 L Lamp self-timer and red-eye correction 135 Language setting on camera 25 Language setting alternative way to get access 185 Lensmate filter adapter 213 Light metering as Shortcut button setting 97 Low Light mode 70, 216 advantages 70 disadvantages 70,71 M

MacBook Pro computer 21

Macro autofocus 30, 45, 204 Macro photography 203 focusing range 204 using self-timer for 205 Manual exposure exposure scale 54 letting camera verify exposure setting 54 Manual exposure mode 53, 140 and Flash Mode setting 86 and ISO settings 55 Manual focus 30, 32 for macro photography 204 in Stitch Assist mode 99 selecting while in Tracking AF mode 80 using with Safety MF 85 Memory card formatting 179 inserting 19 shooting with no card in camera 19 Memory Card formatting 23 inserting 23 selecting 20, 23 Memory card reader 21 Menu button 139 Menu system grayed-out items 77 navigating 76,77 Metadata recorded by camera 24 Metering Method 120 MF icon 32 Mode dial 44, 131 Movie mode 39,77 Movie quality as Shortcut button setting 98 Movie quality setting 39 Movies and memory card capacity 188 detailed settings 191

```
digital zoom when recording 193
editing in the camera 201
editing on computer 42
focus options 40
 Function menu items 195
  image quality 197
  Movie Mode 195
    Color Accent 196
    Color Swap 196
    Miniature effect 195
    Standard 195
  My Colors 197
  white balance 197
 limitations on recording length 188
 limitations on zooming 192
 playback controls 41, 201
 playing 200
 procedure for recording 38
 recording
  control ring 200
  exposure compensation 198
  exposure lock 199
   self-timer 200
 Recording menu items
   AF-assist Beam 193
   Custom Display 194
   Digital Zoom 192
   IS Mode 194
   Safety MF 194
   Set Shortcut Button 194
   Wind Filter 194
 steps for recording 188
 zooming while recording 40
MultiMedia Card (MMC) 20
My Category playback option 156, 158
My Colors 109
 as Shortcut button setting 97
My Colors settings
 B/W 112
 Custom Color 115
```

Darker Skin Tone 113 Lighter Skin Tone 113 Neutral 111 Positive Film 112 Vivid 110 Vivid Blue 113 Vivid Green 114 Vivid Red 114 My Menu 76, 128 selectable items 129

0

Optical slave for flash 230

P

Panorama procedure for making 69 PhotoStitch software 69 PIctBridge 137, 173, 175 Playback general procedures 41, 149 jumping to images 156 motion pictures 41 movies 41, 200 rapid playback of still images 150 Playback button 137, 150 Playback menu 159 Playback menu items Erase 162 Favorites 164 i-Contrast 167 My Category 165 My Colors 171 Protect 163 Red-eye correction 168 Resize 170 Resume 172 Rotate 164 Scroll Display 172 Slideshow 160

Smart Shuffle 160 Trimming 169 Playback screens 152 Power button 133 Power saving options 181 Print button 137, 174 Printing images 172 Print Menu 175 Program mode 29, 38, 45, 75 advantages 46 Program Shift 45, 144

Q

QuickTime software 42 Quick tips 231

R

Rate of Change of ISO 89 RAW images 44, 46, 116, 124, 126, 205 advantages 125, 205 disadvantages 125, 206 functions that don't work with 206 size of 20 RAW+JPEG 46, 98, 125, 126 RAW or JPEG as Shortcut button setting 98 **REC** indicator 40 Recording menu 31, 45, 75 Recording menu options AF-assist Beam 83 AF Frame 78 AF Frame Size 78 Center 78 Face AiAF 78 Tracking AF 79 compared to Servo AF 83 AF-point Zoom 82 Blink Detection 92 Custom Display 92 Date Stamp 93

Flash Settings 85 Flash Exposure Compensation 86 Flash Mode 85, 86 Flash Output 86 Red-Eye Correction 88 Red-Eye Lamp 88 Shutter Sync. 87 IS Mode 93 MF-point Zoom 84 Review 89, 90 Review Info 90 Safety MF 84 Set Shortcut Button 94 **REC Pixels/Compression** as Shortcut button setting 98 **Red-Eye Correction** as Shortcut button setting 99 Registering shooting settings other name for Custom mode 72 Resetting camera settings to defaults 186 Review function 41, 149 Ring function button 133, 134, 141 S Safety Shift 53,89 Save Settings as Shortcut button setting 101 Scene mode 56 Scene types Beach 68 Color Accent 61, 143 Color Swap 62, 143 Fireworks 69 Fish-eye effect 66 Foliage 68 HDR 63 use of My Colors with 64 Kids & Pets 58 Landscape 58,60 Miniature effect 67, 133

Nostalgic 65, 134 Portrait 57 Poster Effect 60 Smart Shutter 59 Snow 69 Stitch Assist 69 Super Vivid 60 Underwater 68 Scroll Display feature 41, 141, 152, 172 SD card 19 SDHC card (Secure Digital High-Capacity) 19,21 SDXC card 19, 22 compatibility issues 21 Self-timer 146 use for macro shooting 147 Self-timer lamp 59,83 Self-timer/Trash button 146 Servo AF 58, 83 as Shortcut button setting 99 Set Shortcut Button 94 Setup menu 23,76 Setup menu items Create Folder 180 CTRL via HDMI 184 Date/Time 183 Distance Units 183 Eye-Fi Settings 184 File Numbering 180 Format 179 Hints & Tips 178 Language 185 LCD Brightness 178 Lens Retract 181 Mute 177 Power Saving 181 Reset All 186 Sound Options 178 Start-up Image 179 Time Zone 182

Video System 184

Volume 177 Shadow Correction setting 104 Sharpness adjusting with Custom Color setting 115 Shooting modes 29, 43 Shortcut button 137 assigning a function to 94 Shot Date playback filter 157 Shutter Priority mode 50, 145 and Flash Mode setting 86 general information 50 use of Safety Shift with 89 Shutter release button 132 Shutter speed 47, 50 Shutter speeds range of available speeds 53 Slideshow selecting images for 161 transitions 160 Slow Synchro flash 209 Smart Shutter 147 Smile self-timer 59 Sonnet memory card reader 21 Step Zoom 132, 134 Stereo Photo Maker software 218 Still/Movie selection 158 Stitch Assist using manual focus with 99 Street photography 215 settings for 73, 215

T

Telescope Meade ETX-90AT 237 Three-dimensional photography 217 procedures for 218 Top direction button 143

U

USB cable

using to connect to printer 173

\mathbf{V}

Video
recording length limitations 21
size of files 20
Volume
for playing back movies 42
for recording movies 40
of camera sounds 177

W

Waterfall
photographing with neutral density filter 235
Waterproof case 222
White balance
as Shortcut button setting 96
Auto White Balance 107
color temperatures 107
custom setting 109
fine adjustments 109
using control ring for 135
general information 106
settings 108
Wi-Fi (wireless) network 22, 184
Wink self-timer 59
Wrist strap 17

Z

Zoom lever 28, 132 using to view index screens 150 Zoom range 132

CPSIA information can be obtained at www.ICGtesting.com Printed in the USA BVIW12n2158081117 499877BV00001B/1